This Brilliant Darkness

This
Brilliant Darkness

A Book of Strangers

JEFF SHARLET

W. W. NORTON & COMPANY

Independent Publishers Since 1923

Page 162: Permission to publish an excerpt from "My Brother Refugee" by Jacob Glatstein
from the original Yiddish poem first published in *The Selected Poems of Jacob Glatstein* (New
York: October House, 1972) has kindly been granted by Joseph Mazel and the estate of
Fanny Mazel Glatstein.

For information about permission to reproduce selections from this book, write to
Permissions, W. W. Norton & Company, Inc., 500 Fifth Avenue, New York, NY 10110

For information about special discounts for bulk purchases, please contact
W. W. Norton Special Sales at specialsales@wwnorton.com or 800-233-4830

Manufacturing by Versa Press
Book design by Patrice Sheridan
Production manager: Julia Druskin

Library of Congress Cataloging-in-Publication Data

Names: Sharlet, Jeff, author.
Title: This brilliant darkness : a book of strangers / Jeff Sharlet.
Description: First edition. | New York, NY : W. W. Norton & Company, [2020]
Identifiers: LCCN 2019030058 | ISBN 9781324003205 (hardcover) |
ISBN 9781324003212 (epub)
Subjects: LCSH: Suffering. | Empathy. | Night people—Psychology.
Classification: LCC BF789.S8 S53 2020 | DDC 818/.603—dc23
LC record available at https://lccn.loc.gov/2019030058

W. W. Norton & Company, Inc., 500 Fifth Avenue, New York, N.Y. 10110
www.wwnorton.com

W. W. Norton & Company Ltd., 15 Carlisle Street, London W1D 3BS

1 2 3 4 5 6 7 8 9 0

Thiziza True Book

For the Sun, which is not his real name, and the Moon, which is not hers.

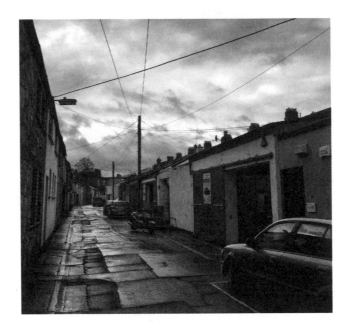

A thing you can't do very well with a phone camera is capture the light that made you stop even as you were racing to school to pick up your daughter on time. But there are compensations. The phone camera comes close enough for the viewer to guess, and in between that guess and the light-as-it-was stands me. The mediation. Perfect camera tech creates the illusion of unmediated vision. That amazing picture that looks like it's real? That's a deception. This—sort of what it looked like, something like what I saw, something like what I felt—is the truth.

Contents

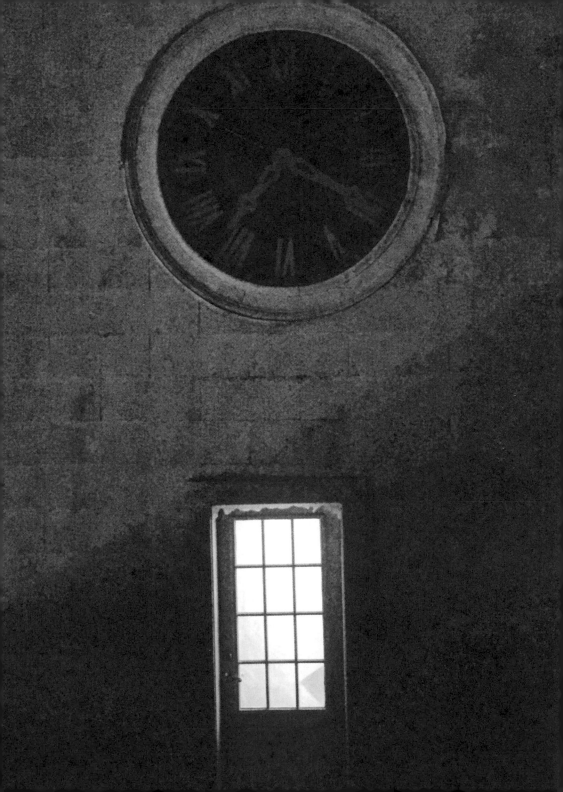

I recall that at first photographic implements were related to techniques of cabinetmaking and the machinery of precision: cameras, in short, were clocks for seeing.

—Roland Barthes, *Camera Lucida*

7:20, a.m. or p.m.

THE CLOCK SAYS 7:20, because it always says 7:20, its hands frozen now for many years, but it was later than that when I took this picture. It was meant to be a picture of a door, on the other side of which is the room where I was writing something else—something I can't recall, to which I never returned—when this book began.

It began with a phone call. A friend of my father's. A few days before, my father, who was seventy-nine, had collapsed, breathless, climbing steep stairs from a beach on Cape Cod. I'd sat with him as he'd gasped, his olive skin veiling blue. A lifeguard had wheeled out an oxygen tank and given him a clear plastic mask that covered his mouth and nose. He kept trying to remove the mask. He wanted to thank the lifeguard. The lifeguard guided my hand to my father's arm, the back of his biceps. It was enough. I did not

hold him, only rested my hand there, and he rested his arm there, and he left the mask on. I watched him breathe. His eyes calmed.

I walked him to his car and returned us to our vacation rental, and then I drove him home. The blue had gone from his color, but what remained was ash. As if he were becoming a black-and-white picture. He listed in his seat, like a boat taking water. His breath was shallow. He said he felt fine. That it must have been something he'd eaten. Or maybe the sun. "All that bright light," he said, his voice an echo of his once-deep baritone. We drove awhile. Then he asked if I remembered the Emily Dickinson poem he'd read to us when we were children. "Of course," I said:

> Because I could not stop for Death—
> He kindly stopped for me—
> The Carriage held but just Ourselves—
> And Immortality.

He squeezed his fist and shook it gently, as he often did when he felt that something had been expressed correctly. He was thinking of the poem, he said, because he was thinking of his brother, who had died in 1969, and of two memories. Or not so much memories as images. I wrote him later to ask if he remembered what he'd told me in the car. He e-mailed back immediately. He couldn't recall anything from that conversation, or much from the months that followed. But the pictures in his mind, yes: "I have two images I've long carried in my mind because they merge. No doubt I spoke to you of them."

The first was from his freshman year in college. He'd gone on a football scholarship, a rough boy then nicknamed Rocky. One night the team went to a movie showing on campus. Rocky sat next to another boy also called Rocky. The movie was not what they expected. It was French, and it had subtitles. They had never seen subtitles. The movie was Jean Cocteau's *Orpheus*, a retelling of the Greek myth of Death and the Underworld in modern Paris. They had never seen anything like it, and they did not like what they saw. One Rocky was flummoxed, but the other Rocky, who soon after that would

quit the football team, start reading books, and begin telling people his name was Bob, was transfixed. Even now he can see it. "It is the poet's 'time,'" my father wrote me, "and the grim reaper comes for him. Death, in the form of a tall, striking woman elegantly dressed in black from head to toe, arrives in a speeding black limo preceded by two motorcycle outriders. They are helmeted, goggled, in military-style attire with submachine guns slung across their backs. They are not large men, but formidable-looking."

That was the first image.

The second was from the funeral for his younger brother Jeff, after whom I'm named, dead in 1969, age twenty-seven, of a cancer likely caused by a chemical predecessor to Agent Orange—Agent Purple—with which he was saturated in Vietnam.

"I was sitting between my parents in the back of a long black limo behind the hearse," my father wrote. "My mother and father were silent, lost in their sadness. We were speeding along a broad, flat thoroughfare in Miami, it was a bright sunny day in June. I could see ahead of the hearse two motorcycle outriders on giant silver Harleys, obviously Miami police moonlighting, very large men. They were helmeted, booted, and wearing reflecting sunglasses. As the cortege approached an intersection, one would speed ahead, dismount, and with the flawless authority of a hand signal, stop all cross traffic until we passed. He then remounted, accelerated, and again took his position leading the hearse. Those impressive men were, as Emily Dickinson might have said, taking Jeff to eternity."

Why did he think of that then? He couldn't remember.

I brought my father to his little house in Schenectady, New York, and helped him walk up the stairs. He held on to the banister while I cleared from his couch piles of magazines and documents, evidence for a book about his brother we had been imagining we would write together. He was breathing fast, but he snapped at me to be careful, he knew just where everything was. I looked around; everything was everywhere. Piles and drifts of documents from 1969 and before, not so much collapsing as sliding into a field of white paper and black ink that covered the table, the floor, his study. In the kitchen he'd piled paper on top of the stove he

never used, and then inside it. Once he had been a tidy man. But he had been sick, I realized then, for a long time. He'd been pinned to his couch by the growing pressure in his chest, his broad frame withering, his breath shallowing, not so much in and out as skimming across him.

I cleared a heap off a chair and sat with him late into the night—he had never slept before two, three in the morning—talking about the book about his brother, which, I knew then, we would not make together. "Will you see a doctor?" I asked. He nodded. He hated to talk about his body. "I'm fine," he said. "I don't want to keep you." He said it twice, so I said good-bye and drove through the night over the mountains between us, back to my home.

To begin working in the clock tower the next day.

Then, the phone call. He's seen the doctor, said my father's friend. "What was it?" I asked.

She didn't say "heart attack." She didn't need to. Maybe I, we, had known all along. What she said was "surgery." A sextuple bypass.

"Six?" I asked. I had never heard of such a thing.

"Six," she agreed. She hadn't, either. Come quick, she said, he's waiting for you in the hospital.

The day my father's friend called was my first in the clock tower. I'd borrowed it from a poet who used it as a writing room because I'd imagined that a tower, two walls of windows overlooking a former factory town and a train station, and a clock always paused as if at either evening or dawn, might grant me a distance I needed; a pause. Time outside of time, to think, after a fashion, as I imagined the poet did, to worry over words as ends in themselves rather than parts of sentences, which were, in turn, of importance only as pieces of stories. But after I got off the phone I packed my books and my papers and began driving through the night, over the Green Mountains, to Schenectady. I would not return to the clock tower for two years.

My father, obviously, survived. And two years later, after the poet gave up the clock tower, I took over the lease.

On the first day of my return to the tower, I had a heart attack.

I was forty-four at the time, a fat man but not a very fat man. I did

not smoke, I drank quite a lot, I'd never slept much, I'd begun eating little orange speed pills when I was writing, and then sometimes when I was reporting—but this, my doctor would tell me, does not explain anything—and I had eaten a hamburger earlier that evening, a Big Mac, no less. But that, too, when your forty-four-year old heart starts grinding to a halt, does not explain anything. Nothing really does.

This is not a book about heart attacks. My father is alive, healthier, in many ways, than he was before; as of this writing, so am I. Good enough. What this book is "about" are the two years in between his cardiac event and mine, the two years that began with a long night drive to Schenectady. Two years of reporting; I am a reporter, and this is a book of other people's lives, lives that became, for a moment—the duration of a snapshot—my life, too.

I Crossed Those Mountains

I crossed those mountains between us often in the months that followed. Almost always I drove at night. It seemed easier, the steep twisting road more likely to belong to me alone; the radio, when I could find a station, less clogged with news and yet more alive with voices. Night-shift voices. People who believed, they said, in God, or aliens, or blue-green algae. The dark all around me made it simpler to believe them, and I wanted to believe. Not in God, or blue-green algae, but in other people's nightmares and dreams, projected onto the black night-glass of the car windows.

I felt very tired, finished with a narrative that had sustained me and occupied my imagination for many years of writing books and for magazines. I'd begun to notice patterns in the stories I told, and then I'd accepted that the patterns were really formulas. Plots that hurtled ever faster from beginning through middle to end—a brightly lit room in which all stories looked the same.

I began ignoring deadlines. I needed money, but I started saying no to assignments. I gave up returning calls. Instead, I took pictures. When I stopped at gas stations, diners, a junk shop that kept strange hours, a

Dunkin' Donuts, where the pictures began to lead to words when I admired the night baker's T-shirt, its image of an ornately drawn skull, and asked if I could take a photograph. "For what?" he asked. "I'm a journalist," I said. It sounded as empty to me as it must have to him. His T-shirt wasn't news. He shrugged. It didn't matter. He let me take my picture. I took it with my phone. Then I spoke to another night baker, and I asked if I could take her picture, too.

I thought I was just taking snapshots. And yet these snapshots, and the questions I asked, and other people's answers, seemed to me, in the middle of the night, to matter more than the work I'd been publishing as journalism. Or maybe they mattered only to me. To my insomnia. I couldn't be certain. I put the words and the pictures on Instagram. I pressed Share. It felt like the first story I'd ever written. As if I were only now, in the long night between my father's home and mine, becoming a writer. My first words were pictures.

I Want to Say

I want to say I'm not a photographer—my lack of training is self-evident—but that's a dodge that makes ever less sense. We're all photographers now, all of us with smartphones, at least, creating vast image libraries of family and funny signs and architecture, party pics and cloudscapes and portraits of our morning lattes. We're constantly practicing, extending our gaze, learning to see, letting our eyes and hearts and minds leap out into startling pools of light and color and shadow, and then reeling ourselves back in, retreating to selfies and cats and all our beautiful jambalayas. It's a tentative process, this stepping out into the world.

"Is honing one's eye for phone pics 'stepping out into the world'?" asks a friend. Yes. Or, rather, the stepping out is the everyday seeing we practice when we notice how lovely the light is as it seems to ruffle our cat's fur, or how gracefully the bridge we cross on the way to work spans the river, or when we think we see a soul—or maybe soullessness—in the eyes of another. The individual image may be so ordinary as to be almost

invisible. The online assembly is the most magnificent documentary art I've found.

I use both those terms, "assembly" and "magnificent," with their ancestry in mind—the democracy implicit in the former, the royalty implied by the latter. The individual picture is clever or maudlin or harrowing or silly, "good" or "bad," composed or simply clicked. Everyday people, a whole lot of them, each staking out the same-sized square. Social media cynics point out that the squares are laid out on a matrix, that Instagram is a form of submission to a distant corporate intelligence. True enough. We should not mistake the Instagram square for a public one. But nor should we miss the dignity afforded by the small solidarities of hashtags: the solidarity of recognition, of seeing one another.

Something I've noticed about Instagram: People rarely photograph other people. By "other people" I mean strangers. There's street photography—hashtags like #street, #streetart, and #streetfaces—but these picture takers are ringers, even if they're "iPhone only." They've already learned how to break the fourth wall, that of the daily theater of self, to venture past the gentle solipsism of everyday life. Journalists know how to do that, too—when we have an assignment and a notebook in hand. It's easy to take pictures when they're notes for a story.

It's much harder when the picture is the story. That's not quite right, though, because the pictures I've been trying to take are not *the story;* they're passages within it. Usually when words and pictures are paired, either image serves text, as "illustration," or text serves image, as "caption." But I grew up on comic books, words + pictures that are essential to one another. Instagram, when I first saw it, reminded me of a comic book. Like a comic book, it was arranged in panels. A picture, words, and the space across which you, the reader, carry the story to the next picture + words. The action between is implicit. Or maybe even contractual, like the deal the comic book artist makes with the reader: I'll supply the pieces, the fragments of a story; you'll make it real by setting it in motion.

The fragments in this book—some from the towns around my home and others gathered on reporting trips, in Los Angeles and Nairobi,

Kampala and Moscow—are snapshots. That word might be read as a disclaimer or as advice on how to view them, but to me it has come to represent something more ambitious, or maybe just more hopeful. The very word *snapshot* expresses the essential exclamation point of its form. Snapshots say, *Look at this!* Snapshots say, *I saw, and I want you to see, too.* The *you* may be your friends or your kids or even just your future self, but it's not a museumgoer viewing the image "preserved in sacred isolation," as the critic John Berger wrote. It's not a spectator; "there's no mess or risk" to spectacle, as another critic, Lucas Mann, observes. It's the deeply democratic, or maybe even religious, notion that what *I* see—one person's vision—could matter to *you* so much that *we* could see together.

Darkness Isn't the Absence

Darkness isn't the absence of light, it's the presence of ink. The stuff from which letters and words and stories are made. Darkness moves; it flows from one letter, from one image, to the next. The picture that begins this preface is the last I took for what would become this book. I took it because an editor asked me to, which means it's also the only photograph I've ever taken that might be said to have been made on assignment. "Journalism." The editor thought it might work to illustrate some words about my heart attack. We decided it didn't, and discarded it. He also thought it might suggest something about beginnings and endings. I hope, here, it does. What I hope you see, beneath a clock the hands of which are forever paused at either evening or dawn—what I have come to see, anyway—is just how relative "beginnings" and "endings" are, how they, too, move according to the light.

I'm writing these words in another room I've borrowed. I came here hoping to find a beginning to this book, one that would allow me to conclude the work I didn't know I was undertaking after my father's heart attack, when I set out across the mountains. Tonight, like the night of my own heart attack, is a Saturday evening. I've been sitting at this desk for too long. Only the computer screen glows. A deeper blue seeps in through the

windows, steeping the room in soft shadow. On nights such as these I think of that pressure that filled my chest, as darkness fell on the clock tower, as I sat in the corner of that little room, unable to stand, watching shadows first gray, then blue, then black fill my vision, a kind of darkness show. That darkness remains. But tonight I'm also thinking of how, that evening, I thought I'd written this book's final word; and how, on this night, I'm finally writing its first ones, after which my night shift can come to a close. Time for me to go home. My children are waiting.

I realize only now how many of the people I sought out and took snapshots of between my father's heart attack and mine wanted to go home, too. I know now how hard that can be. But also, sometimes, like a snapshot, how simple. Like the little pictures between us, the moments on which we pause, together, as the darkness flows by.

I depend on others' courage.

—Robert Adams, *Why People Photograph*

Night Shift

THE NIGHT SHIFT is for me a luxury, the freedom to indulge my insomnia by writing at a Dunkin' Donuts, one of the only places open at midnight where I live, up north on the river between Vermont and New Hampshire. Lately, though, my insomnia doesn't feel like such a gift. Too much to think about. So *click, click,* goes the camera—the phone—looking for other people's stories to fill the hours. This is Mike; he's thirty-four, he's been a night baker for a year, and tonight's his last shift. Come six a.m., "no more uniform." He decided to start early. He's says he's going to be a painter. What kind? "Well, I'm painting a church . . ." He means the walls. The new job started early, too. "So I'm working, like, eighty-hour days." He means weeks. He's tired. He doesn't like baking. Rotten pay, rotten hours, rotten work. "You don't think. It's just repetition." Painting, you pay attention. "You can't be afraid up there." The ladder, up high. "I'm not afraid," he says. "I can do anything." He says he could be a carpenter. "But it hasn't happened." Why does he bake? "Couldn't get a job." Work's like that, he says, there are bad times. Everything's like that, he says. There are bad times.

"Who's the tear for?" The tattoo by his right eye.

"For my son," he says, "who died when he was two months old."

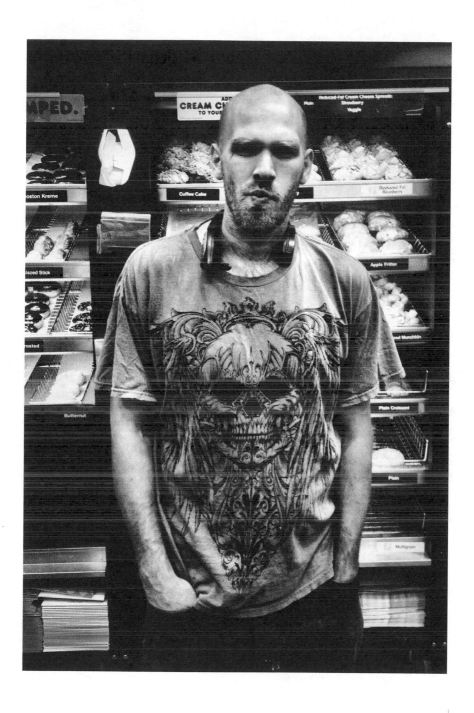

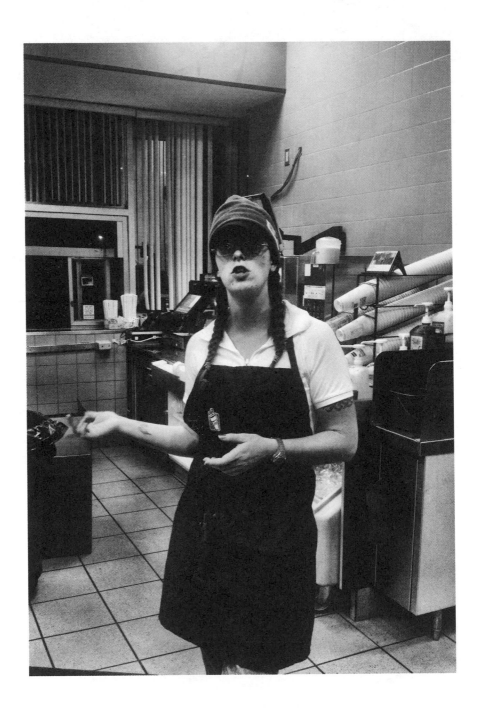

"My mother was the night baker before me," she says. Kelly's twenty-seven. She started baking doughnuts when she was seven. "My mom was the night baker," she says again. "If I was, you know, 'naughty,' she took me with her." If Kelly was naughty, she went to work with her mother and made doughnuts. She did that for years. She quit. She returned. She's been working here a year and a half, a night baker like her mother.

She takes her smoke breaks out front, because there's no camera out back. "We've been robbed." Man walked in the back door, emptied the safe. Kelly wasn't working. "I'm just lucky," she says.

She's quitting again in two weeks. She's going to be a security guard, night shift. "Fifteen dollars an hour." The sum makes her marvel. She won't mind the hours. She doesn't like days.

"The night shift," she says, "I'm wired for it." She's a natural. But she'll be back, she says. For coffee. "I don't eat doughnuts anymore."

Night nurse thirteen years and that was enough, at least for a while. She was good with difficult children. The troubled ones, the violent ones, she knew how to calm them. Night nurse thirteen years, she couldn't take it anymore. "But I'll go back," she says. "This is just for a little while."

She and her wife used to live in the city. Manchester, New Hampshire. "It's a tough town," she says. "We didn't want to do it anymore." They decided to move to the country, roughly speaking; they have an apartment near the highway and the hospital. "What changed was my daughter," she says. "My daughter is three years old. I didn't want her growing up around that." Manchester, New Hampshire. "It can be a very tough town."

Night shift at Dunkin' Donuts, a few months now. "I shouldn't be here," she says. But she is. "My daughter will be safer."

Peri likes her curves. When she visits Dunkin' Donuts, she finds she needs to do a lot of stretching. Lean, arch, twist. She smiles, she flirts a little with Mike behind the counter. I wanted to show a picture of her pretty like that, happy, but then this moment. One-fifteen a.m.

She's the night manager at the Taco Bell next door. She trades Taco Bell for Dunkin', quesadillas for coffee, two or three cups a shift. She used to manage a Wendy's, down in Dover, New Hampshire. "I'm a city girl," she says. Concord, then New Jersey, then Dover, then here, which is the least like a city of all.

She was at Wendy's eight years. One night, smoke break, Peri got robbed. "Two thirty-eight a.m.," she says. She wraps herself in her arms. A man with a gun and zip ties. He said there were more men waiting. Peri screamed. He took $3,000. He took somebody's truck. Peri waited for him to be gone. "I could smoke," she says. Hands zip-tied together, she'd held on to her cigarette. That's what she remembers. And: "I thought about my daughter." One year old. Peri couldn't take chances anymore. That night, zip-tied, she decided to move. That's how she came here. She says they caught the stickup man. "He said he did it for his family." She doesn't believe him.

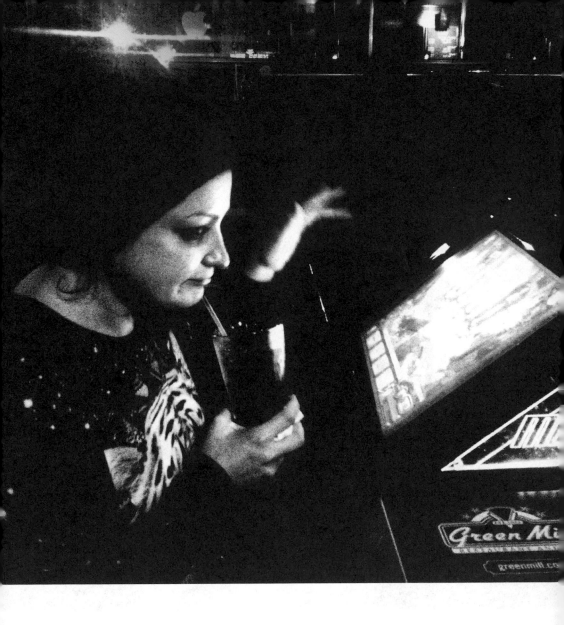

"Killing time," Tracy says. I'm at a bar in a strange city, meeting friends. She's not. She was playing when we arrived, and now it's last call. Hardly anybody here but Tracy.

I ask if she's winning. "It's *Photo Hunt*," she says. "You just have to find things." I thought she was gambling. "Oh, no," she says. "It's just"—she finds what she's looking for. "Now," she says, "I'm looking for a shield." She finds her shield. She's not a regular, she says. "I just come here all the time." Because it's easy. "My boyfriend's the bartender." Big man, I'd noticed his shirt, taut across the shoulders.

That's not him, Tracy says. "I mean, he used to work here." Now he's at a restaurant. She works there, too. Tonight's his shift. He's closing. She's waiting. It's last call. "He'll be here soon." She smiles, looks up from *Photo Hunt*, points out the door. "He lives right there." Across the street. "It's convenient."

Later, my friend Blair says, "Twelve seconds." Twelve seconds for Tracy to mention her boyfriend.

"I wasn't—"

"Doesn't matter," says Blair. "Mention of boyfriend; someone's expecting you; mention of proximity."

"I didn't mean to—"

"It's not about you."

"It's true," says Q, Blair's boyfriend.

Blair says: "'I have a boyfriend. He'll be here soon. He's close by.' You do it without thinking."

Ryan is working. He's brought out into the night a trash bag of packing peanuts, a cup of water in which he dips them before sticking them to the window of a darkened café, and a portable loudspeaker with a microphone. "There's always going to be obstacles to loving your child," he broadcasts. "You must destroy them." The obstacles, he means.

He's wearing a sombrero and beneath it a wig of yellow curls. Also a toga, or maybe a muumuu. A garment of his own devising, yellow-and-green batik, tied tight around his chest, just below the nipple. He knows what he looks like. It's his work, he says, "being crazy." He makes a living. Social Security, the last ten years.

"I think he's telling the truth," says a woman named Laura, after-hours drunk, who's been helping him stick peanuts to the window of this closed café. She means about his daughter. "I'm a mother," she says.

"I'm crazy," Ryan says, "but I'm a great dad."

His wife works here by day. Their daughter is named C——. "For a friend who committed suicide," he says. Her middle name's Nirvana, after the band. His wife has custody. "She told the court I came into the coffee shop and threw water at her." False. "I was throwing water at somebody else, and she got splashed."

Laura says, "Kids like water."

"It's discrimination," Ryan says, "because I'm insane."

"I have to go now, Ryan," Laura says. "My baby needs me." Her boy. He's turning eight on Sunday.

Ryan's working on the next window. He's writing his baby girl's name. C——. "It's pretty, right?" he says. He smiles. "She loved me." Past tense. "I'll probably never see her again."

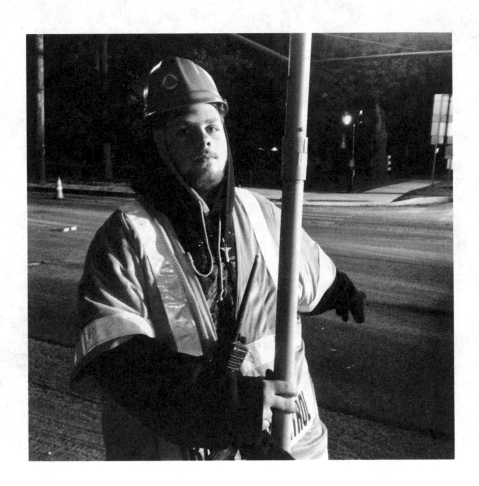

"I like the night," says James.

"Me, too," I say. "It's easier."

"It's time and a half," says James. Time is twelve dollars and change an hour. "I haven't figured out the half." Four months on the job. "Best job I ever had." Only job he's ever had. To get it, he had to take a test. The test asked, "What do you do if a car doesn't stop?"

Does that happen?

"Last night." Drunk driver, mowed down a sign.

What did you do?

"I got out of the way."

A car throbbing with bass rolls up, four girls looking for a Monday night party. James flicks his sign. They stop. He waves. They laugh. It's a good job.

What did you do before this?

"Nothing."

James is twenty. He came here to be with his grandparents. They were dying. Now they're dead. He's still here. The job will end soon. Less roadwork in winter. He doesn't know what he'll do. He wants to move to Alaska. He's heard they give you land if you increase its value ten times. That, and the nights are long.

Larry LaRose and I stand together at midnight, watching a hydraulic hammer open the road. I'm on my way home, but it's taking a while. Sometimes I need to pause. Watch the hammer fall.

A big hammer: five thousand pounds of pressure, the excavator operator tells me when he takes a break to eat pistachios. They're digging a hole to put in a water main, but they've hit a ledge of rock. "What kind of rock?" I ask.

"I dunno," says the operator. "Mother Earth." He cracks a pistachio and tosses the shell into the hole. "We're going through."

LaRose stares, scowling. I say I like his hat. He smiles. "You can take a picture if you want." He leans his cane against a bush and poses. "And I'll show you something else." He unzips his fleece and, under that, rummages through his shirt buttons. He withdraws a pendant and more lanyards. The pendant is a round transparent disk: a hologram of Jesus. Each of the lanyards holds a card or a piece of paper in plastic: the names of his caregivers; a Kiwanis Club group for the mentally disabled; an invitation to a Halloween dance.

He asks me to write down the numbers of his caregivers, so I can say hello. He tells me I can come to the dance.

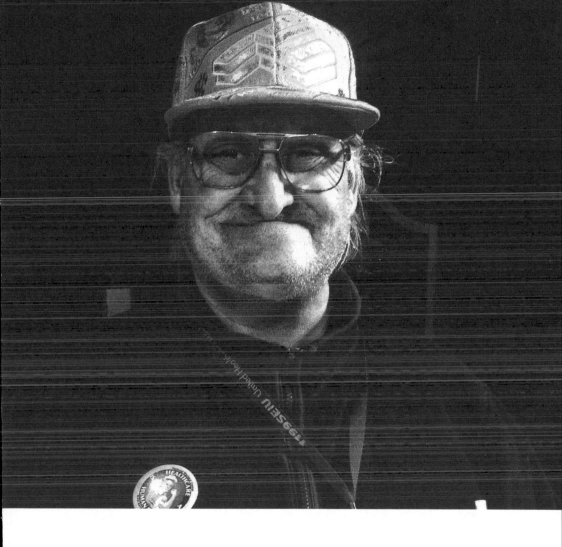

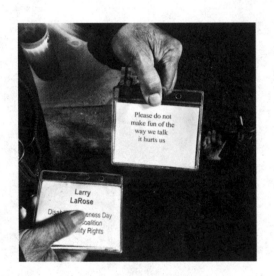

Please do not
make fun of the
way we talk
it hurts us

The last lanyard card Larry LaRose wants to show me. The line breaks are as wise and true as the message. Then he shows me a picture of himself that he keeps in the same plastic sleeve with a photo of his twin brother, Mike. Two smiling big men in plaid and ball caps. Mike died. "11/20," says LaRose. I don't ask the year.

He wants me to know he'd taken good care of his brother. "Now you have everything," he says, pleased. "So you didn't come out here for nothing."

My night shift ended early, one a.m., asleep in a chair. Then it's five-thirty, I'm still in the chair, the lamp still bright. Time for the paper. Down to the road. Glance at the trees, difficult to read. Big news upriver. "Kelsey Jacobs, 16, Needed Just One Arrow." To kill a bear, black in name and actual color, dressed out at 305 pounds. It's believed the animal was about eight years old. Jacobs aimed for the bear's heart and pierced it. She plans to make a gun rack from its paws.

Headline: "Fluoride in Water?"

In Thetford, the reward for the serial police car arsonist climbs to $7,000. No takers.

Local heroin supply thought to be contaminated. Nine ODs in fourteen days.

Some are tempted to pickle their beets, but now is the time to eat them.

Hartland boy, 9, pictured with a pole saw, the lance leveraged across his blue-jeaned thigh, his curling arms miming a man's, mouth agape at the glory of the distant blade.

Canaan girl dead, 18. Obituary says she loved "big lifted jeeps" and getting dirty. Her name was Chardonnay. OD. Does that make ten?

Classifieds full of studded snows. There's to be a talk titled "Winged Hussars." The used princess costume is still for sale. The sun will set at 6:05. The moon will not rise.

••••• AT&T 4G 1:08 AM ⟩

← **#NIGHTSHIFT**

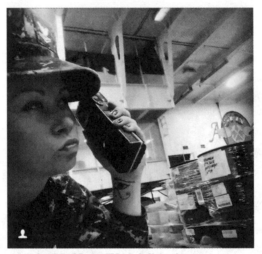

 c_huddle25, teej7914, jeffsharlet

most.definitely Negative sir...i can not locate
any fucks. #NBD #nothingtodo #nightshift

mattt_rios Complete opposite from us...we
should switch commands haha #jealous

#Rise&GrindMF$

THE FIRST SELFIE I screenshotted was a joke. Not mine, the photographer's, whose Instagram account is called most.definitely. The user's name, or, at least, her Instagram name, is AngelMfByrd♡. "Navy lyfe," reads her bio, and then a star, and "Rise&GrindMF$ Life changing Mode%100 LadyBoss♀ Tatted●~Fwm~." She seems to be a sailor on the night shift. Tough work, a real rise&grind, and she's an MF, which you can probably figure out, and she's doing it for the money, like we all are, and she wraps it up with "Fwm." Which usually means "Fuck with me," as in, *don't*. I think it's a great picture. At work in your navy camo, your cap pulled low against the fluorescent glare of a warehouse, a walkie-talkie in your hand and below it, on your wrist, "tatted," an Egyptian Eye of Horus, a symbol of power and protection, staring up at your own two eyes, narrowed, as you declare, according to your caption, "Negative sir . . . I can not locate any fucks."

AngelMfByrd♡ hashtagged the picture #nightshift, which is how I found it. Sitting in the Dunkin' Donuts again, 1:08 a.m. (according to the screenshot I snapped), drinking my third cup of coffee—because when

you can't sleep you might as well stop trying—struggling to write toward a deadline. I, too, was having trouble locating fucks, much less the words I really needed. AngelMfByrd♡'s selfie made me laugh. And I kept looking, staring at the matrix on my phone, my own red eyes scanning a tiny sample of the then 670,000 photographs and counting hashtagged #nightshift. Most of them were people like me, awake when they didn't want to be. Like me, they were looking at the screen in their hands.

@ty_landl's night-shift selfie was a picture not of his face or his body but of his gear, the heavy black boots he was preparing to put on for work. "I am a freezer man," wrote @taf7861 beneath a self-portrait of a bundled-up warehouse worker who looked like he was fighting to keep his eyes open, and losing. By comparison, @rated_em_4mature was dapper: French blue shirt, red, silver, and white striped tie, stylish glasses, his tired but direct gaze vitally at odds with the numbing panel fluorescent lighting above him. Then there was @dgeislerr, with a noirish black-and-white, half of his face and both eyes in shadow, the picture framed so we know he has a badge but can't read it. "Working the streets," he wrote, "and im not even a hooker." He hashtagged it #thinblueline, #popo, #nightshift.

I began asking night shifters if I could call them.

@ladyleomarkisha—Markisha McClenton—answered. Her self-portrait, close-up, is muted in dim light. She might be on her way to work. She might be coming home. Her workdays begin and end in the dark and they are dark in between. She's a lab technician in Jacksonville, Florida. Her specialty is blood. She's had this shift since her son was seven. "Freedom," she told me when I called her at her lab. That's why she works these hours: the freedom to work at night and to raise her children during the day. To her, this is good fortune. She is smiling in her selfie, her full lips a rich magenta. But her eyes are midnight eyes, three a.m. eyes. Why take a photo at that hour? "People forget about us," she said.

The #nightshift hashtag is especially well populated by the armed

professions and the healing ones. Sometimes they are almost one and the same, as in the case of @armedmedic3153, a.k.a. Marcelo Aguirre, a paramedic who works the night shift in Newark, New Jersey. He owns an AR-15, a nine-millimeter, and a shotgun, but the only thing he shoots on the night shift is his camera. He works nights so he can study days; he wants to be a doctor. Nights are good preparation for that, because you get more serious cases. People get hurt more often, hurt themselves more often, succumb more often—stroke, heart, seizure. You learn on the job. A twelve-hour course each night you're on. Twenty-four hours if you take a double. After a while the adrenaline that juices you when you're new— when you're still keeping a tally of the lives you've saved—disappears. You just do the job. "High speed and low drag," Aguirre told me when I spoke to him on the phone. "Please ignore the siren," he said as we talked. "We're going to a call."

 "There's people still struggling like I struggle," a miner named Mike Tatum told me on his break, explaining why he posts pictures and why he looks at them. "Working through the night, not sleeping next to your wife, missing your kids because they go to school before you get home." Tatum likes to post pictures of the heavy machines used to dig coal from Wyoming strip mines. He drives a D11 bulldozer. "I push dirt," he said. Other machines dig the coal. Twelve hours of 'dozing, four nights in a row. His wife got a job as a drug tester, keeping the miners clean. Tatum stays clean. "Sunflower seeds," he said. Better than coffee. Drink lots of water. Instagram. He came to this job, a good one, thirty dollars an hour or more for as long as the coal lasts, after construction work dried up in California. "Nobody back home has really seen what we do out here," he said. It's a good job, he swears. He's brought his six-year-old boy out to see

the machines. He'd be proud if his kids grew up to be miners. A good job. Rough on the back. But you're just sitting. Driving the 'dozer. Nobody bothers you. Hours without a word. "Pretty easy," he said. Plenty of time to think. To make plans. Things he can do with his days, when he has days.

"Quite a few fatalities the past year," he observed. He heard about a man at a nearby mine who drove a machine into the pit. "Maybe a suicide." It didn't seem like an accident; the man had to drive through a couple of berms to go over the edge. "Splat," said Tatum. "And a couple more."

"Nightwalkers," Pierre Bell, @piebell522, names the men and women who find their peace after midnight. I called him one night while he was working the behavior unit as a nurse's aide at an assisted living facility in Akron, Ohio.

"What's 'behavior'?" I asked.

"Combative," he said. "Lockdown. Spit, kick, hit, bite."

It's not so bad, he added, especially at night, when the anger subsides and the alarm I heard beeping in the background is an event rather than a constant song. The other aide will get that one. Bell, a twenty-eight-year-old father of a nine-month-old, was sitting with the nightwalkers. The strange ones, the restless ones, the storytellers. "Some were in wars," he told me "Some were teachers." Sometimes they talk for hours. Sometimes there's something good on television. Last night it was a Catholic Mass. "I'm actually a Baptist," he said, "but it doesn't bother me." If they're up, he's up. It feels to him like a matter of courtesy. The behavior ward is his patients' home. He's only visiting. Trying out the night they live in.

And on his break, he can slip away. Take a snapshot, make a record of himself in this new country of the other hours, post it on Instagram.

He took the one that caught my eye when he was in the bathroom. "I saw the dark behind me," he said. "I thought it could be a picture." A lovely one, as was the shot that followed hours later: Bell's baby boy, the reason he works the night shift. Not for the money—he took a pay cut to win this shift—but for the days he can spend with his son, a warm, handsome little guy with his father's gentle eyes, warmer in the golden sunlight of the morning.

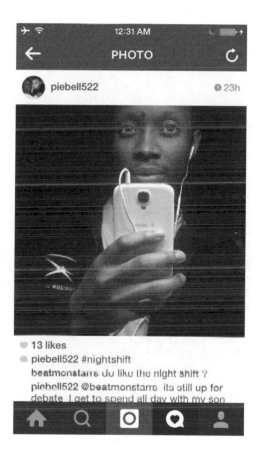

12:31 AM

← PHOTO ↻

piebell522 ⏱ 23h

♡ 13 likes

piebell522 #nightshift

beatmonstarrs do liku the night shift ?
piebell522 @beatmonstarrs its still up for
debate I get to spend all day with my son

It struck me then he didn't seem to understand he was only doing fairy tales. Yet they were really very ordinary—full of sprites, nymphs, gods, everything ordinary and old.

—Cynthia Ozick, *The Pagan Rabbi*

Prayer Hands

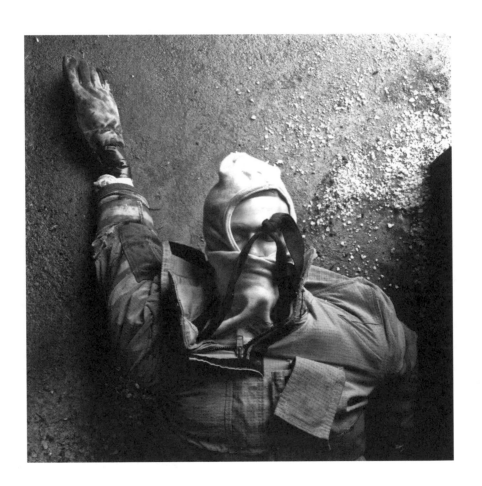

Local news. Sunday announcements in the paper for forty little towns beaded along the river that divides Vermont from New Hampshire: "Card Showers" for Cecile Jarry, 99, and Fred Aldrich, 90. Also, a meeting of the Sherlock Holmes Club this Wednesday. Whitman Brook Orchard declares itself in possession of a "magical apple." The mental hospital, destroyed three years ago by Hurricane Irene, remains closed. An "artistic arborist" seeks to hire a tree climber. A classified offers an old copy of *The Working Boy* magazine, for $10. Deer heads, two at $125 per, "more available."

At the town dump, three crumpled cars and a dummy, his feet in the winter salt, as if being dragged under. I linger, but not long. These are not good days for trespassing. Our police department is still wondering who torched its fleet of cruisers; every car, burned. At home my daughter Aithne, which is not her real name, looks at the picture. She is four. She has never seen a dummy. "Was he killed?" she asks.

"No. He was never alive."

"Good," she says. "I don't want him to have died."

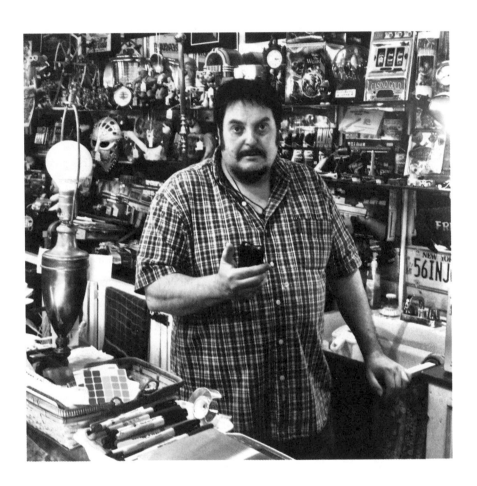

| JEFF SHARLET

1.

At first I thought Larry might be a not-so-secret supervillain. His store, a grackle's shop of shiny pop cult detritus, samurai swords, and Franklin Mint collectibles, was called Treasure Center. Open very late on a dead-dark road through the mountains. I don't know why I stopped, driving to my father's. Maybe because Larry seemed to keep hours like mine. "Adults Only," read a handwritten sign—inside. But there was nothing naughty for sale. "I just don't like children," said Larry. I thought of my daughter. How much she'd like Larry's collection. How children love rooms full of things to touch, rooms cluttered with stories told by surfaces, smooth or bumpy or sharp.

"They break things," said Larry. This was also true.

He tapped a button on the black box in his hand, and a red glow grew between his fingers. A kind of stun gun he'd been showing off to a friend. "You could use this on your wife," he volunteered. "You know, if she got annoying."

2.

Larry said he'd moved to this dead little mountain town after his previous shop, the Wizard's Den, burned down. He said he wanted to be near his mother. "You'll see her flitting around," he said. I didn't, but I saw her things: stuffed puppies and martyr figurines, gilded teapots and a statue of Saint Lucy, holding her eyes, plucked out by the emperor's men for refusing to look upon sin.

A skinny girl in shorts and a spaghetti-string tank top came in. Eighteen, maybe. "Danielle," said Larry, not pleased. Danielle wanted to sell him an iPhone. It wasn't hers.

"Look," she said. She smiled, leaning across the counter and holding the phone beneath her chin with steepled fingers laced across her cleavage. "Please? Please?"

Larry stared down at his own hands, pressed against the counter's edge, his voice a murmur. "You know I don't buy those."

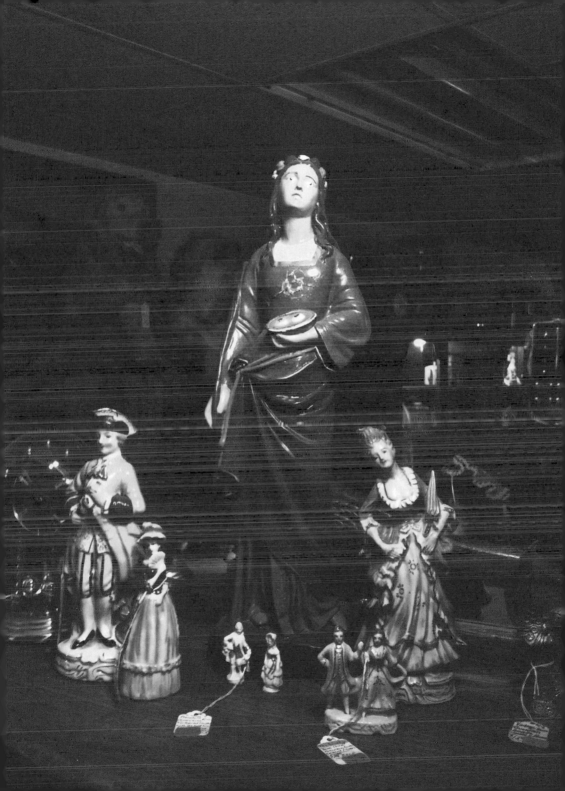

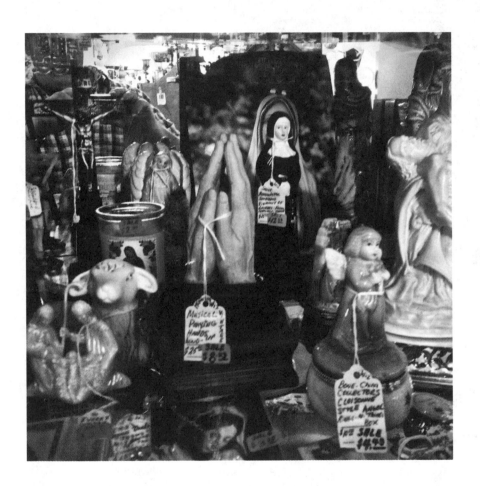

3.

I wanted to buy something, because I'd been taking pictures. It seemed like a fair exchange. But what would it be? A *Friday the 13th* Jason mask? A dusty crystal ball? A bone china angel? Then I found the hands. "Musical" and "wind-up," and marked down from $25 to eight and change.

"That's a good choice," said Larry. Plastic, painted pink matte over veiny knuckles and long pointed fingers, as if they'd come from a horror model kit repurposed for prayer. "Listen," he said, and twisted. From within the plastic Bible base emerged a broken necklace of melody.

"Best religious kitsch I've seen in a long time," I said.

Larry didn't smile. It wasn't kitsch. Hadn't I read the sign? *Treasure Center.*

He wrapped the hands in newspaper and he gave me his card, a block of color-xeroxed handwritten inventory—"OLD Bottle's," "DOLL-COLLECTION," "Knives," "CASH *FOR*GOLD!"—printed on paper and cut with scissors. "The Treasure Center membership club card," one stamp per purchase toward five & 15 percent off.

Larry stamped once, considered, stamped again. "You can also have a piece of candy," he said. "Free." He nudged forward a red plastic bowl full of Smarties and hot balls. "Choose."

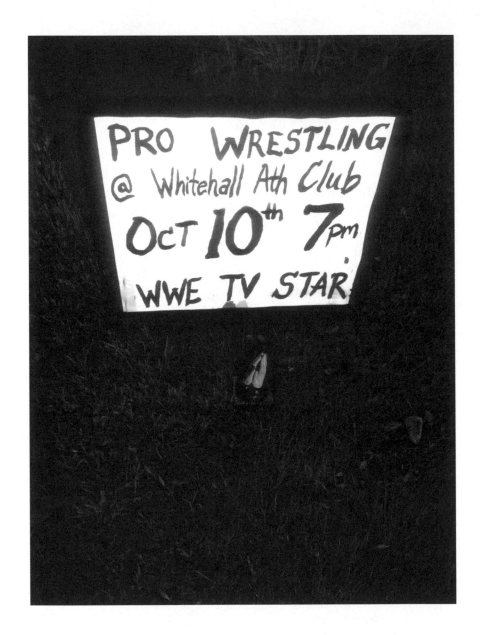

4.

I took the hands and got back on the road, a long late-night drive through the mountains, not much radio and a lot on my mind. I decided to distract myself by taking pictures of the hands. But no setting seemed right. Not the yellow haze of soft serve stands open for the end-of-summer trade, not the Labatt Blue glow of no-name small-town taverns, not the lit-up American flags hanging limp in front of junkyards. That'd be kitsch on kitsch, and I'd come to think of the hands as better than that. Then I spotted a homemade lawn sign: "PRO WRESTLING" in a shuttered-up town, with a "WWE TV STAR."

I don't think wrestling really is kitsch. It's neither naively nor knowingly sentimental; it's defiantly sentimental, *sensational* in the most generous sense of the term. An appeal to the senses, one that says *look*. Look: the sign, the hand of the kid who painted this sign, thrumming with pleasure, a WWE TV star, right here in Whitehall—

I shined my headlights at the sign, set the hands down, and gave them a twist.

5.

I wanted to record a video of the prayer hands turning, but you couldn't hear their tune over the crickets and the road. Instead I put them on my dashboard and listened.

I lack belief in the supernatural power of prayer, but I appreciate prayer's resonance in the natural world. Especially in hands such as these, a peculiar echo of the faith that made them and the faith that put them in a glass case at the Treasure Center, as free of irony as I am of the divine.

God is more than I need.

I prefer things, and the people who tend them.

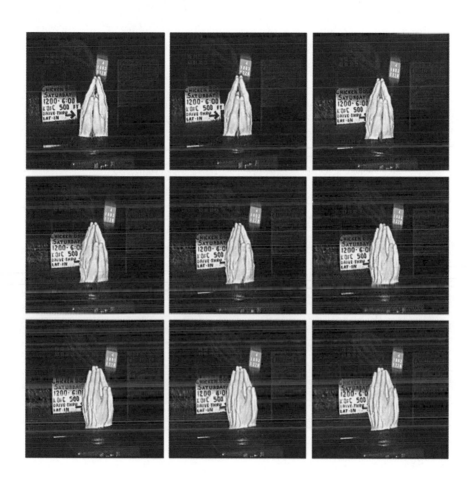

Local news. "There are more homeless gravestones floating around New England than one might think," the cemetery commissioner of Townshend, Vermont, tells our paper. "Memory requires it not," reads the stone of one Sarah J. Grant, died January 24, 1868, "but affection places this record here." Only, where? The stone was taken. *Was* taken. Passive voice. Who took it? Nobody knows. The stone returns to us now through the estate of a rich man who built a castle across the river in Walpole.

Another rich man, another floating gravestone: "Give these sacred relics room," reads the stone of one Noah Aldrich, died an infant some two hundred years ago, "to seek a slumber in the dust." Seek elsewhere, says the rich man, who has exhumed Noah and the whole Aldrich clan. Reburied the family in a "more sensible location," he says, paid handsomely to do so. Each skeleton "disarticulated," reassembled, in "cedar coffins handmade in the style of the day." The rich man will build his home on the hill that was theirs, now barren. "Like Grandma's house," he says of the construction he plans. It is not clear whose grandmother he means. He intends to make soft cider there, "slightly fermented."

Articles for Sale:

"6 Gal Crock."

"Adult 'O' Trains."

"All Angel Blade," spelled just so.

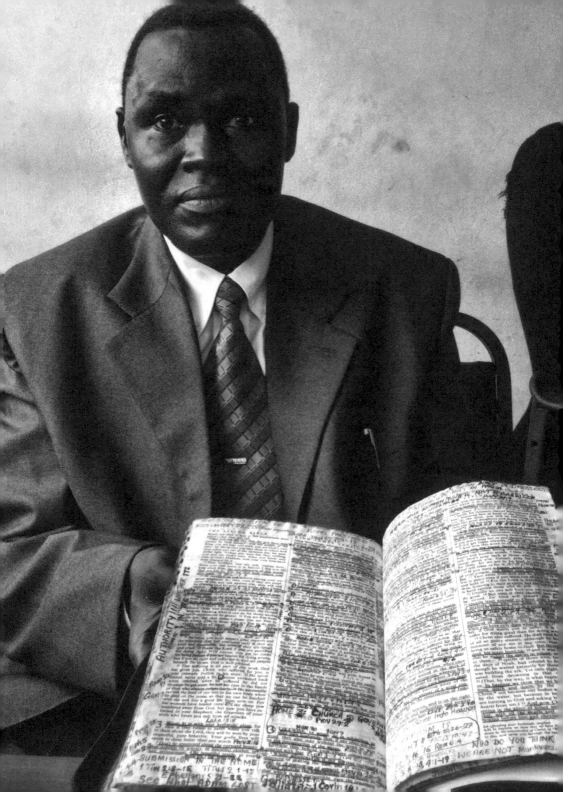

He stares at me, through me, beyond me. A skeletal office over an alley in a slum in Kampala. Uganda. Between us his Bible, annotated in color. He is concerned with witches. Sometimes he calls them sorcerers. His accent is strong. English is second. And even before his own tongue, there's scripture. Thanks be to God. Scripture defends him. It has. It will. He hopes. "I am destined to die," he says.

I say, "Aren't we all?"

He stares. Repeats himself: "I am destined to die." He has been cursed. Powerful witches. In his own church. "My own church," he says again, patting the margins. "My own church."

"Do not give them my name," he says. By "them" he means you. Reading. What would you do with it? What will you do with these words? "They could do anything," he says. Because these words are not fixed. You can bend them, rearrange them, make them your own, use them against him.

Only scripture is unchanging, all his red ink in the margins nothing more than breath against stone. Breath, not blood. "My words leave no stain."

He had been an assistant pastor, his church had been large, there had been many assistant pastors. The bishop they'd served had grown wary of their dreams. The bishop preached a prophecy: "One of you will die, for being rebellious. The churches should be warned that rebellion is very bad. A big mistake! God will kill somebody."

He'd fled. The prophecy had followed. "But," he says, pushing his Bible aside, planting his finger on the table, "the week I was to die, the bishop, he disappeared!"

The bishop disappeared; scripture remains. Breath against stone.

She's a whisperer, her method not so much imperious as imploring. She works the loose edge of the smaller-than-desired crowd drawn by her pastor, Pastor Lou from Kansas, who has arrived this morning and will leave the country this evening. She's one *mzungu* among many. She doesn't know that term. It means white. Rich. A little dizzy, a little lost. It can be gentle, teasing. It can be hard, descriptive. It can mean white. It can mean fool.

She means Jesus. "I am a vessel," she says. "He works through me." She turns away. She looks for one who'll receive. Her mouth flicks between smile and frown. She looks for girls. She bends down. She whispers, "Can I pray for you?" She does. Her hands close together, as if she's been given something precious to hold. A small piece of a girl's shoulder, her hand reaching around the girl's back, flat across pink polka dots, drawing the girl away from her friend. These girls already believe. But do they believe enough? Believe like she believes? She can't be certain. We never can.

| JEFF SHARLET

"Here is the table," he says. Here is where he'll perform his last abortion. They're illegal in Kenya, but he's quitting soon. He's not really a doctor, he explains. A year of college. Some biology. He knows how to do abortions. He'll do just one more. "Just for the money," he says. He's getting married, to the mother of his three children, a proper wedding. He's been saving a long time. For a proper wedding, in a Catholic church. It's what she wants. He wants it for her.

They took a marriage class. The priest talked about abortion. A threat to marriage, said the priest, a threat to the nation. The abortionist did not tell the priest what he does for a living. Now he keeps a Bible by his abortion table. "Just one more," he says. You can watch, he tells me. I don't want to.

The patient doesn't come. A sign? No. There will be another. "Just one more," he says. "It's a sin," he explains.

"Mortal sin," I say. According to his church, that is.

"'Mortal'?" He doesn't know this English word. "Spell it."

I write it down. He studies it: m-o-r-t-a-l. "Damned," I say. He looks alarmed. "I'm not saying that," I tell him. "I don't believe it. Your church does."

"I do not believe you." What if a woman comes to him, her life in danger? "Who should I kill? Mother or child?" He needs guidance. "I will ask my wife's priest," he says. The priest will tell him. Who to let die, mother or child.

A question is a threat, the door which slams shut, or swings open: on another threat.

—James Baldwin, *The Devil Finds Work*

You Need to
Be So Close

I didn't take this picture. I was looking for somebody else on Facebook when I found this guy. Eric. Which is not his real name. He'd just posted a new profile photo. Maybe this boy with a gun is part of my visual world, too. My social media neighbor. There's not much information on his page. He works at "making money" and Foot Locker. Several of his profile pictures feature him and his friends flashing gang signs, but it's hard to take them seriously. Maybe we shouldn't take the gun seriously, either. The corner of Eric's mouth, behind the mouth of the gun, reveals the boyish smile seen in his other photos. He's cute. Girls like him. Most of his friends are girls, most of them depicted in their profile photos taking selfies of themselves in mirrors, hips cocked, maximum cleavage. Anna augments her profile with a banner collage of four cleavage pictures. No face; just her chest, which she evidently feels best represents her. The pictures are usually awkward, often out of focus or snapped at a wacky angle, more endearing than sexy. One girl says she works at "Pimping Hoes University," another is an alumna of "Too Gee'd Up University," and a third went to "Smart Ass U" before finding her current position as a "smoker at Dope House." Most of these women include a lot of pictures of younger siblings, nephews and nieces, and their own babies. Most of them with jobs work retail. It's all kind of lovely. Even Eric, once you see him in context. A lot of women performing "bad girl" and cracking up about it. A universe of female friends for a young man performing "bad boy" and cracking up about it. It's funny, right? A gun. Pointed at you. Looking at this picture.

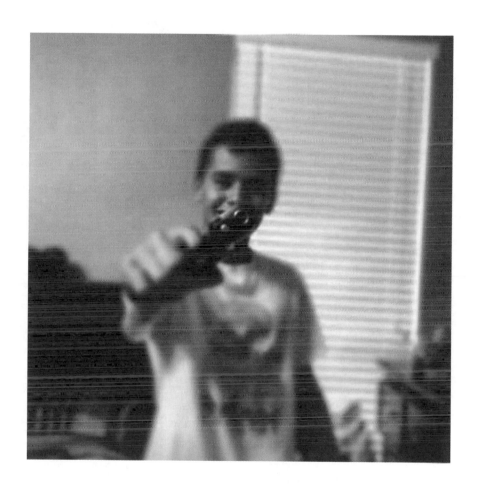

"This is just a toy," Mike says. His real knife is at home.

What's the toy for?

"Cutting."

What?

That which needs to be cut.

Mike unsheathes. Flips it, hands me the grip. A Muela Bowie, made in Spain: $300. A good knife will cost you. First knife he bought, thirty-five years ago, a nice knife, $200. Thirty-five years ago. And his real knife? "That's her. Had 'er thirty-five years."

"My daughter took a picture of me," he says. There's more to that thought, but the train is gone. He thinks. I heft the knife. I don't notice the point. It's a foot from Mike's gut. Mike notices. He pinches the blade. I let go. He spins it around. His thought has returned. "My daughter took a picture of me with my real knife and my long hair." He brushes a strand away. "When she was in high school. She put my picture in her locker."

His toy knife is a town knife. His real knife is for the woods. Hunting, sure. "And whatever else happens. You can use a real knife for all sorts of things." I ask if he's ever had to use it to defend himself. "Oh, no." He thinks the question is foolish. Melodramatic. "Thing about a knife"— he unsheathes, steps forward, the point between us, both of us notice now—"is that you need to be so close."

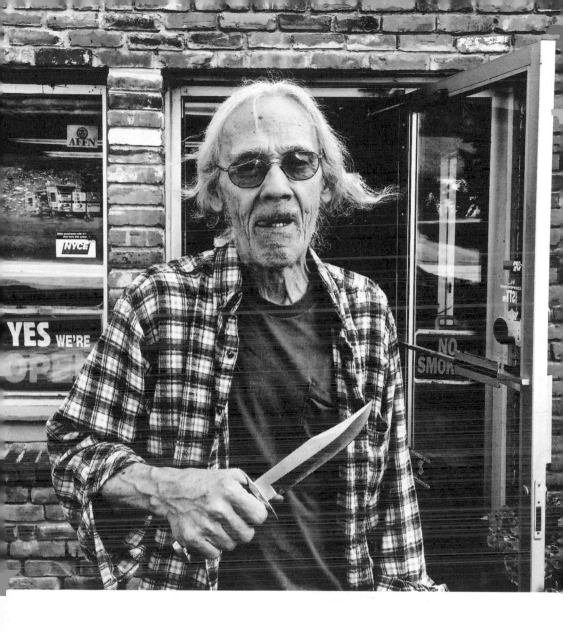

Ralph clocked me for what I am the moment he saw me on his security cameras. He has four. That was the day before yesterday, when I'd knocked. I wanted to ask about his flags. Four, flying from a birch-tree pole: on top the broken yellow snake that's come to mean "Don't Tread on Me"; then a tattered Stars and Stripes; below that, a bright red Stars and Bars, battle flag of the Confederacy; on the bottom the black, white, and blue of the "Blue Lives Matter" crowd. I knocked. Nobody home. A sign that read, "HEY ASSHOLE! This ain't your fuckin' land. SO GO AWAY NOW." Lot of used ammunition on the ground, and bullet-battered, man-shaped targets skulking among the bone-bare trees.

Across the road—Route 4, up in the mountains—a car pulled into the empty parking lot of a restaurant that wasn't open. Engine idling. Driver looking my way. Down the road, a woman came out of the only other house. Heavy black boots, black pants, thick black jacket, big black rottweiler. She held her dog back, watching. I chose the car across the road.

Nice older lady, Ada, and sure she knew Ralph, and yeah, she knew about his sign. But give him a call! "He don't mind." Which was how he came to be waiting for me this afternoon. Happy to answer my questions. He had a question of his own. "You don't mind my asking," he said, "what's your nationality?" U.S. citizen. "Uh-huh," he said, as in "You know what I mean." I did. He showed me a tattoo on his left arm: 88. Eighth letter of the alphabet. The letter *H*. HH. It didn't mean Howard Hughes. "Heil Hitler," he said.

But it was an old tattoo, the ink blue and blurry. Ralph's not like that anymore. Not exactly. "What's your nationality?" he asked. "And don't lie." Would I lie to a man who wanted to show me his sidearm, a loaded nine?

"I'm a Jew," I said.

Ralph smiled. "I knew it since as soon as I seen you." He didn't mind. Better an honest Jew than a white liar. Now, he said, we could talk. He wanted me to understand. There were more tattoos, he said. More flags, more guns, more rottweilers. More ammunition. He was ready. He was prepared. "Do you take my meaning?"

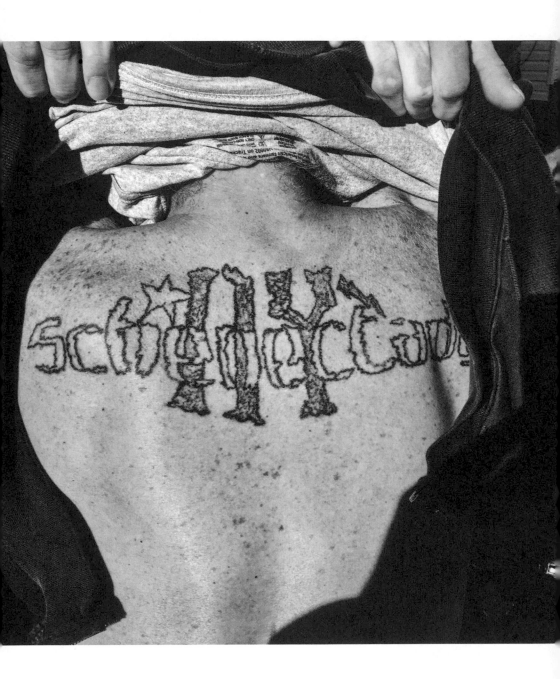

"Yo, man, I know you." It's true. He does. Michael. Passed out next to me the other night while I was eating a burrito. It's his burrito joint. Not his, but you know. A place he belongs. "He's schiz," says the woman who made my burrito. "He knows we won't call." Police, she means.

Tattooed beneath his left eye, where harder men might have a tear, there's a thick-inked heart, and underneath the right eye, a star. He says, "Yo, man, I know you," and I say, "I know you," and he says, "Yeah, you do." And then: "Police know me, too, yo, man, I almost got arrested for preaching Yahweh. They afraid of me for preaching Yahweh."

Problem was, he says, cops thought he was a Jew.

I don't ask.

He asks, so I give, two dollars, and he grips my hand and whispers in my ear that next time he sees me he'll bring me a bottle. "Or drugs!" he says. It's so earnest.

Outside, he freestyles. "I'm thinking in the hallway, I'm thinking Yah*way* all day, I'm sentient, I'm"—I lose hold of his words—"in the name of the *is* I pray to the sky, my god is he crumpled up, he's ele-fly."

"Poetry of the streets!" shouts a drunk woman. The street is Broadway, dead empty.

"Poetry of the streets!" says Michael, and falls down laughing, rolling in his poetry and rolling up his sleeves to show me more tattoos, hearts and shamrocks and unfinished words, something on his knuckle, "because I punched a concrete wall just to get to the other side."

Serious, though, Michael needs a job. Wants to be a preacher. "I believe in the old Tor-*rah*, I believe in the *Dead* Sea Scrolls, I'm fighting demons we can't see."

I believe it, I say.

"SOS to the TDY," he says, which means Schenectady.

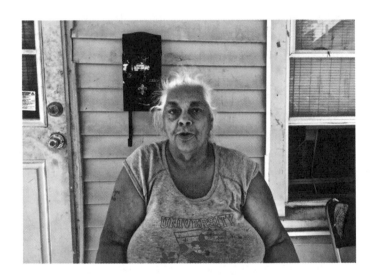

"It's my brother you want," says Hattie. "I don't own the house. I don't own nothing. It's his." She doesn't mean this house, 545, which belongs to her daughter, who is peering through the screen behind her. She means the one next door, boarded-up blank eyes in place of windows, like every fourth or fifth house in this part of the city. Top of the hill, view of the factory, G.E. Forty years ago it employed forty thousand, which was when Hattie's brother Gary bought the house next door for $1,000 down. Now Gary's gone—he lives across town—and so are the jobs.

Houses went dark first on Summit Avenue, and then the lights started going out on Mumford. The nice Polish two doors down passed, and the Polish widow, she just couldn't anymore. The minister across the street left. Schenectady, says Hattie, is giving her brother bullshit about his old home. "He paid the city fifteen thousand dollars to tear it down. 'Fifteen and end it,' he told them. But they ain't. There it is."

There it is, the one next door: In puffy graffiti across the plywood where once there was a picture window, the word "SLOB." Up above, gray vinyl siding melted and charred. "A fire," says Hattie. "Oxygen." Gary's fiancée was on the oxygen. She was also a smoker. Gary paid the city to take the ruin off his hands, but the city wouldn't listen, so Gary left it behind.

Hattie remains. "Worst mistake I ever made," she says, "coming to Schenectady." To which she came fifty-four years ago, when she was seventeen.

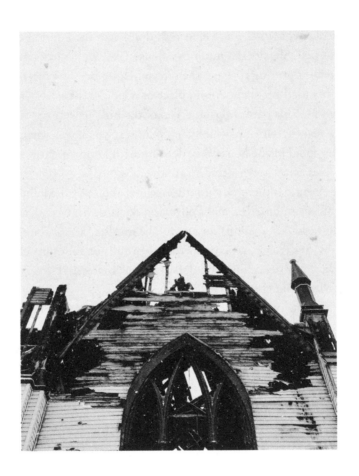

JEFF SHARLET

Of course, the police told him that he had the right to remain silent, but there were things he wanted to say. Yes, he had torched the church. Among the oldest in a town of old churches, Lebanon, New Hampshire. Did the police know, he asked them, that he had set the fire with an American flag? They hadn't. Or that first, he had jerked off? They had not known that, either. Looking at pictures of little girls on the church computer, he bragged. Gymnastics, he said, or maybe pornography, he couldn't be sure.

Later, he'd stabbed two friends. In between, he'd set another fire in another building. "Because," the police would say, "he knew that kids lived there."

He was twenty-seven, fond of hiking and getting high and tattoos and large knives. A white man in a small town in New Hampshire who liked to pose for pictures flashing what he imagined to be gang signs. He also admired pictures of sunsets. And he liked other pictures, too. That was his problem. Pictures. Also, fire. It was not his first time for either.

Maybe he meant it to be his last. He told the police (there were things he needed them to know) that he used the flag to burn the church, that he tried to burn the children, that he did what he did and, if they let him go, would do more—because he was angry with God. "Mad at God," he said, for making him want what he wanted. Pictures, and children, and flames.

Long time ago. Sometime in the seventies, when he was still Reverend Carl, which was after he was a sniper. "Eighty-second Airborne," he says. There's a chain around his neck, a silver cross, twining round it a silver dragon. The cross rests mid-chest, between the horns of a devil etched in red flames across his black muscle T. "You like that?" he asks. The cross, he means.

I like it all.

He holds out his fist: silver ring, another cross. Pulls up his shirt, shows me his belt buckle: silver cross on tooled leather. Turns each shoulder to show me blurry crosses, both sides. "Ink and thread," he says. "Nineteen sixty-seven. Nineteen, before I went over." Vietnam, he means.

He does yardwork. Pays good, in New Hampshire. He used to preach. "North and South Carolina," he says. "Old-school. Out of a tent. Quite a few years." He doesn't anymore. Doesn't know why.

"You're a Catholic?" he asks.

Not much of anything.

"Atheist?"

Not even that.

"You do believe in God?"

Sure.

He nods into his coffee. "All you gotta do is look around," he says.

He does not.

"You'll see God everywhere else."

Else? I don't ask. I want to know about the devil on his shirt. He shakes his head. "I got him on my shoulder. Saying, What the hell you doin' now?"

Carl can't answer.

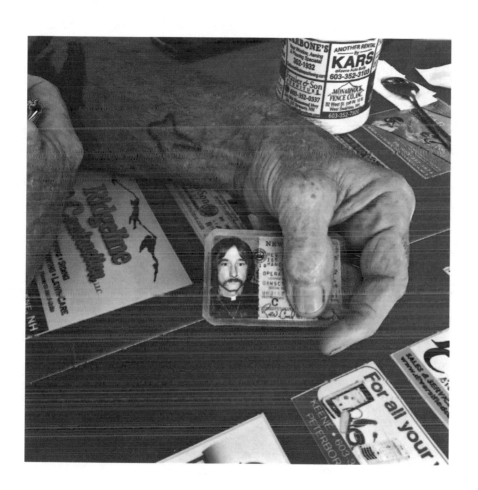

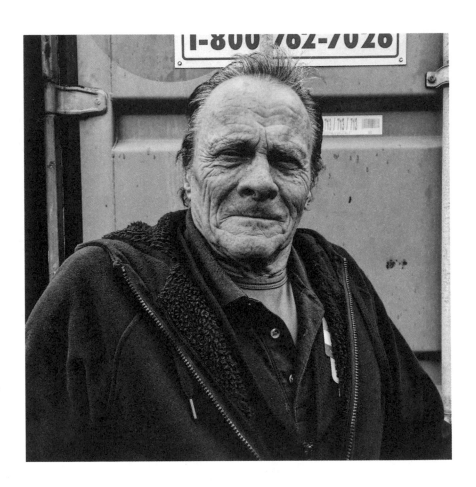

I ask if I can take his picture.

"Where?" he says.

"The green?"

He steps left, from the brown container to the green one. He gathers himself and settles on a face. Then he breaks it. He has a question. "You like the green?"

"I do."

"Me, too," he says. "I took a picture of it myself the other day." The other side, he means; the word "EVERGREEN" in peeling green paint on faded green corrugated steel. He summons his face again. I take my picture. Then another and another. "You got me now," he says.

"I do," I agree.

"I'm in your phone."

I nod.

"Have fun with that," he says.

I hold out my hand. He pulls his away. "You don't want to," he says. "I'm dirty,"

"What, you want a story?" he says. "You don't get a fucking story." He pulls his T-shirt taut. "Story of my fucking life," he says. "What more do you need?"

"That's plenty," I agree.

"Fucking truth," he says. He laughs, a lot of teeth gone.

Shooting Star

THAT SONG—"SHOOTING STAR," by Bad Company—has been stuck in my head since my first job as a reporter, twenty-five years ago. My beats were courts-martial and homelessness. Soldiers and sailors and marines, going away for impossibly long sentences because they'd gotten into a fight or smoked some weed, and the best places to panhandle, cops you could trust and cops you should run from, the street-level trade in crack and heroin.

This was in San Diego, a city on the ocean that faces away from the water. I lived in a single room occupancy hotel across from the paper, in a small cube of prickly stucco with room for a bed and a ceiling fan, no AC. I spent a lot of time outside. There was a guy named Jim who slept in front of my building and who for a cup of coffee and the change would tell me what I'd gotten wrong in my stories. A lot, usually. I liked having a reader. "You gotta get out more, bro," he'd say. Not like a surfer; Jim was from Missouri, worked fishing boats when he could but mostly worked at staying high. Sometimes we'd wander together, and he'd tell people I was his little brother. Some believed him, most didn't care. He told a lot of stories. He

liked to say he'd been at the siege of Khe Sanh in Vietnam, which, since he also liked to say he was thirty-four, meant he would have been the U.S. military's only preteen marine.

But when he wanted to really underline a point he'd drop his jeans, turn around, and point at his ass. From the lower left cheek, an open wound ripped down the back of his thigh. "Split like a baked potato," he'd say. The stink was astonishing. He said he'd come off a fishing boat flush, booked a room in a fancy hotel, and gone for a stroll. Then, he said, he got rolled—"Cut," he'd say, running his fingers up and down the raw flesh. It would have healed, he said, but a cop everyone called Sammy gave him a beating, and now it would not close. It looked deep, and he claimed you could touch the bone, but I never verified. He said he used for the pain, and although other users would laugh at such a claim—just another one of Jim's stories—there was a larger truth to the idea. Crack got him high; heroin seemed to drain straight into the wound. "Keeps me walking," he liked to say.

One night his friend Edward said, "You on a mission. You fixing to die." That unsettled Jim. So we walked to Denny's, the one in the shadow of the old apartment hotel El Cortez, abandoned, windows like an insect's black eyes, and ordered Grand Slams.

"Let's go to the beach," Jim said. It was after midnight. He said we'd find his friend Tommy. When we got there, the beach was empty. "Down there, maybe," Jim said, "in the dark."

I hesitated.

The dark, the stories.

No Tommy.

Jim was several steps ahead before he noticed I'd stopped. He turned. Saw me look past his shoulder, saw me not meet his eyes. "Don't get like the rest of them," he said. "Not now." It was too late; I already had. I was. Like the rest of them.

We sat on the sand. No talk. Just the dark and some beer, the sound of the waves and then the sound of Jim snoring.

The next day he let me give him a ride to the hospital. I promised they'd

admit him. If they wouldn't, I told him, I'd say I was a reporter and that'd open some doors, believe me. He didn't, but he took the ride. At least there was a radio.

He flipped through the dial. "I want some rock 'n' roll," he said. Then he found it. "Shooting Star." He tapped along on his good knee, then he drummed on the dash, then he rolled down the window and shouted the words. "Don'tcha know!"

Mercy wouldn't take him. I said I was a reporter. I was young enough then to believe that things worked that way. That stories—or even just the threat of one—possessed certain powers. The nurse ignored me. She told Jim, "You're high."

Only on heroin.

"Try a clinic," she offered.

Jim asked me to drop him off by the train tracks. Told me not to follow.

I saw him again my last day in San Diego, on my way out of town. He was walking down by the Pacific Highway, sucking on a pipe. "A clinic!" he said, like it'd been funny. The leg, he said, yeah, still open. Not so funny.

Years later, when I returned to San Diego, I looked for him, but I never did find him. Which is why, I think, I cannot get that fucking song out of my mind.

Be Here Soon

LARU AND K'SAUNA got an apartment, but Laru was smoking crack, not paying his share. He did what he could, but he couldn't. One night he called 911, over and over. Finally the police came. Then Laru wouldn't answer the door, so they kicked it down and took him to the psych ward. When he came home—he never really came home. Just his body, not his mind.

That July, K'sauna had their baby girl. In October, he said he was leaving. California, he said, a fresh start. He would send for them. That February, his mother died. His mother died, and his father was dying, and a month later his sister died. Who was left? K'sauna.

That's how I know her name. Laru was smoking meth by his tent, Skid Row, L.A., and talking about a dead friend named Africa and the Holy Ghost and the angel of death, and then he said "K'sauna," and looked at me for the first time, and said a number.

"Let me see how you wrote that down," he said.

Nine digits, not ten.

There aren't enough numbers, I said.

"Nine," he said. "You missed no numbers." Then he turned away, gone.

Nine numbers. I needed one more. So I tried them all: 0, 1, 2, 3, 4, 5, 6, 7, 8, 9. The number that was not missing was 9. That was K'sauna.

"Tell him," she said. Tell Laru she had her own an apartment now. Tell him, she said. Tell him he could come home. Tell him about his baby girl. "Listen." She held up the phone so I'd be able to tell Laru I'd heard his baby girl's tears. "She wants her daddy home." Tell him, she said. "Tell him to please call."

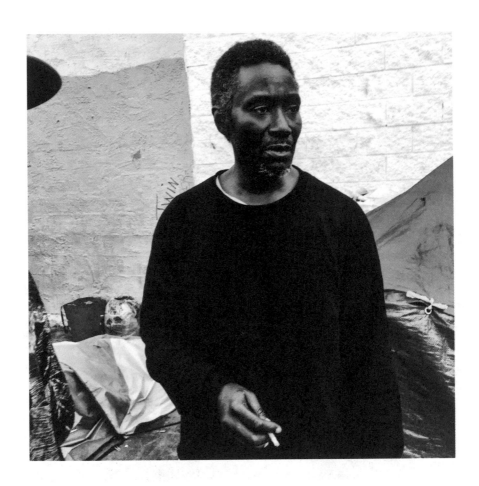

Eight cops, some in body armor, some undercovers—musclebound men in tight black T"s—turning out the tents of a group of junkies, self-declared. I ask the officer in charge what is happening. He does not like my question. But I am white, and I look as middle-class as I am. "There is no way," says the officer, "for me to explain what we do that you'd understand."

"Try me. I'm a reporter."

Press. Eight cops, four cars, not a word: Like synchronized swimmers they get in their vehicles and drove away in a line.

I ask the tent dwellers what they'd done. "Done?" The idea was puzzling. They don't do much of anything. Those years are gone. They use, yes; never where you can see them. The youngest among them, a man named Gary Braxton, says the police called it a "random narcotics sweep." No such thing under the Constitution. Gary nods. Did the police show them warrants? "What for?" he asks. There's no indignation left to summon. "Police," he says, "police." Cops are what they are. Do I have any more questions? He needs to pick up his things.

Blood on the blacktop, eighty, eighty-five degrees. Skid Row. Man on a corner nods out, goes down. "Crunch," one observer sums up his collapse. "Crack," says another. A woman in hot-pink sweats squats, puts a hand on his back, and tells him sweet things. Her sweats are about three sizes too small. Clothes she was given, not clothes she chose. They roll off her hips and ride up her spine. No one pays much mind, not to the man leaking blood or to the half-naked woman squatting above him. Not the police, either. One squad rolls by, then another. Station's right there. Then some cops stop, settling like crows. Can you move? You can? Roll over. Cop pats him down. Runs his ID. Might be a warrant. "Get lucky," says an officer.

A man sitting on a crate outside the corner store says he called an ambulance. "They're our friends," another man, General Jeff, tells me. General Jeff likes the ambulances. "They pick up the bodies, the dead ones and the dying ones and all those that haven't quite gotten there."

The woman in pink sweats rubs the man's shoulder. Ambulance'll be here soon.

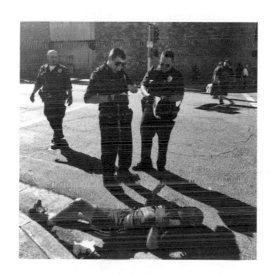

1.

"My name is Jared," he says. "You know, like the Subway guy?" Jared's a "spice pet"—an aide, in the most generous sense, to the dealers on Spice Row, the north side of San Pedro between Fifth and Sixth, Skid Row. Crack, heroin, meth, spice. Five dollars, ten dollars. Also loosies, a buck a cigarette. The dealers are black; spice pets are white. The dealers are "affiliated"—in the most generous sense—with the gangs of their youth, before they came to Skid Row. Heavy men who sit in office chairs on the street and nod at the addicts, serviced by spice pets like Jared, who are paid in kind.

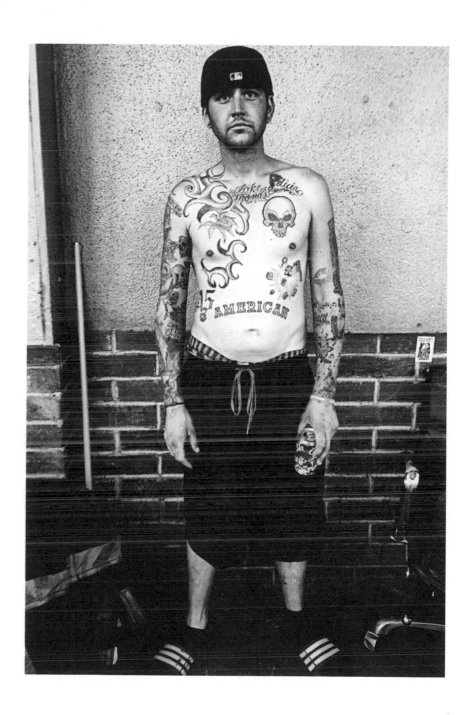

2.

Jared wants to show me his Facebook page. "Jared Miller." There are a lot of them. We scroll and scroll. He can't find himself. I hand the phone over. He signs in. "There I am," he says. He smiles. There he is. A little boy, the image of the man to come: It's Jared's son, four years old, for whom, on his left forearm, Jared carries a tattoo of a bird on a slender branch. "Because he can't fly yet," says Jared, cradling the phone with its picture close to his eyes.

And there's Jared above his little boy, a bird with strong wings.

"This is his mom," Jared says, pointing to a Facebook snapshot of a crisp young couple. "Before the drugs, you know." The drugs he takes, he means.

She's pretty. He was, too, muscular and rosy and bright-eyed, a straight-backed young man. There's a tuxedo. (I think; I scroll, and I scroll, but now I can't find him.) There's a man with a buzz-cut and color in his cheeks and a baby in his arms; there's Jared crouching with his boy, in a yard in sun at an angle, early morning or maybe setting, with his arms around his woman and his child, his future, golden.

3.

He used to be a soldier, and he still carries the armor, Ephesians 6:11: "Put on the whole armor of God, that ye may be able to stand against the wiles of the devil." But it was soldiering that ended him. "I started in the army," he says. Drugs, he means.

One of the dealers snaps at him. Spice Pet has an errand. Spice Pet can't find his sneakers. They're in front of him. He keeps looking. "I don't have them," he says to no one. He doesn't have anything. Just the birds on his arm. "That's my son," he says again. "Those two are for my mom and my dad," he says of the birds above the one that stands for him, three generations from elbow to palm. And there's his armor, the words between the chicken wings of his once-powerful shoulders. "A song of David," I say. He knows what I mean. He recites the words. "I-will-rescue-those-who-love-me . . ." He turns and spreads his wings, murmuring his psalm, a song of Jared Miller.

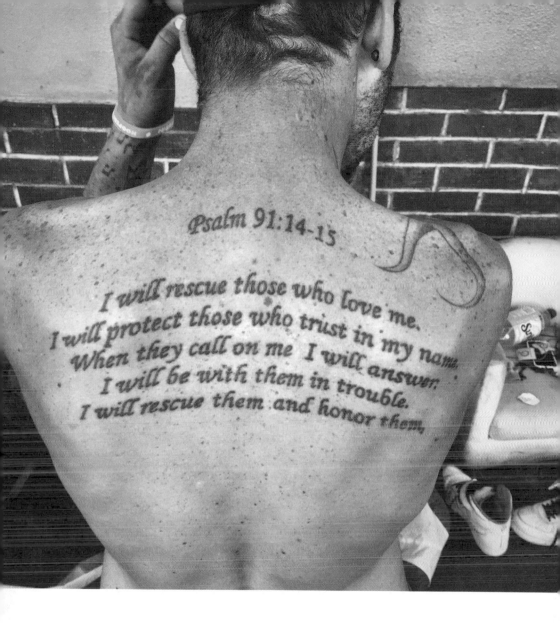

skidrowfolkI have seen this guy around. Spice $1?

robbinl3this is his ex mother in law have u seen him we dont know if he is dead!! please let us know my daugther is his ex wife and has his son she needs to know if he is alive

april_85_@robbinl3 - we all know where Jared is. He's on skid row. If the family is willing to go down and look for him I would show you all where he hangs out. But no one has stepped up to go. He's not part of my life anymore but he should be part of [his son's]. That's what makes me sad about the situation. - April ☺

[felicia]He should not be apart of [his son's] life till he gets help girl **@april_85_**

[felicia]But yes his family should go there and find him.. **@april_85_**

april_85_@[felicia]_ I never said right now but he is his dad. One day hopefully soon Jared will realize his son needs him to be there and will want to change his life.

[felicia]@april_85_

[felicia]He is his bio dad and yes one day when he gets himself help and becomes the man [his son] needs in his life but till then I can't let [him] see him nor will I you know what I mean I'm only doing it to help and protect [him]

april_85_I'm not saying you're wrong to do so **[felicia]**

[felicia]Ok thanks it's a hard but I need to do it

News, not a story: When I first posted these pictures, there arose in the comments a conversation between several women who had once been in Jared's life. An ex-girlfriend, an ex-mother-in-law, and an ex-wife, the mother of his boy. From that conversation, Jared's mother found me. We corresponded, and then we spoke. Like so many who suffer on Skid Row, Jared has a family that loves him. He is not alone. Jared has a mother who loves him and who has sought him out and who has tried to help him. It has been hard. Today she writes with good news. It is hard good news, but she believes it is good news, and she says Jared does, too. He was arrested. I don't know what for; I didn't ask. It could have been for drugs; it could have been for looking at a cop too long. The court offered Jared a choice, his mother writes: nine months in jail or as much as eighteen months in rehab. Jared chose rehab. News, not a story. Hard but good news and, maybe, a better story yet to come.

Six months later, Jared Miller overdosed, as he had many times before. This time he died.

Here is another verse from the psalm Jared had tattooed between his once-strong shoulders: *He will cover you with his feathers, and under his wings you will find refuge . . .*

Rest in peace, Jared Miller. Yours was a sweet soul.

I got myself a room with a view. Spent a couple of days looking out the window. Most of the time I forget that we live almost always in a state of stark contrast: the clutter of our thin plane, the emptiness above.

12:07 p.m.

OPEN YOUR EYES. Darkness: a luxury afforded the man who owns two tents, one popped right inside the other. No street light filtering in, no headlights rising along tent walls. Just—dark. You could be anywhere. Your father's house, before dawn in Cameroon. Paris, or pretend it's Berlin. *You know it's America.* Stretch: You want to run, the canyon, your long legs striding up the ridge, out of the haze, until you reach the great vista. L.A., the city beneath you. You'll close your eyes and feel the sun on your skin, and in your mind a movie will roll, the film of all that is yet to come. You've always been gifted like this, granted stories and the power to believe them. *Merci,* you think, *merci, Dieu. Thank you, God.* •

Open your eyes. March 1, 2015. Sunday. You need to call her. Your sister, Line. The other half of who you are. *Bonne nuit,* you texted her last night. Every day you text her. *I'll call you tomorrow, mon coeur, my heart, my dear.*

Darkness. Silence. Earplugs: You don't hear the street begin to breathe. The tent people and the blanket people, the single-room-occupancy people coming out for prayer and breakfast at the missions, the stay-awake-all-night-dancing-in-place-for-twenty-hours tweaking people, the flat-out-facedown sidewalk people. The corner men who piss at the foot of the two-story glass cross that drew you to pitch your tents on this corner.

Sunday, Skid Row, Los Angeles, America. This is where you are. On a mattress in a tent on the sidewalk. You flick on your flashlight. Taped to the tent's walls are photographs of Africa you cut from magazines. And a picture of Beyoncé. Isn't that a woman. Stretch: You're going nowhere today. But your body remains strong, muscle at the shoulder, tapered at the waist, a forty-three-year-old man still elegantly drawn. "Tall beautiful

black king," says your friend Moonchild. Some days, you actually feel like one. When the chemistry is right. Crystal raising you up, spice shifting you sideways. When you feel like you can vision your way home, across the ocean, right through the front door of your father's house in Douala.

Zip open the tents, smell the street. Zoom into the right-now-right-here, crouching on your milk crate in front of the tents and staring down at the sidewalk you sweep and sweep until you break the broom, and then how can you keep it clean? "Tall beautiful black king." Not this morning. So you take up the play. *Macbeth*. You've been studying, learning lines, reading them aloud. *Come, seeling night . . .*

("Paperback," your friend James Attaway will say one night as he slips off into his own spice dream. Why did he read? "To understand himself," James will say, a pipe rolling out of his hand, onto the pavement.)

The street throbbing. Gospel booming from Miss Mecca's corner store, radios rolling by in wheelchairs. *I'm a boss-ass bitch, bitch, bitch* on repeat, and so many ancient songs, Public Enemy, N.W.A, and older music, music from the listeners' last good days, the Dramatics, Marvin Gaye, voices that balloon into the evening. The police and the mission workers and the drive-bys, snapping pictures from automobile windows, think Skid Row gets worse at night, but they're wrong. It gets better. The cool air tamps down the fumes. The tents rise.

You read out loud; *loud*. Maybe it's the chemistry. End of the month, money dried up, everybody's stash dwindling or gone. No spice left to contain you, just the crystal rising in your gorge. *I have almost forgot the taste of fears . . .*

("He read at certain times," your friend Juju Padjuzu will say, willing himself sober so he can tell your story. Crashed on the couch at the back of Miss Mecca's store, sweating even in the after-midnight chill. "He'd start around seven, read straight through to nine-thirty. Not always out loud. But that Saturday night—")

"Am I disturbing you?" you ask Juju, his tent next to yours beneath the fig tree.

Juju says no, he loves to listen. He says he knows what you're reading. Says he remembers it from high school, years ago. *The very play.* Says it's beautiful. The play, your voice, the way you read: "You sound like Africa," says Juju. That's what they call you here. Africa. You've never told anyone your real name. That's for home. For your father's house, to which you will return.

("He call his father," your sister, Line, will say, repeating it over and over, rocking with tears, "he call his father, he say, 'Dad, don't worry, you will see me soon. You will see me soon.'")

You read. *Tomorrow and tomorrow and tomorrow . . .*

"Brother," Juju says, "I love you."

————

The irony is almost too crude, but there it is: Charly "Africa" Keunang read plays because as a younger man he'd dreamed of becoming an actor. He had immigrated to the United States to be in the movies. That didn't happen until the day he died. Just past noon on March 1, 2015, three police officers pinned Charly to the sidewalk and shot him. Six times; bullets number two and number three, decreed the coroner, were fatal. The coroner's numbering is random; it is almost certain that one of these two was the first shot fired. One entered just above his right nipple, the other close to the center of his chest. "Yellow gunpowder is present on the skin," reads the official autopsy; "soot is present in the wound." And: "This is a contact gunshot wound." Not "point-blank," considered the distance at which you cannot miss; "contact." Gun pressed against bone, bullet traveling directly from barrel to the flesh, no distance in between. Time of death: 12:07 p.m. Several bystanders took phone videos. One, a mission worker, posted his online.

Charly's death was unusual mainly in that it was documented. He was at least the 175th person killed by American law enforcement that year. In comparison, the number killed by law enforcement in Germany and the United Kingdom combined by that point of the year was: 1, same as it had been for the entire year previous. By the year's end, the American death toll

would rise to at least 1,146. This is likely an underestimate. The FBI tracks the number of police officers "feloniously killed" each year—41 the year the police killed Charly—but the only records of people killed by police officers are those gathered from press reports. Many of those killed were shot while committing a violent crime. Then again, of the 36 black people killed by police officers in the month that followed Charly's shooting, 17 were unarmed. Charly was unarmed.

It's hard to locate him in a time line of such deaths. Should we begin with Oscar Grant, shot in the back while handcuffed, lying facedown, in 2009? Or Sean Bell, killed in a hail of fifty bullets on his wedding day in 2006? Or Orlando Barlow, shot, in 2003, while on his knees, surrendering, after which officers printed up T-shirts that read, "BDRT," for "Baby Daddy Removal Team"? Or maybe even further back? Much further?

In 2013, three activists, Patrisse Cullors, Opal Tometi, and Alicia Garza, launched the hashtag #BlackLivesMatter in response to the acquittal of George Zimmerman, a neighborhood-watch vigilante who shot and killed a young black man named Trayvon Martin after calling the police to report Martin for walking through Zimmerman's neighborhood. In between Trayvon and now there are the killings that didn't make as much national news—among them Ernest Satterwhite, shot in his own driveway, and Dontre Hamilton, a mentally ill homeless man roused from his sleep and shot fourteen times after he grabbed a baton, and John Crawford III, shot, on video, without warning in an Ohio Walmart while shopping for a BB gun. And then there are the martyrs, a word the weight of which is sustained by the gaze of a nation that the deaths of these men and boys has drawn: Eric Garner, strangled on video in Staten Island; Michael Brown in Ferguson; Tamir Rice, who was twelve, and who bled to death before the eyes of his fourteen-year-old sister, who was handcuffed by police for rushing to her dying brother's side.

Added to this very incomplete count, there's Charly. Millions watched him die, but his name is not well known. Garner was a family man; Brown,

a young man of promise; Rice, just a boy. Charly was homeless and an addict, and at the end, convulsing with electric current from a Taser pressed directly into his skin, flattened on the sidewalk, he struggled. Much of the media was skeptical—as if the only black lives that matter are virtuous ones. And besides, the bodies just kept coming. Not long after Charly's death there was that of Walter Scott, shot in the back on video, and Freddie Gray, whose "rough ride" in the back of a Baltimore police van, his spine snapped, we can only imagine. Many can imagine all too easily, memories of years and decades and generations of police violence against black bodies simmering, which is why, on the day of Freddie Gray's funeral, two days after Charly's, Baltimore burned.

But this story is about Charly. One black life that mattered, no more or less than any other. It begins, like so many stories, with its end: just before noon on that March Sunday, sun dappling the sidewalk between a man holding the cell phone recording a video and a figure windmilling his arms at a circle of four police officers. That's what the public saw—an out-of-control man, "resisting arrest."

In silent security-camera footage from the Union Rescue Mission, the conflict builds more slowly. There is at first only one policeman, a sergeant, a former counterterrorism officer named Chand Syed. If the sergeant is concerned, he does not show it. Then two more policemen arrive. First is Francisco Martinez. Martinez has a reputation. "Hard-ass bitch cop," J. Washington, a corner man who watched it happen, will tell me. "Napoleon cop." Martinez's partner is an African-American rookie the LAPD will refuse to identify. His name is Joshua Volasgis.

Martinez and Syed are wearing body cameras, the video from which the LAPD will refuse to release for nearly three years.

But everything leaks. This time, it leaked to me. I was able to watch the video and to listen to recordings of internal police interviews with Martinez, Volasgis, Syed, and other officers involved. I began one night around eight, and I watched and listened until dawn. I watched Charly die a dozen times over, and then a dozen times more. Slower, then faster, then

A still from the Union Rescue Mission security video.

freezing each individual frame, noting every gesture, every moment, the location of every hand, and then speeding up again. It was, of course, the same awful story each time, and yet different, too. Sometimes it was about Martinez, sometimes Volasgis, or Syed; then—with the first bullet, the first bang—it always became a story about Charly.

————

In the version of events Volasgis, the rookie, would tell detectives from the Force Investigation Division (FID) later that night, it was straightforward. Martinez asked "the suspect"—Charly—for ID. Charly "became very agitated and aggressive," with "clenched fists" and "screaming." Volasgis says they told Charly to get up against the wall, and that Charly did not do so. They told him what to do, and he did not do it, so force became necessary, and then, Volasgis will say, Charly reached for his gun—and that, Volasgis's chief will later declare, explains why they killed him.

Volasgis had only ten months on the force. On the audio I heard, his voice is urgent, emphatic, confused. Martinez, Volasgis's training officer, sounds bored. Martinez tells FID detectives that a "victim"—Laru Jay Curls, Charly's friend and neighbor—said Charly had threatened him with a mini–baseball bat. Volasgis says Laru was in "fear for his life." In the body-cam video I saw, Laru sits quietly on the curb next to Charly's tent, a lean man with a great shock of hair, bony arms resting on bony knees. The audio on the body cams is rough. I can't hear anybody ask Charly about a bat.

In the post-shooting interview, an FID detective asks Martinez if he *saw* a bat. No, Martinez says, but he can imagine it. "For the benefit of the tape," says an FID detective, describing Martinez's actions, "you're holding your hands about eighteen to twenty inches apart"—the length, according to Martinez, of the bat he did not see.

"Assault with a deadly weapon, then?" the detective asks after some more questions.

"Yes, it is," says Martinez. On this, the threat of the mini-bat nobody saw, Martinez is clear.

The rest of his investigation is foggy. Martinez tries to question Charly, he tells the detectives, but it's useless. "Just talking, not making any sense."

"What was he saying?" asks a detective.

"I don't remember."

What Charly is saying, according to Martinez's body cam, is: "Let me express myself."

What Martinez is saying is: "You're gonna get tased."

———

The documentation of Charly Keunang's last five minutes and thirty-one seconds begins shortly before Martinez and Volasgis arrive. It begins, in the video from Sergeant Syed's body cam, with a survey of a quiet Sunday morning on Skid Row. There's the fig tree with its dense canopy, the mission's red wall, the two-story glass cross. There's a flattened tent, a crumpled tarp, a blue tent still standing. That's Charly's.

About five feet away sits Laru. "Our victim, supposedly," Sergeant Syed tells Martinez and Volasgis when they arrive. Charly is standing between his tent and his milk crate. He's wearing dusty black slacks, a black hoodie tiled in a pattern of Moorish gold, and a knit cap, white with a black band. He is not screaming. A woman and two children pass between him and Syed. "Hello!" says the younger one. "Hi!" says Syed.

As with Syed's body cam, there is thirty seconds of silence on the copy of Martinez's body-cam video. Then we hear birds in the trees. We hear Martinez. He's a buzz-cut cop in wraparound shades, barrel-chested and barrel-bellied. He points at Charly, points to his own chest, and says, "You don't tell me how to do my job!"

Charly's feet are planted. He is not approaching. No "fists." No "screaming." His shoulders are slumped. He gestures toward Martinez with his right hand, open, at waist level, as if it say, *Cool it.*

But you don't tell a cop to cool it. Not even with an open hand.

Sergeant Syed, watching from a distance, says, "All right, here we go."

Martinez: "We're going to do things my way."

Charly tries to say, "Listen."

Martinez: "No, it doesn't work that way." Police on Skid Row, in Martinez's mind, don't "listen." To Volasgis he says: "Partner, give me your Taser."

Volasgis, a tall, lean man with an uneasy stance, unholsters a bright green Taser and passes it to Martinez. "You're gonna get tased," Martinez says. "You understand?"

Charly nods. "If you let me express myself, maybe you may have a chance to explain why you're doing this right now." His Cameroonian French accent is crisp, his tone formal. *Let me express myself.* Let me put this trouble, all these troubles, into words.

"Sir," says Syed, his voice still easy, "you're gonna get hurt if you don't comply. This Taser's gonna hurt."

There's no *if* about it in Martinez's words: "Sir, you're gonna get tased."

Charly turns to Syed. "You see? He don't let me express myself."

Syed spreads his palms open in front of him. "Relax," he says. Martinez starts to speak; Syed gestures at him, too. Martinez stops. "Can you relax?" Syed asks, speaking, it seems, to Martinez as much as to Charly.

"Let me express myself, Martinez," says Charly. He knows Martinez's name. A lot of people on Skid Row know Martinez's name.

Up against the wall, says Martinez.

"Let me express myself," Charly says.

What would he have told them had they done so?

Doesn't matter now. Against the wall.

"Your job is to let people express themselves." His dark eyes are large, steady, intent, as if he can stare Martinez into listening.

"There you go again," Martinez says. Against. The. Wall.

"Are you gonna listen?" Charly asks.

"Sir, this is why you're gonna get tased!"

It's too late. "You can go ahead and"—Charly could be saying "kill me," but I can't be sure. Then he says clearly, "You can go ahead and tase me."

He makes a time-out gesture. He edges his right foot forward. His left remains in the tent.

A still from an anonymous bystander's phone video.

Behind them, a crumpled tarp rises from the ground like a blue ghost. A thin woman in capri pants and a beige windbreaker emerges, wanders around the tree to see what's going on. Volasgis pushes her into the street. "Skinny little girl," thinks a man watching. "What they pushing on her so hard for?"

Martinez aims the Taser. "Don't walk up to me." Charly isn't. He's leaning forward, pointing. He moves his right foot forward; his left remains in the tent. Martinez says it again: "Don't walk up to me."

Charly tries Syed. "Listen," he says, swinging his gaze around, "tell this guy to stop it." He turns back to Martinez, both hands palm out, hands held low: "You need to stop it right now."

Then Charly turns away from the policemen, bends down, crawls into the darkness of his tent, and says, "Leave me alone."

Of course, they won't now. It's speeding up. It's going to happen now. It doesn't have to, but it is.

Syed tries to talk Charly out of the tent. Martinez has another idea. "Let him in there," he says. "Let him in there." He steps in front, aiming the Taser. Volasgis follows, gun drawn, held in a side grip. Like in a movie, a position the academy would have told him is good for nothing. He's wobbling. Syed and another sergeant who's arrived peel back the tent, and now there's Charly, on one knee, his arms wrapped around himself. He picks something off the tent floor. Something small—a lighter, maybe, or a pipe, something smaller than the palm of his hand. A cook at the Union Rescue Mission who saw thinks it was a flip phone. Charly pushes down his thighs with his hands and starts to rise. It looks like he's about to put his hands up; but we will never know, because then Martinez's Taser beeps, twice, and the darts fly, and Charly turns, and this is where it begins. The end:

Charly stands and then spins. "Like a whirlwind," remembers Miss Mecca, watching from her corner store. He weaves between two cops, his outstretched arms carrying him full circle. The whirlwind is flapping his arms. Palms open; no fists—no fists—spinning, as if he is fighting air. What he is fighting are the Taser's wires and the electric current flowing

through them. The connection is not complete—Charly wouldn't be standing if the darts were fully embedded—but the darts are hanging on to something and he's tangled in wires and so he is swinging his arms, and he throws down whatever it is in his hand—matches? a lighter? a flip phone?—and he begins to twirl.

PAUSE. Rewind. Slow it down. He is not a whirlwind, he's a windmill, his open hands twisting behind his body as he wraps himself in the current, the wire, up on his toes, on one foot, falling. His hands wide open.

Volasgis, who has dropped his nightstick—he just lets go, as if he's forgotten it's in his hand—grabs him from the side. The officers swarm.

"My nigger!" somebody watching shouts. "My nigger!"

Freeze the frame: the fifth minute, the tenth second, of Syed's cam: Charly has come full circle, facing Syed, arms spread, fingers spread, legs spread, on his toes, falling.

Now Volasgis is catching him.

"I then grabbed the suspect," he'll say, "and punched the suspect approximately two, three times in the facial area."

"Bombing on him" is how a mission worker will describe the blows.

A fluid motion, Volasgis will tell the detectives. "Grab, punch, and he wraps me up at that point as he falls to the ground." Volasgis feels the suspect holding on. "My belt!" he'll cry.

PAUSE. Rewind. This time, through Martinez's eyes: The rookie holds the man, draws back an arm, his fist clenched, and drives it down into the suspect's face. Martinez's hands enter the frame. Martinez is trying to hold on to Volasgis, keep the rookie standing, but the rookie is punching down. Freeze: the second minute, the fortieth second of Martinez's cam. Martinez appears to be grabbing for his partner. His belt. It's not Charly grabbing Volasgis; it's Martinez.

In this same second, we see Charly's hand as close to Volasgis's gun as we'll ever see it come. His hand outstretched, open, holding nothing, as he falls.

Holding nothing.

Volasgis's gun remains in its holster.

PLAY. "Get his ass!" shouts Syed. "Get his ass!"

They get his ass. And meanwhile, the skinny woman walks around the knot of men with her hand in her pocket and picks up the nightstick Volasgis dropped. The skinny woman's name is Trishawn Carey, but on the street people call her T or Trey or Nicki Minaj or sometimes Nicki Mirage, because, as one woman puts it, "she got some back going on." Not in the video. She's a skeleton, crouched and holding the stick like a batter. What she means to do with it isn't clear. It's likely not clear to her. Fifty-one-fifty, say those who know her, slang for insane. Earlier that morning, she'd been in the hospital, for a diabetic collapse. Later, when I visit her in jail—her bail will be set at $1,085,000, and she'll be facing life without parole for picking up the stick, with which she didn't touch a soul—she'll tell me she doesn't remember what happened, she doesn't really know why she's in jail. Then, crying without tears, she'll sing hymns. Pretty little soprano through the jailhouse phone.

"My stick!" shouts Volasgis. "My stick!"

Two other officers tackle Nicki Mirage, who weighs, according to legal documents, 102 pounds.

In a bystander's video, we hear an officer shout, "Put the cameras down!"

The man holding the phone says, "I'm just doing my job."

There are four officers on Charly now.

"Stop resisting!" yells Martinez. "Stop resisting!"

An officer named Daniel Torres moves in with a second Taser and, using it as a stun gun—direct to the body, contact with flesh—hits Charly's outer right thigh, then his inner thigh, in toward the crotch. There is the beetle-like *zk-zk-zk*. Charly's one free foot spasms. He's convulsing, arching—freeze that frame, too, one foot in the air, four cops, wires, darts, the current—

The police will say the Taser didn't connect. True? We'll have to trust them. Some Tasers record voltage, but the police wouldn't release the data.

So what we have is this: In the cell-phone video, a glint of sun on a squad car, reflected light dissecting the scene, and Volasgis, shouting, "He has my gun! He has my gun! He has my gun!"

Charly Keunang does not have the gun. It is possible that he did, at the end, reach for it. It is possible that, convulsing with electric current, his arm jerked toward it. It is possible that he never thought of the gun, thought of nothing by then but the pain and the terror.

What is not possible, though, is that Charly had the gun.

Freeze the cell-phone video and you see a hand in silhouette. Martinez will say yes, he saw a hand. Whose? He can't be sure. He will say Volasgis screamed. Volasgis will say he was straddling the suspect, that the suspect had "defeated" both "levels of retention" of his holster, that the gun was coming out, that he was "capping" Charly's hand.

Volasgis wears his gun on his right hip.

Charly's on his back, twisted onto his right side.

Syed's cam: We don't see Charly reach.

Martinez's cam: We don't see Charly reach.

But maybe he is: Maybe, while he is being beaten, his left arm is snaking across the pavement, making a ninety-degree turn up Volasgis's thigh, twisting Volasgis's utility belt, defeating two levels of retention, and overpowering the strength of the big man sitting on top of him.

This is possible.

What is not possible is this: "The suspect," Volasgis will say, "relinquished it"—the gun—"upon being fired upon." Slow the cams down

again: "He has my gun! He has my gun!" Frame by frame, Volasgis rises. Sunlight between his body and Charly's. His right hand—the one with which Volasgis will say he was holding his gun—swings backward.

His left—the one he'll say is holding Charly down—appears first to grasp at the left side of his belt. Like he's capping. A gun that isn't there. Because he wears his gun on his right side.

In the heat of the moment, Volasgis does not appear to know his left from his right.

And then his left hand flies up. And Martinez's gun is drawn; and Volasgis is rising; sunlight between the bodies; could Charly still be holding on to Volasgis's gun? Is his arm really that long?

Bang.

Freeze: the fifth minute, the thirty-third second of Syed's cam. Martinez squatting over Charly, who is no longer moving; Volasgis is standing; and Martinez, with his left hand, is holding Charly's body down; in Martinez's right hand is his gun.

Full speed: Some people hear three shots; most make out five. The autopsy commissioned by Charly's family—the public coroner's office refused to release theirs for months—says the police shot Charly six times, a number with which the official report, finally made available after the media has moved on, will concur. Martinez says he shot once; if the autopsy is to be believed, he may have shot twice. Torres says he heard the shot, assumed Charly had the gun, and shot twice; that leaves three bullets for Sergeant Syed to put into Charly.

"Boom-boo-boom, boom-boo-boom," says Hadiya Najeri Palmer, who watched from her wheelchair.

"Goddamn!" hollers the man holding the cell phone. "Motherfucker. Motherfucker. Motherfu-u-u-cker."

The officers spread out in a circle around the body. Like petals. Charly is dying. Volasgis is wilting. He hunches over, as if his breath is leaving him. His arms hang slack. He stares at Charly. "You got your gun?" one of

the other officers asks Volasgis. The gun, they will say, is the reason they needed to shoot him. Volasgis reaches down to his hip. His gun. It's in his holster. It never left his holster. He draws it, holding it strangely—no side grip now—as if it can't be, this thing in his hand. The cams on Syed and Martinez's chests are steady. Charly's hand twitches.

One officer says, "Stop moving!" Another officer picks up the cry: "Stop resisting!" he says, to the body on the ground, to the crowd that has gathered, the camera that is recording, the detectives who will question them that evening. "Stop resisting," he tells Charly, who is Charly no more.

They arrest the body. This they do by rolling it and twisting its arms behind its back. In case it struggles. It could be a threat. The corpse.

They do not read the body its rights.

Later, the detectives will ask Volasgis, "Did he resist?"

He will seem puzzled by the question. "I was focused on the cuffs, sir."

The detectives will ask Martinez: "Did he make a statement?"

"Who?" Martinez will say.

The detectives will ask Torres, who cuffed the body: "Did he say anything?"

"Who?"

"The subject."

The body. Charly, dead at 12:07.

"No." Torres will tell the detectives. "He did not."

———

Ten months before he died, shortly after he became homeless for the first time, Charly started a Twitter account under the handle @bothleservant. He wrote in English and French, his native tongue, often about health. Health of body— he'd long been interested in nutrition—and spirit. He called himself "Both" because that's what it felt like to be Charly: human and divine, the good and the bad. He chose "Le Servant" because he hoped the sins of his past would help him be humble. "En réalité 'ton enemy jure' c'est tout ce que tu as," he tweeted

on May 21, 2014. "In reality, 'thy sworn enemy'"—by which he meant Satan, ill health, injustice, and even the self—"that's all you have." By which he meant, I think, that he believed that adversity would make him—or you, or me, anyone out there who might read the lonely tweets he wrote as he made his peace with sleeping beneath the open sky—stronger.

———

Police on Skid Row aren't like other police; or maybe they *are* like other police, only more so. They're a specially designated fifty-officer detachment called the Safer Cities Initiative Task Force, one cop per square block of what's known as the Skid Row containment zone. It's not so much a police presence as an occupation, headquartered in Central Division's mostly windowless cement bunker, the front of which features a tile mural of American policing that begins with a white cowboy, proceeds through a white cop helping a white woman and her daughter cross the street, and concludes with what appears to be an entirely white class of modern police cadets. Some Safer Cities cops call Skid Row "the box" and think of themselves as its walls. Police describe their approach as a "Homeless Reduction Strategy." To L.A.'s downtown developers' association, it's part of an "urban renaissance," a scrubbing of the city's core to make it safe for lofts and bistros. At one point the Safer Cities Initiative considered narrowing the sidewalks to make them more difficult to sleep on, but it's proven easier to push the "threat," as the developers call homeless men and women, into the containment zone. Increasingly, it's divided vertically: street people below, "loft people" above. A block from Charly's corner, in a converted industrial space called Little Tokyo Lofts—part of Skid Row's rebranding—a half million dollars will buy a young professional fifteen-foot ceilings, a working fireplace, and a private dog run, insulated from the street by what the building's management lists as the site's top amenity: twenty-four-hour security with video surveillance, one of the many little private police forces of downtown L.A.

"Containment" is really recycling: A concentration of services such as

shelters and food kitchens (not nearly enough; approximately one thousand fewer beds than there are homeless people) combined with "broken windows" policing results in a relentless jail-prison-street churn, as the police pursue petty users, crack down on open containers, and wage war on jaywalkers. In the first year of Safer Cities, police issued some twelve thousand citations to Skid Row residents, around 80 percent of which were for "pedestrian violations," with around six thousand of those for "walking on 'don't walk' signal, flashing or solid." I received such a ticket myself, when I crossed San Pedro to ask why police had just slammed a man face-first into the wall for drinking a beer. An officer put me against the wall, too, and handed me a ticket for $197.

How do homeless people pay all these tickets? They don't. That's the point. An unresolved ticket becomes an arrest warrant. The result is the criminalization of Skid Row, which then justifies the deployment of more force, since a large percentage of the population is, technically, "wanted." There is a special squad of mental health professionals, the SMART team, attached to the Safer Cities Initiative Task Force, but it is rarely deployed. The SMART team did not come for Charly, although it was only four blocks away, tucked inside Central. Nobody I met on Skid Row could remember seeing any of them. One police sergeant shrugged when I asked why, then rubbed his fingers together, the universal symbol for money, a.k.a. resources. An officer I met at the front desk of Central told me he didn't like even going outside; he talked instead about a teddy bear tacked to a wall next to a map on which the containment zone was blocked off in yellow. The bear wore an LAPD uniform, and you could buy one for ten dollars. Another said he and his partner had brought three ODs back from the dead with Narcan in a single day, all of them in a public toilet close to Charly's tree. Charly had called that toilet the "Felony Room."

Public bathrooms on Skid Row perform many functions. In addition to the usual ones, they are for shooting up, smoking up, and cooking up; there's a YouTube video online showing you how to prepare bunk, fake crack, in one such bathroom. They are, in short, for privacy, and

the private lives of most addicts are not so much frightening as sad. Sergeant Deon Joseph, known on the street as the "photo-op cop" for the frequency with which the LAPD presents him to reporters, showed me video of a woman testifying about her experience of the bathrooms. She had come to complain to the police. Joseph requisitioned some sticky notes from a junior officer to cover the woman's face on the screen, and then, because her language was salty—Joseph is a devout Christian— gave me his own personal earbuds to listen with, so that the audio would not upset his fellow officers. The woman's distress, meanwhile, was real. The filth, the needles, the pipes, and most of all the humiliation, people pushing the door open while she's on the seat. "It's so fucking embarrassing," she moans. "Lotta sex in there?" Joseph asks in the video. Yes, she agrees, there is, but the point is that people bust in when you're doing your personal business and— "Condoms?" Video Joseph interjects. *Yes*, she says, and continues on the subject of even more basic and private bodily functions until Joseph interrupts again—and I should add that throughout this, since he can't hear the audio, he's leaning over to me to ask if she's talking about sex—and she gets it, and starts giving him what he wants, tales of people with no privacy using the only room with a door they can call their own, if even for a few minutes, to, yes, have sex. "Do you think a camera there might help?" Video Joseph asks the woman. Actual Joseph, sitting beside me, seems to recognize this part; he's nodding along. Right. A camera. For the bathroom.

Such is the state of policing in America: funny because it's sad, sad because it's funny, unless you're black or poor or both, in which case it's as often as not simply an accusation. Of what does not really matter.

———

After the killing, two witnesses told me that they had been informed by police officers, while being interviewed, that Charly had been gay. The witnesses said that the police seemed to believe that this fact, if it was a fact, might make them less sympathetic to the dead man. They said an

officer told them that some cops had caught Charly and a neighbor in the act on a rooftop. I spoke to the neighbor, who seemed not so much offended—neither he nor anyone else knew Charly to be gay, and so far as he was concerned a man's sex life was his own—as genuinely puzzled. Charly wasn't on any rooftop! Charly didn't even like to leave the corner. "He was like a tree," Miss Mecca, the shopkeeper, told me. "He never moved."

His "corner" was actually in the middle of a block of South San Pedro, halfway between Fifth Street and Sixth. It was called a corner because the street is interrupted there by a wide driveway that leads into the underground parking garage of the Union Rescue Mission, an angular five-story building that houses the largest homeless shelter in the United States. "Everybody else used to want to be against the wall," Tony Jones, a mission worker, told me. Every so often, security would roll out of the mission and shuffle the homeless along. Charly did not want to be shuffled. He preferred the fig tree. Skid Row is a district of one-story warehouses and very little vegetation to interrupt the right angles of sidewalk and wall. The tree was shelter not so much from rain as from the sun, under which homeless people, forbidden by the city from keeping their tents raised past dawn, sizzle like cracked eggs. Charly thought the tree could be his umbrella.

There was the public toilet there, too, and you could take showers in the mission. There was Miss Mecca's store and a storefront church down the block with a powerful choir, the voices of which, many nights, mingled with the street noise, and a dapper old homeless man called Dice who sold soap and candy and sausages and eggs he cooked on a hot plate; and, across the street, there was Spice Row. Dealers with names like Evil and Strange and Dennis—some men need no exaggeration—would fulfill your drug needs for five or ten dollars.

Nobody had camped under the tree before. And because nobody had camped there before, it was relatively clean, despite the urine at the foot of the two-story glass cross. "Monday," says Tony Jones, "it's my duty to go

out there, me and my crew, just to power-wash, to scrub it down." A lot of people resented Jones for disrupting their sleep or their high or their fragile sense of place, making them pack up what they had and move for an hour. Not Charly. "He would be one of the only ones that would voluntarily get up, move his tent, help a couple of other people move their stuff." "Thank you," Charly would tell Jones. "I appreciate what you're doing."

Hadiya Palmer, who watched him die, remembers that about Charly, too. "He butted in on our conversations," she told me late one night, speaking from the midst of her worldly possessions, which were strapped to her wheelchair. "He was trying to ask us if we wanted the fronts of our tents swept." Hadiya and her girlfriend said no. Charly swept anyway. Hadiya was not pleased. "You swept all the dirt and filth that came in from the streets," she told him. She was obsessed with the filthiness of Skid Row. "CDC can take a cotton swab and put it on the petri dish and it will gremlin up, just like, *shiiiiit*."

Charly kept sweeping. He wanted it to be clean. "Ssh," he whispered. "Ssh. Sshhhh."

After Charly died, a trans woman named Tasha, famously beautiful and widely desired on Skid Row, asked, "Why they"—the police, the media, which very quickly began reproducing anything the police fed them—"creating him to be an animal? I spent a night in his tent. Didn't have anywhere else to go. Night was cold." Skid Row can be especially hard on trans women. Charly, though, was kind. "That man respectful."

––––––––

When I first visit Miss Mecca's store, that's all she'll say at first. "A respectful man." She's tired of reporters. So we talk about her store. It's a garage, actually, out of which she and a business partner started selling little grocery items two years ago, when she'd returned to Skid Row after a long sojourn in the suburbs. She'd had a house with a lawn outside the city, and a job as a school-bus driver, and a family. She'd also had a temper, and she'd taken a misdemeanor from time to time, and one thing led to another until

she'd lost the job and left the house and returned to Skid Row, to which she'd first started coming to party back when she was a teenager. "I was a thug," she says. She does a little swagger. "Gangsta," she says. She's small and curvy, the color of dark caramel, wearing one of the all-white outfits she favors these days: tight white jeans, a flowing white blouse, a robin's-egg scarf, and lots of jewelry, symbols of Christ and Judaism and Islam and Buddhism. "God take the thugs," she says.

Mecca knows almost everybody. A tiny, weathered Asian woman called Asian Persuasion passing by grins toothlessly at Miss Mecca and promises her she hasn't been selling her body lately. A giant former gangbanger called Brain, his neck, face, and bare skull covered with ink, flicks little smiles in her direction; full 51-50, but when he sits by Mecca's store his monologues simmer instead of boil. A woman named Violet begins tripping out right on the spot where Charly was killed, twirling and falling just like he did, until Mecca walks into her whirling arms and whispers to her, nose to nose, and Violet settles. "Thank you, Miss Mecca," she says.

Mecca likes to know who's living on her corner. When Charly moved in under the fig tree, she approached him with the coy, sweet smile she uses when she comes up on somebody she knows is deep in the struggle—the one to stay alive. She looked at him like he was a man with shoulders, "a nice-sized man," she says. Charly appreciated that. He never said his name. Somebody—might've been Mecca—dubbed him Africa, because that was where he was from. "Like an African ambassador," one man will tell me. Dignified. He had a way of sweeping his gaze over a scene that seemed to invite others into the patience of his exile. He was always waiting. He had been waiting for a long time. People thought there was something about his eyes, even when he was high, that seemed to say in that precise French accent of his, *Perhaps you could be patient, too.* "He had manners," says Mecca.

Charly picked his spot under the tree in part because it gave him a little distance. He wanted to set up his tent and let it stand, he wanted to sit on his milk crate and look at the mission's two-story glass cross, he wanted

what he considered polite conversation. He was the first to put his tent on that corner, but others followed. That happened easiest if he'd invited you, like his friends James and Juju. "He gave me a break from talking about just Skid Row things," says James. "With him we talked about everything. Politics. God. History. Education. *Strong* dialogue, man."

"He really got down on his Bible thing," says Juju. "He prayed. He used to sit up and look at the cross right there." Then they'd get high together. "Blood brothers," says Juju. "We were smoking buddies." He means this as a bond.

Juju likes to wander, and when he did, he trusted his tent to Charly's keeping. "And he would do it. Wouldn't try to say, 'That'll be twenty-nine ninety-nine.'" That is, Charly wouldn't try to sell Juju's tent while he was gone. Some people try to sell almost anything on Skid Row. "Everything short of a horse come down this street," said another man. Charly sold things, too. Little things, things he bought and traded for with money his sister sent him. Spice, sometimes, but he wasn't a dealer. Charly also gave things away. That's how Juju met him. Juju, meandering down San Pedro, new to the block, looking like he does, his eyes red with juice. "I walked past his tent and he said, 'Bro, don't worry, here's some food. There's some more coming.'"

Juju had a monthly check, but Charly more often had cash. "Go across the street," he'd say, "and get us some spice." For a lot of users on Skid Row, drugs are an escape. For Charly—and for Juju when he was with Charly—spice and crystal together felt like good medicine, the kind that doesn't take you out of the world but lets you be in it. For a while, the fear subsides.

Then it returns. One night Juju and James and I sit on the sidewalk, our backs against the mission wall, looking at Charly's tree. They're meditating on what Juju calls "the spirit of violence." They say they'd felt it coming the morning Charly died. "We can tell," says James. "Been around violence so long." Charly had been out of sorts that morning. There'd been a fight with a man called Yung Amazin'. What the fight was about—Y.A., as he's known, because nobody wants to call him

Amazin', said it was about "territory," and everybody else thought Y.A. stole something—never becomes clear, even when I later meet Y.A., and he leans against Charly's tree, smiling, and tells me he's glad Africa got killed. So it'd been that kind of day; and now, sitting against the wall with Juju and James, it begins to feel like that kind of night, too. Juju holding back tears, James telling me that after Charly died he'd had to hold Juju back, lest Juju also be taken by the man with eight arms—by which he means, I'd realize only later, the four police officers who'd killed their friend. "Vengeance is not ours," James says, and the two men spark up some spice, and the fear, for a while, subsides.

The next time I see Juju it's after midnight, a little party at Mecca's. Every night was a little party at Mecca's. Sergeant Joseph, the photo-op cop determined to eradicate bathroom sex, had told me that Miss Mecca's store was a "drug spot." He'd said you could bring your business there, rent a patch of her concrete floor back beyond her books, her paintings, her Hello Kitty sweaters, sit on your ass and get high. He'd said it was worse than that. He'd said Mecca worked for "the Cubans"—popular lore held that Cubans, hardened by Castro's prison, ruled the corner—and that the Cubans drugged girls and took them to the back of Mecca's store to make rape porn. He'd said maybe the Cubans killed the girls. I spent many nights at Miss Mecca's. She may have been holding—a common enough practice in which shopkeepers allow dealers to hide their stashes—but I never did see any bodies, or Cubans, or porn.

It was true that sometimes people came there to cool out. Mecca would let someone having a bad time sit quietly back by the bathroom. And sometimes people came to sell something. New sneakers, stacked heels, a dirty blanket, somebody else's CDs, a can of shaving cream. Midnight, one a.m., somebody would come around carrying a thing and a beseeching smile. "I got this thing, Miss Mecca," he'd say, this thing he'd found or stolen or received. He'd say he just needed a few dollars. Mecca would scoff, she'd haggle, she'd say she needed to talk to her father— her father was God—and then she'd give the seller a few dollars. Later

someone would admire the thing, and as often as not, she'd give it away. "Everything must go," she'd say, because she was going out of business. She'd been saying that for a long time.

Sometimes they came to consult. Mecca's Bible is always on hand, and some nights a stoop-backed homeless rabbi in a black coat, black hat, and tzitzit would cane his way in around two a.m. to discuss what he could recall of the Zohar. Sometimes people came to sing or to rap. One night an aspiring actor named Dana, a breathtakingly beautiful man, lean of waist and broad of shoulder, dense with muscle—homeless, at the moment, and trying to stay sober—pirouetted across Miss Mecca's concrete floor, the dark skin of his face, distant in private ecstasy, gathering and shattering the store's cold fluorescence as he turned.

"Like Africa, right?" Mecca would say after he was gone. She was either bestowing a blessing or perceiving one: Charly's death spiral, remembered by Dana's grace. Dana had wanted to talk, but he'd kept distracting himself with song, rising up suddenly according to his own inner cues, his long arms spreading upward like a condor's dusky wings, filling the half-empty garage with gospel, soaring into "You Are Holy," a saccharine gospel hit made haunting by the echo and shadow of the garage's darkened interior, where a fat man whose name I did not know, calming down from a bad high, sat in a lonely chair while he waited for the world to stop twirling.

Juju comes to talk about Charly. He's stayed sober to do so. He tells me everything he can remember—mostly just about their smoking days, but also about the time he lost his tent and Africa let him enter his sanctuary; and about how sometimes they'd get into fights like roommates, "over a sock"; and about what he called Africa's "innocence." Charly had lacked the calculation common to those who survive on the street, the mental apparatus of minute adjustments and diminishments by which a man might come to line himself up against a wall, unasked, when a cop approached. Africa let himself feel indignation. Juju had liked that. Being with Africa had let him feel a little indignation, as well. Juju needed it. "I was a man

once, too," he says. Young man with a future, in Baton Rouge. President of the Honor Society, he says. He'd wanted to play football in college but wasn't big enough or fast enough, so he went army, ten years. He says he made it to E6, staff sergeant, and then something came over him. "God consciousness." He'd quit to study for the ministry. And then—"I went on a walkabout." Why, he can't or won't explain. That was a dozen years ago. He's still walking, his eyes red and yellow, and what was evidently once a powerful frame gone slack, as if he's lost his stuffing. That's what he liked about Africa. The man hadn't lost his stuffing.

We drift out into the night, and together we do our best to recall what we can of Charly's play, *Macbeth*, a soliloquy from it that twenty-seven years ago— Juju and I are the same age— we'd both had to memorize and recite in high school. We get only as far as "all our yesterdays." Then, around four a.m., Juju spots a dude on San Julian who might be able to help him with a little something, and he promises we'll figure out the rest at the rally for Charly later that morning.

It comes to me after Juju departs. The forgotten words bubble up like the sour smell of the sidewalk in the still before dawn. *And all our yesterdays have lighted fools / The way to dusty death* . . . and on through to the sound and fury, signifying nothing.

The rally's in the street in front of Charly's tree. Activists local and imported, singing, "Can't kill Africa," driving the slogan up and down the scale around the work of a couple of street drummers. When Juju returns he wants to stand but he can't, so he posts against the wall and then slowly sinks. Sitting, listing, his pants half off his hips and soaked at the crotch because he was too wasted to walk the ten steps to the pissing corner under the giant glass cross. You do what you can. What he can do is stay conscious. He's been high for hours. It's not working this time. The fear won't subside. He's puked on the sidewalk beside him. A thin yellow pool. He's crying. He wants to tell me something. I can't hear over the drums. He wants me to sit down. There's the yellow pool. In front of him is some cardboard, and he reaches for it, and he puts the cardboard over the bile.

Manners. He looks up at me with his face shining in the morning sun. Sweat, and tears. I sit down. He leans in, tries to say something: "Africa—" But he can say no more.

———

The stories the LAPD tells about why its officers had to shoot Charly Keunang—there are two, the official one, delivered by Chief Charlie Beck, and the one leaked to the press—are contradictory and yet ultimately the same. Chief Beck said that Charly reached for the gun. Law enforcement sources admitted to the *Los Angeles Times* that the body-cam footage does not show Charly doing so. The police didn't release the 911 call said to have initiated the encounter, but Beck urged us to imagine what was said. "Sometimes," said Beck, "[it gets] lost in here that there was a victim." He meant Charly's neighbor, Laru Jay Curls. The "victim," continued Beck, "had to be treated by an ambulance." This was true—you can see it in the security camera footage. Ambulance pulls up, ambulance pulls away. Laru's treatment consisted of an ice pack he was sitting on when Martinez and Volasgis arrived. When the guns fire, Laru throws his hands up as if he, too, is about to be shot. That night, he camped on the site of the killing. TV reporters did their stand-ups with his tent in the background. Nobody bothered to ask him a question.

Meanwhile, the L.A. *Times* reproduced accounts of the body cams the police would not actually show them, citing unnamed sources. These sources spoke not of the shooting but of Charly's "resistance." That Charly was agitated, that, after he was tased, he spun out of control, wasn't in dispute. The question was whether the police had been justified in the use of force in the first place, and then in shooting him six times while he was pinned to the ground, unarmed.

"Sources familiar with the investigation" responded with a non sequitur: Charly was an ex-con, and he was wanted for not reporting to his probation officer. Both facts are true, and neither is an answer. The point was to change the question. Not "Was the killing justified?" Or,

looming even larger, "Does the LAPD have a race problem?" That wasn't a question Chief Beck wanted to answer, and it wasn't the question the media asked him. The question they asked was smaller. Meaner. "What did *this* man"—a man with a record, homeless, a drug user—"do to deserve to die?"

The police officers who killed Charly didn't know his name, much less his history. Anonymous sources—"leaks" intended to shape the narrative to follow the official story—told the press he'd been identified as Charley Saturmin Robinet; that name is the alias under which he had, indeed, been convicted of bank robbery in 2000. This, despite the fact that the probation officer with whom, it was "leaked," he had been missing appointments knew that his name was Charly Keunang. A vagrant called "Charley Robinet" had no family, no past at all but that of a singular crime. "Charley Robinet" was a blank slate on which the police could write their own story. Charly Keunang had a sister and a mother in Massachusetts, a father waiting for him in Cameroon. The only known photograph of Charley Robinet, the one that went into wide circulation, was his 2000 mug shot, blank-eyed, grimacing. Charly Keunang's sister, Line, could have offered the press snapshots less than a year old: Charly in a suit, Charly beaming with his big arms wrapped around his mother. Charley Robinet was nobody. Charly Keunang was loved.

———

Both,
Is that you?
—*Charly's first tweet, May 18, 2014*

———

Charly Leundeu Keunang was born in Douala, Cameroon, to Heleine Tchayou and Isaac Keunang on September 6, 1971, eleven years into the nation's independence. Heleine and Isaac were members of the Bamileke people, who took pride in their entrepreneurial reputation, and they were

church people, devout but never extreme. They had moved to the city from farms, peanuts and corn, in Bana, a region of red dirt and green hills five hours beyond Douala by unpaved road. They had loved the farms on which they'd been raised, and the families that had raised them, and the language of that land, which they knew simply as Bana, the language of home. But the countryside was pouring into Douala, a port city at the mouth of the yawning Wouri River, the "New York of Cameroon," Charly's older sister, Line (pronounced "Leen"), would call it years later. Nobody came because it was pretty. The city of Charly's childhood was architecturally rushed, a jumble of merely functional colonial relics and bottom-line new construction. Isaac and Heleine built the house into which Charly was born on a new street without a name, and the larger one to which they moved when he was a toddler on another new street with no name. Two stories, a bedroom for each child. Isaac was an auto mechanic, and in Douala, its streets jammed with cars newly bought but often outdated, that meant a certain prestige. There was a public school nearby, but a private one, Fraternité, was better. Although the children could have walked, Isaac liked to drive them, in one after another of a succession of well-maintained automobiles, an Opel, a Datsun, a Volkswagen. He liked to watch his tall, long-limbed girl and his big-eyed boy tumble out of the car with their book bags and march into school.

At noon Isaac and the children came home for a lunch of beans and plantains, and Isaac would turn on the news. "Stop making noise now," he'd hush them, pointing at the radio, to which they were all to attend. He did not want his children to be political—"We go without politics," he would say, for such ideas were becoming dangerous in Cameroon then—but he wanted them to know the world, to speak Bana and French and English, to understand themselves as equal to anyone. After learning, there was play. Isaac had bought a piece of land with room to host the neighborhood children for soccer matches. Heleine would preside from the kitchen. Line, three years older than Charly, was her deputy. Charly was their darling.

There's a pair of family photos in which Line, seven or eight, wears a pinafore with ruffled sleeves while Charly, four or five, the favored son, is pictured in not one but two outfits, a handsome wide-collared striped shirt in the first image, a white shirt with white shoes in the second. In the family portrait, Isaac wears a sharp-shouldered suit and tie, Heleine a collared dress. They're a handsome couple, plump-faced; in America you might think them midwestern. Charly has his father's lips and high cheekbones, his mother's arched brows. His eyes, deep and dark, are the meeting between mother and father, with a gaze like gravity. But he is his father's son. You see it in the way Isaac holds the boy, the way little Charly, standing between his seated father's knees, leans back into his papa's big arms.

Charly was like that; he leaned into love. He was good at making friends. Or, rather, he just seemed to have them. Other boys came to Charly. As others were drawn to him, he was drawn to his sister. They were almost always pictured holding hands. "Sis," he would say, urging her to play with him, "c'mon, you need to be active." She preferred to watch his games. She liked that he never turned anyone away, that he would play any position to make room for another boy.

He loved movies, even the mechanism behind them—wheels of celluloid becoming a delta of light spreading out to the screen to become a story. When Charly and Line had done especially well in school, their parents would take them to a local cinema. As a boy, Charly loved the Sylvester Stallone of *Rocky* and *Rambo*. As he grew, he became a fan of the French star Alain Delon, who'd gained international fame starring in *Plein Soleil*, an adaptation of *The Talented Mr. Ripley*, Patricia Highsmith's novel of stolen identity. None of the movies, though, featured anyone who looked like Charly. So Charly wrote his own, and in the darkness before sleep he would close his eyes to make a screen, his personal cinema. Once he built a makeshift film projector. He was very proud of it. But when he sold the projector to a friend, the boy's father promptly marched over to the Keunang house to complain: The only

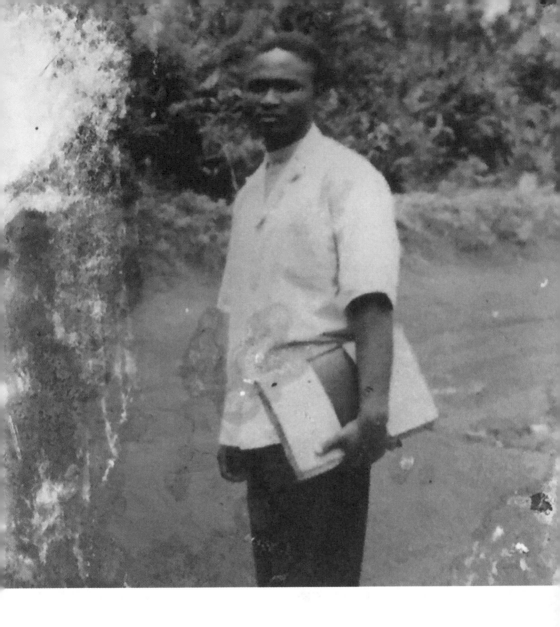

movies this projector showed were those of the viewer's own imagination. Charly's father was delighted; he told the man that he should wish for his own son to be blessed with such a vision.

Near the end of high school, Charly announced, "I'm going to graduate in math." He wanted to please his parents by choosing the most difficult major. He completed his baccalaureate and enrolled at the University of Douala, where he added physics to his studies. There's a picture of him as a college man, standing on a red dirt road, scholar-faced—grave eyes, no hint of his serene smile—in a crisp white shirt, his books under his arm. But one year in, Charly's father lost his job. There would no longer be money for education.

Charly had to find work of his own, and that would mean going abroad. Cameroonians prize education, but their economy doesn't come close to matching their degrees. To be educated in Cameroon means to be ready to leave Cameroon. It is a diaspora of the talented, says David Singui, a Cameroonian businessman in L.A. who, after Charly's death, became an adviser to the family. Singui asked me to imagine Charly's dilemma. "He is an only son"—expected to provide for his parents in their later years—"he is looking left, looking right, looking at Daddy, looking at Mommy—and there is no hope." The pressure came from all around him. "If you don't get out of the country, there are names for you: selfish, lazy. They will say you don't want to take care of your parents. You can't stay in Cameroon with a bright mind."

So Charly left. Like many Cameroonians, he found that the language he'd inherited from his people's colonial subjection carried him to the rich nation that Cameroon had not long before fought for its freedom. France. At first the plan was to make enough money to enroll in a French university; then it became simply to make enough to survive. Later, he'd tell stories of gangsters and stickups, although those who heard them thought they sounded too much like movies. It's just as likely that he was a day laborer. He found a job driving luxury cars from Germany to France. So long as he lived in his imagination, racing sleek new Porsches

along the autobahn, it was glamorous work, but at the end of every drive he had to turn the car over and walk away. He did not have a car of his own.

He called home often. He did not tell stories, he asked for them, and he never spoke of troubles. It was only later that the family realized how little they knew of his French sojourn. "Like a black box," says Line's husband, Charles. After two years, Charly decided that there was no more future for him in Europe than in Cameroon. "There are so many of us in France," says Singui, "you end up competing with your cousin." Cameroonians found the French racist, and many who knew the United States only by its celebrities believed that America would be more open to Africans; Charly, who spoke passable English, was one of them.

His timing made him part of a wave of educated Africans. They came to open businesses, to earn MBAs, to become CPAs. Charly had something else in mind. A school he had learned about, he told Line. The Beverly Hills Playhouse. The very best. *Playhouse?* said Line. What kind of school was that? *For acting,* said Charly. It's a measure of Line's love that she accepted this ambition. She didn't ask questions. Had she done so, Charly might have told her about the movies in his mind, ones in which he slipped easily into the roles of his favorite actor, Robert De Niro, whose lines as Vito Corleone and Jake LaMotta he'd memorized.

After the police killed Charly, the press would report that he came to the United States on a stolen French passport. It's more likely that he bought it, a common means of entry for African immigrants in the 1990s. Most African immigrants would discard their cover identities once they'd found their countrymen. Charly had something else in mind, a path not so much Cameroonian or French as quintessentially American: reinvention. Like the stars: Roy Scherer, of Winnetka, Illinois, became Rock Hudson; Issur Danielovitch of Amsterdam, New York, became Kirk Douglas; Archie Leach of Horfield, England, became Cary Grant. Charly Keunang of Douala became Charley Robinet and, in 1999, arrived at last in Hollywood to begin his career.

May 21, 2014: "Regarding existence, only the liar will live the truth. Lie to yourself if you must lie."

―――――

Hollywood, USA: He lived in a dingy apartment on Wilcox Avenue, carless in L.A. Later he'd say he'd found work as a French tutor. He told people he met that he was the son of a French martial arts master, that he'd grown up on an island. He was beautiful: innate style, a liquid line of smooth muscle, the easy grin, the giant eyes, and with what funds he had, he kept himself stylish. "*GQ*," remembers his friend Big Herc. He liked to run in the canyon nearby. He was a teetotaler, a my-body-is-my-temple man. He studied nutrition, subscribed to esoteric health regimes, made a little money as a personal trainer. He sent some of it home to help pay for Line's wedding. "My sister!" he lamented, "I can't believe I can't attend."

He liked to sit in the lobby of his apartment building, reading lines. Sometimes other aspiring actors, mostly immigrants, would join him. "Like the U.N.," says the director of the Beverly Hills Playhouse. The director does not remember him in particular. There had been Clooney and Baldwin and Swayze, also many, many more with no names. "Thousands and thousands." Charley Robinet, easily forgotten. Class twice a week, four hours a night. Students presented scenes. Charly loved soliloquys. "He was deep," remembers a friend. But he couldn't afford his lessons. "Pay up front," says the director. They might float you, but for only so long.

Which is how, one chilly Tuesday in February 2000, Charly came to be riding shotgun in a little Dodge Neon with a friend called Fat Raja, who'd approached him with a plan, a bank robbery, based on a movie, *Heat,* which starred De Niro and Al Pacino. Squeezed into the backseat as they scoped out their target, a Wells Fargo, was Big Herc, short for Hercules, a giant, baby-faced man who was the only working artist among the three—known

for his roles in in a subgenre of porn called "black muscle," a star of films such as *Budonkadunk #8* and *Shave Dat Nappy Thang #13*.

Raja, a porn talent scout, had offered more than once to get Charly into what he and Herc called the "porn game," but Charly had always said no. "Hey, man," Raja would say, "I can make you some money." *No*, said Charly; he was a real actor.

Even in the porn game, Big Herc says now, you met a lot of would-be actors. The smart ones got that what made you an actor was an acting job. And then there were men like Charly, men with destinies, or so they believed, and sometimes they could make you almost believe it. Herc had to admit, Charly was persuasive. Herc was all muscle—no camera would ever care about anything but his body. Charly was all eyes. You felt like he was looking into your soul. He was dapper, not just in dress but in the way he moved. He made Herc think of a black James Bond: upper-crust, *refined*. And Herc thought Charly was the smartest man he'd ever met, too. Always reading. He got Herc to read with him. His imagination, thought Herc, was like the ocean.

But the man, Herc saw, lacked sense. For Herc, the bank job was his shot at becoming something more than "black muscle." He was going to take his share and invest. He'd managed some rappers; he wanted to start his own record label. Raja wanted to establish a production company. Charly said he was in it to pay for his acting lessons.

Charly was always telling Herc how much he loved De Niro, but that February Tuesday Herc thought Charly sounded more like *Reservoir Dogs*. One of those whiny white bitches with their skinny black ties, blah, blah, "Like a Virgin," blah, blah. Now, with Charly, it's chocolate. Won't shut up about it.

"Need it before I can rob a bank," he says.

Raja: "You don't need no fucking chocolate."

"I gotta have my chocolate, man, or else I can't."

The plan had been so simple. Fat Raja drives, Big Herc carries an assault rifle, Charly says he can handle a nine. Big Herc's job is to loom,

keep them flat on the floor. Charly's is to vault over the counter and get the money. Get the money, get out, nobody's hurt, not even the bank; it's insured. "Victimless crime," they told one another. But now? Charly's afraid, Herc can tell. Charly had boasted of gunplay in Paris and London, but Herc, who as a teenager had been in a gang—porn, he'd say, saved him from a life of crime—was beginning to suspect that he was the only member of the trio with actual criminal experience. He wanted the job to be boring. Charly wanted it to be cool. It was like he thought this thing with the chocolate was characterization.

"Pull over," Charly says. He needs his chocolate now.

"Excuse me?" says Raja. "Not a whole lotta black people here." Three black men in Calabasas, and next day there's a bank robbery? There's your Hershey's.

Not Hershey's, says Charly. *Godiva.*

Raja caves; they stop at a gas station.

This dude, Herc thinks, *is not ready.*

The next morning it's raining. *There really is no good day to rob a bank,* thinks Herc, but he worries that it's a sign. When Fat Raja pulls up with Charly, Charly's silent. No stories, no chocolate, no De Niro. Herc worries that this, too, may be a sign. Too late now.

Herc's first in the door with the rifle. Charly's right behind. Years later, he'll say there'd been somebody on the inside. Never proven. If there is, he's not acting like it. He vaults over the counter, shouting in a fake accent. Obviously fake: *Middle Eastern or cracked Jamaican,* thinks a teller, Ali Sabzi. "Open the fucking vault or I'll kill you!" Charly shouts. Sabzi can't open the vault. Charly doesn't understand. The clock is ticking. Charly makes Sabzi show him his keys. "They're not the keys to the vault," Sabzi pleads. Charly doesn't get it. Or maybe he does. It doesn't matter, though, because this is where the story really goes wrong: Charly brings his pistol down hard on the bank teller's skull.

Herc stares, horrified. *You don't need to do that,* he thinks. Why did Charly do that? Herc knows: *That's something they do in the movies.*

An assistant manager opens a safety-deposit box. Jackpot. Charly stuffs $94,000 into a bag, and they're out the door, but they've taken too long. They make it to the Neon, even manage to switch it for another vehicle— Raja rented both of them on somebody else's credit card—but they're too easy to find. There's a car chase. Thirty miles, their red Navigator alone on the 101, a galaxy of red and blue sirens filling the lanes behind. Spikes in the road. They ditch the car; run. Charly makes for the beach; he's caught. There's $33,500 stuffed in his underwear. He thanks a deputy for not shooting him.

Later, after he weeps, thinking of the shame he has brought to his family—he is afraid the news will kill his mother—and after he's come to the conclusion that his family must never know—he will remain Charley Robinet, lest they learn the terrible thing that Charly Keunang has done— the police will find two more bills they overlooked. Stuck to his ass. A ten and a fifty.

"I have spoiled my life," he tells an FBI agent. There is nothing left to lose. "I will tell you everything about me." He tells the agent about university, about France, about coming to America. He tells him about acting lessons. He didn't want to be a criminal, he says. He wanted to be an artist. He'd believed that the bank job—like the fake passport—was the way in. He'd believed it would come naturally. Not the crime; the act. The fact. Both. "To rob a bank," he says, "is just like any acting."

Only, it wasn't. He knows that now. Too late. "My mom," he says, crying. "I didn't hit anyone." But he did. He knows. There's a moment inside, Charly tells the agent, where he's scanning the lobby and he's got hold of the teller and the gun's in his hand, and he's shouting— "My English was not that good, so you say stuff to get them to give you money"—and he spots, down on the floor, a mother and a baby. "And I remember it was—" He stops. He cannot explain.

Years later, when he sees Line for the last time, perhaps it is this moment—the mother, the baby, the gun, the blood, the money—that he'll recall when he tells her he's sorry, that he had failed at America.

Big Herc—today Marcus Timmons, married, a respectable man—pled out. He did eight years, eight months. Raja pled. He did seven years. Charly? Herc can't make sense of it. He confessed—and then he pled not guilty. Herc thinks Charly was crazy. Thinks he lost it in the federal detention center, where the three men spent several months awaiting trial. "He had a lot of run-ins," Herc says now. Herc—Timmons—is a successful businessman. He restores classic cars. He likes talking about smart choices. He sounds like a Rotarian. A middle-aged man looking back on the worst decision of his life, one from which he alone recovered. Raja's dead now, never got back on his feet after prison, died of lupus. And Charly? Still in prison, Timmons figured, until one day he saw a familiar mug shot on the TV news. "Homeless Man Killed by LAPD on Skid Row Was Convicted Bank Robber" was the line on KTLA. Charley Robinet. Homeless. Dead. *Fool*, thought Timmons. *It didn't have to go that way.*

In jail, it went like this: At first, Herc and Charly were tight, lifting weights together, and Herc, who'd done time, tried to teach Charly the rules. But Charly didn't want to learn. He didn't get it. "You gotta humble yourself," Herc would tell him. That wasn't Charly. "Very adamant in what he believes." He spent more and more time meditating. Wouldn't line up for head count. His cellmate, an African—Charly was still pretending to be a Frenchman—came to Herc and Raja to ask them to talk sense to the man. Lost cause. The last real conversation Herc had with Charly came two months in, when Herc got the discovery papers in his case—including Charly's confession. Herc and Raja confronted Charly in his cell. Charly wept. He swore he'd make it up to them. He'd go to trial, he'd take it all back. "Forget it, dude," Herc told him. "Case closed. Get your deal." Charly wept. "I'll go to trial," he promised. "I'll act!" "Delusional," Timmons says now. Charly thought he could De Niro his way past his own confession.

It's clear from the court records, though, that Charly actually had an argument: He believed he'd been denied a lawyer when he'd made his confession. He'd been held in a cell for four hours and not allowed the customary phone call. When an FBI agent arrived, Charly asked, "Wouldn't it be better if I had a lawyer?"

The agent played semantics. "You're asking me what I think?" What the agent thought was that Charly had better start talking.

The court took Charly's point under consideration, but he'd been caught red-handed. He got fifteen years. Charly succeeded at only one thing: He kept his incarceration secret from his family. Imprisoned as Charley Robinet, Charly Keunang disappeared. This was his consolation.

Charly served fourteen years in federal prison. What happened? He read. He meditated. He worked out. He tried to kill himself three times. The third time by starvation. Thirty days without food, he'd say later. But he didn't die. He failed. He failed, Marcus Timmons marvels now, at suicide.

In 2003, the prison tried to move Charly to the mental health unit. Charly refused. In 2005, the prison sought a court order; a "mental disease or defect," read the petition. After that, he did not have a choice, and of the almost ten years he spent in a prison psychiatric ward, there is no public record.

"The insane asylum"—that's what he called it when, years later, he told Miss Mecca where he'd been before he came to Skid Row—was unspeakable. He told her he thought she should know who her neighbor was. But he couldn't say more. He did not know how to express himself, he said. He did not think he wanted to.

Sssh, she said. No need. "Hey, baby," she told him, "that's *your* story." Charly nodded. Yes, it was.

———

June 7, 2014: "What a heart we are. A decaying yet evanescent heart we are."

June 10, says Line. She says it often. June 10, 2014: the day Charly returned. "Tuesday," she says.

On this Tuesday, hot and rain-slick in the broken blacktop Boston exurb of Malden, Line and her husband, Charles, are going to a friend's to make arrangements for a memorial. In Cameroon, they wake the dead through the night, until dawn begins to melt the grief away.

Line and Charles are bound: to each other, to their families, to the constellation of Cameroonians scattered across a country without customs, a nation in which immigrants lose their names. But tonight they'll make plans to come together for Line and Charles: It is Charles's sister who has died, his sister whose soul must be sent home over the ocean.

As they're about to leave, there's a message on Line's phone. A Facebook notification, a friend request. Line does not have a lot of Facebook friends. She has Charles; she has Jaycee, their two-year-old daughter; she has a job as a nurse's aide; and she has her ailing mother, living with her in a spare, tidy apartment behind a run-down strip mall.

Once, she had Charly, too. When he stopped calling, she placed a missing persons ad on a French-language website. When that didn't work, she applied for a diversity visa to the U.S. She waited six years; when she received it, she gave notice at her job in Douala, a good job as an executive assistant, and told her husband he would have to choose between his professorship in economics at the University of Douala and her. There was no Line without Charly. So they moved to America to look for him. But that was eight years ago, and he had disappeared six years before that, and she knows she should accept that he is gone, without even a body to wake through to the dawn.

She looks at her phone.

Facebook: "Charly Keunang wants to be your friend."

Line Marquise Foming is a steady woman. Cheekbones like the beams of a house, a deep voice of long vowels. Her gaze is direct; she blinks slowly.

But then sometimes a key turns, and the past tumbles forward, and her hand flies up. Her voice shivers to a halt. She looks away. She shields her tears as she remembers.

Line stares at the message.

She blinks. "A joke," she says.

Charles looks at his wife's phone. *Charly Keunang.* The name, in Charles's life, not for the brother-in-law he never met, the man who helped pay for his wedding, but for the absence that has always been part of his marriage. *Charly Keunang.* It's a name for that which is not there.

"I hate this kind of joke," says Line. Charles is silent at first. What kind of joke could she mean?

"Don't say anything," Charles tells her under his breath. They don't want her mother to hear. They don't know what this could mean. Whisper when you don't understand.

"Let's go," says Line.

They get into the car. Charles can see that she's beginning to teeter. It can't be him. Who would make such a joke? It can't be.

"No," agrees Charles. "I can't explain." A university economist in Cameroon, he's studying now to be an accountant in America. He's a by-the-numbers man. A data man.

They need more data.

"Go ahead," he says. "Respond."

Line stares at her phone. "Who," she taps, "are you?"

"Je suis ton frère." I am your brother.

Line begins to shake.

"Wait," says Charles.

She has been waiting fourteen years.

"Wait," he says. "Let's go and do what we need to do." Her brother may be alive, but his sister is not. The dead must come before the living. Wait.

So Charly waits, too. In L.A., sitting on a sun-dappled blanket in Griffith Park, his home now, in a secluded stand of eucalyptus and red cedar, everything he cares for—his Bible, his running shoes, a few plays—

within his reach. Except Line. "To love what we do," he'd recently tweeted, "we must love its difficulties even better." He likes paradoxes, contradictions that complete one another. Riddles with not one answer but two: Both. Line-without-Charly, Charly-without-Line. *What a heart we are.*

Line waits. Returns home. Charles parks. The engine ticks. Night soothing day. Sitting in the car, she dials the number Charly has sent her.

"Who are you?" she asks.

And then he is there, the rich, deep sound of her baby brother, now a man. "Sis," he says.

It is a joke, she thinks. Why would someone do this to her?

"Sis," he says again.

Her voice hardens. "My father's name?"

"Isaac," he says.

"My mother's?"

"Heleine." Then the ghost in the phone names their grandmother and their uncle and their cousins, names and middle names, roots and branches and leaves. He speaks to her of their grandparents' farm, its green hills and yams, about their peanut races—who could fill a basket first—and how he always lost, because he gobbled up the peanuts faster than he could pick them. He speaks now not in English or French but in Bana, the language of their summers together in the little town far from Douala.

"Oh, my God," says Line, and at last she lets herself believe what she already knows. *Mon frère.* Returned. Charly-with-Line, Line-with-Charly. Both. It is, she thinks, like he has been given back to her by God. This time, she thinks, she will hold on, like she holds on to the picture she keeps in her phone: He's four, she's seven, her long skinny arm popping out of her pinafore, reaching down to wrap up his little fingers, everything about him so small except his eyes. His eyes will always be open windows. She's seven, he's four, and her eyes are sleepy-proud: *Look what I have, look at my brother in his little white suit.* His eyes so wide. He believes in his big sister. He is a believer. Hold his hand. Hold it *tight, tighter,* never let go.

The day Line called Charly, he wrote what would be his last tweet: "When driven by something bigger than himself, Man is not beatable." Then he stopped tweeting into the void. Now he could talk to Line. Line sent him money for a bus ticket, and eight days after he contacted her, he arrived late one evening. Line was waiting at South Station in Boston. She had to be sure that it was really Charly. That all of him was still there. "If I see my brother today," she told her husband, clutching his hand, "I got what I wanted in America."

And then Charly got off the bus. "I'm here!" he called. *My brother*, she thought, and pinched her leg hard to make sure the moment was real. "We catch each other up," she says now. "We catch each other like this." She wraps her arms around herself. "The happiest day of my life," she whispers, whispers it twice.

He returned to Los Angeles. He texted or spoke with her nearly every day left of the 263 days allotted to him, right up to the end, the last night, and then he put his phone down, and he took up the play. *Tomorrow and tomorrow and tomorrow.*

The temptation of tragedy is the illusion of inevitability, the retrospective consolation that it could not have been otherwise.

But it was, for a time, otherwise.

Their conversations were sweetly formal, filled with endearments, *mon coeur,* my heart. They spoke of family, of their mother, of their father, of going home. "Sis," he told Line, "if they ask me to choose between food and going back home—I choose to go back home." They did not speak of the robbery. She knew where he'd been, but they did not need to speak of prison. They did not speak of the halfway home to which he was sent after prison or of Griffith Park, to which he moved for a time. He would not tell her he was alone, because he wasn't, so long as he had his big sister.

And he had a new friend, Jose. Jose had been visiting another friend

in the halfway home, and then he and Charly became friends, too. When Charly moved to Griffith Park, Jose would visit. Jose trusted Charly. He offered him a room with his family, his parents, beyond the city, Jurupa Valley. For five months Charly lived in a room above their garage and worked for his keep; he fed goats, he fed chickens. He began writing a business plan, for a venture he was going to call Okolo'o, exporting Cameroonian crafts once he returned home. He listened to classical music on the radio, and Jose introduced him to the pop music of the previous fourteen years. Charly loved a Coldplay song called "Paradise"; he'd watch the video over and over, a man in an elephant suit trying desperately to get back to his elephant friends in Africa. It was absurd. Charly liked that. His life had been absurd. Together, he and Jose went to the Cathedral of Our Lady of the Angels in the city, listened to its choir, discussed the wonders of its construction, sharp lines that felt soft and soaring, air filled with gentle light. They ate meals with Jose's parents, immigrants themselves. "Papa," he said, thanking the old man. "Mama."

One day he called his father. Isaac said, "Come home," and Charly wept, because he could not. His Cameroonian passport was long gone, and the passport under which he'd come to the States carried the name of another man. Charly Keunang wasn't an American or a Frenchman. His own country did not recognize the ex-con with no proof of who he was other than his memories. *There is a house in Douala, see the big yard in which the children gather? He had been their host, once. Surely someone there remembers his name?* Keunang, Robinet? *Both,* he wanted to say, but he knew that was not the answer.

He tried. Jose drove him to an immigration office in the city. He was undocumented in every sense. They would have to deport him. He dressed to go home. On the street, outside, the two men said good-bye. Forty-five minutes later, Charly called Jose: They would not deport him. His paperwork was missing.

Jose brought him to immigration again.

This time, Charly told him.

Inside, he said, *Deport me. Send me home. I am not an American.*
This time security escorted him out.

He considered urinating on the sidewalk, so that he would be arrested. They would have to deport him then, yes?

Jose drove him into the city for a third time, and then a fourth.

He started smoking weed. He started smoking spice.

"By the end . . ." says Jose, but he'll say no more, because Charly is gone. By fall, Jose had decided that Charly couldn't remain. At first he set Charly up with a tent in a quiet area near a river, not far from his own home. For a while that calmed Charly. He imagined the waters carrying him home. Again he began to plan. Then, remembers Jose, another homeless man sleeping by the river was stabbed. Charly decided he could not live there. Jose was volunteering at a mission in the city. Charly moved into the mission. Then, without telling Jose, he moved out. At some point— Jose's not certain—he found crystal. One day, in October or November, nobody is sure, a man who did not mention his name came with a tent to the two-story cross on San Pedro.

———

At first Charly told himself he'd moved to Skid Row to be closer to the immigration office. He would keep trying. Once he refused to leave the office. They made him. After a while, he stopped going. He stopped meeting with his probation officer, too. People began to call him Africa. He did not correct them. By then, he was flickering; present and gone.

On good days, he liked to talk. Sitting on his milk crate, he drew around himself his small circle of crystal philosophers, men to whom the drug seemed to return—as long as a ten-dollar hit lasted—the power to make sense of the tragedy and comedy that had funneled them down at last to this dusty corner. "Politics. God. History," says James Attaway. "He was a good *comrade,*" says Juju. And then there was the third man: Laru, who would call the police on Charly that Sunday. Because, he'd tell me, there was, hidden in his Bible, a bus ticket home to Minnesota and to his

Jose at Charly's camp in Griffith Park.

infant daughter; and because that morning when Laru and Africa scuffled, over Laru's wrong words to a woman, Laru's Bible fell open, and his ticket fluttered away. Gone. That's why he called the police. Africa would understand. He, too, had lost his ticket home.

To Line, who sent him money, Charly never spoke a word of Laru or James or Juju, not of his tent or his crate or even the cross under which he'd come to live. She knew nothing of Skid Row. He was holding on, he promised, he would never leave her again, he swore. But all the miles between them, L.A. to Boston, all the America in between, it was growing stronger. So he would take himself away from the noise of the street to call her. He would hide in his tent and call.

"When we talked," Line says, "we always talked about God." Charly would tell her, "Maybe we can say, 'God will protect you.'" Charly wanted Line to be protected. From what was, from what might be coming.

Charly always had been a believer. Line was more cautious. A churchwoman, yes; but belief? Her baby brother's first disappearance had taught her how. *He's alive*, she'd think during his missing years. "You can say he's alive when you do not see the body. You still believe." His reappearance strengthened her faith further.

Bonne nuit, mon coeur, he wrote her that last Saturday night.

And then came that Sunday morning. Maybe it was always coming. Maybe it's coming now.

It is.

Open your eyes. You must remember to call Line. You must remember God. *Both.* In the darkness, before you smell the piss at the foot of the cross, the dew on the fig leaves, the spice you don't have, you say the prayers with which you begin each morning. And when your prayers are complete, you are ready. You zip your tent open, and that Sunday begins.

"What did he pray for?" I ask Juju.

Juju seems surprised by the question.

"A man's prayers," he says, "is between him and God."

In Malden, Massachusetts, Charly's mother, Heleine, is watching the evening news. "Line," she calls to her daughter, "you see what I'm seeing here?"

"Yes," answers Line, looking at that awful video—some poor homeless black man, shot like a dog—on their big-screen TV. "I already saw it," says Line. It's Monday now; the killing has already been news for twenty-four hours. She's worried about Charly. He didn't call on Sunday, like he'd promised. Charly always called. She'd tried him in the afternoon. No answer. In the evening, that awful news. Poor man. Homeless. Thank God for Jose, who gives Charly a home.

Tuesday she tries again. "*Bonjour,* brother!" she texts. No answer. She keeps coming back to the story of this man called Africa. They say he has family overseas. This worries her.

The call comes at two-thirty a.m. Her cousin Dorice, calling from Cameroon. "What happened?" Line demands. She won't let Dorice answer. "Why you call me at this time?" Dorice starts to speak. "Two-thirty in the morning!" says Line. "Why do you call me at—"

"*Vois-tu Charly?*" Do you see Charly?

"I say, 'What?'" Line tells me one afternoon in her Malden home. Her recitation until now has been monotone, her gaze fixed over my shoulder. A sturdy woman, until the key turns. The key has turned. It will never turn back. The killed man, Dorice says. There's a mug shot. Charly.

Now it is a month later. The long Saturday between Good Friday and Easter Sunday. In the Christian time in which Line lives, it is the day after the killing, the day the dead don't rise. Her brother came back from the dead once, but there will be no more resurrections. She keels forward. Her voice goes hollow and high like I've not heard it in hours of talking, not even through other passages of tears. "I put my hand on my head!" And she does, now. "She's sick!" she says. She's talking about her mother, Heleine, who's now sobbing. And then Heleine, a regal woman

in a magnificent Cameroonian yellow dress, reaches over and grips her daughter's knee.

Line's daughter, Jaycee, goes to her mother's side and holds her. It's not the hug of a child. It's the embrace of one who consoles. Jaycee is three. Line accepts what Jaycee gives her, and then she nudges her toward Heleine. Jaycee walks slowly into her grandmother's great yellow dress, her pink shirt disappearing. Heleine enfolds her. It's as if Heleine is taking her children back, Line and Line's daughter and Charly and the children Charly will never have, two generations of grief returning to the womb. Back over the ocean, back to the house in Douala, back before he was born, before he could be killed. She takes the gift her granddaughter gives her. The little girl presses her head against her African grandmother's belly. She is three. This killing is her inheritance. Her American story.

———

Charly's body remained, refrigerated, at the Angelus Funeral Home on Crenshaw Boulevard for nearly three months. The family wanted to ship the body to Cameroon, but it is expensive. A family friend made a GoFundMe page, but in two months they raised only $1,346, not nearly enough. So the body waited. One hundred and ninety pounds, seventy-one inches long. "Well-built, muscular, and fairly well-nourished," reads the family's autopsy report. Three ribs are cracked, at least two of them by "Gunshot wound #1." This is the second autopsy, and much has already been done. "Sections of skin are absent," says the examiner of wounds number two and three. "The entrance wounds have been removed." Number three would have passed through the heart. Number four is lodged in the liver. The coroner's study of number five, which hit the left arm, required "extensive dissection." Number six—though they may not have struck in this order—beveled Charly's left wrist.

Maybe number three was the first: through the heart and he was gone. Maybe it was number six, because he held up his arm.

Maybe this matters. Maybe one day we'll know for certain.

What we do know is that Charly Keunang died, shot six times by police officers in America.

That is a fact.

And then came another, a better truth, or maybe just the least cruel truth the facts of the dead will allow: Charly went home. The family could not raise the money, but a donor came forth, and Line and Heleine flew across the ocean with Charly in a coffin. On May 24, 2015, Line and Heleine and Isaac, the father to whose house Charly had promised he would return, laid Charly Leundeu Keunang in his own ground, from which he will never be moved, and they waked him through to the dawn.

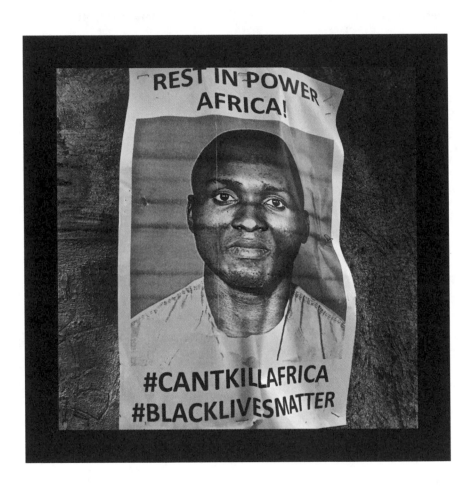

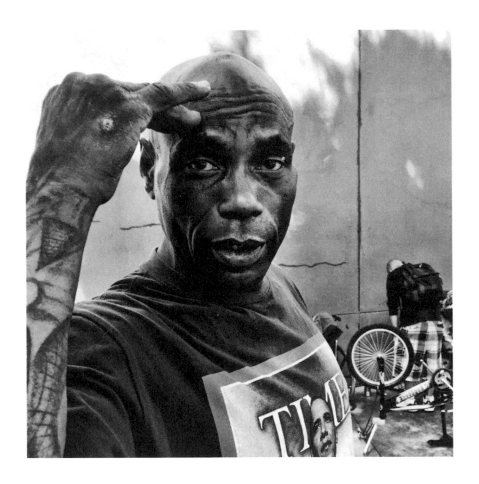

Says he's called Telepathic. Says he knows what I'm thinking. His real name, he says, is Virgil. Named by his mother for the poet. "Like *The Inferno*," as in Dante's, into which the shade of Virgil is Dante's guide. This Virgil is a sweeper. He sweeps Africa's memorial clean.

"Where'd you get the broom?" I ask.

"Where does anybody get a broom?" He edges his around the cardboard angel wings, around the books left out for the dead man. Short, sharp strokes, precise as his clipped words. The sidewalk is clean. As clean as it can be. Virgil throws the broom down and walks into the road. Brain—former gangbanger, a hulk, full 51-50, mind gone, tattoos crawling round his shaved skull—darts out to retrieve it. A broom! Where does anybody get a broom?

Brain takes his back to the wall and sits, tucks the broom behind himself, and then brings it back out across his knees: Brain counts the bristles.

מײַן גאָט שלאָפֿט און איך וואַך איבער אים.
מײַן מידער ברודער חלומט דער חלום פֿון מײַן פֿאָלק.
ער ווערט קליין ווי אַ קינד,
און איך וויג אים אַרײַן אין חלום פֿון מײַן פֿאָלק.
שלאָף, מײַן גאָט, מײַן וואָגל־ברודער,
שלאָפֿן, אַרײַן אין חלום פֿון מײַן פֿאָלק.

My God sleeps while I keep watch,
my tired brother dreams the dream of my people.
He's as small as a child
and I rock him into the dream.
Sleep, my God, my brother refugee,
Sleep, and vanish into our dream.

—Jacob Glatstein, "My Brother Refugee,"
translated from the Yiddish by Ruth Whitman

As We Are

| JEFF SHARLET

Local news. I took this picture and thought it didn't matter. Just a scale. Minimalist? Minimalizing? I understand pictures by the stories I want to tell about them or through them, the way they expand for me into words. What story could I tell about this scale? It's at the back of a store in the town I live in, and I took this picture while I was buying Play-Doh for my daughter. I took this picture of the scale I've passed many times because this time it looked blue and yellow and bright. I took it because the scale is filled with numbers and seems to be opening its arms to share, and because in the bar at its base I recognize myself, sometimes a measurer. I took it because I like crowded pictures, details excerpted from something larger, because of the yellow disk peeking out from behind the scale, because of 3M and Ace, and DeWalt in the corner. I'm in it, too, and if I pushed the contrast harder you might see me—those are my red shoulders, my hands gathered in the center, holding my phone, my face hidden behind the phone's faint reflection. My daughter's there, too, though she's not tall enough to make it into the frame. Also, she's standing behind me. But she's there, pushing a kid-sized shopping cart containing Play-Doh, from which later she'll shape a pumpkin in a pumpkin patch. She'll use a knife to etch in the pumpkin's ribs, and she'll say, "Did you know the more lines there are, the more seeds are inside?"

"Really?" I'll ask.

"Yes," she'll say, holding up a little clay pumpkin, "thousands."

One spring day my daughter sighed and said, "When will I ever get to see Ireland?" I didn't know where her longing came from, but a week later I received an invitation to teach a writing course in Dublin. I accepted solely so that I could appear to be able to grant her wishes. Not long after I returned from Skid Row, we began preparing to move, for a while, across the ocean.

On my shelves I found this edition of *Ulysses*, hardcover, pages stitched, not glued. My mother's. She died of breast cancer in 1989. I opened the book. Out fell a postcard. From my older sister to our mother, decades past: "Dear Mommy, I'm very sorry you banged up your hip. It scared me half to death. Don't worry about the job and concert. Sorry we couldn't come sooner but we were at the library. Love, Jocelyn." I added a shaky "Jeff." My father wrote our mother's name.

They were divorced, bitterly, but he brought us to the hospital. It was the first day of her first real job on her own, working for a publisher. A truck ran a red light. My mother flew twenty feet before shattering against blacktop, her proud beautiful cheekbones splintering, her hip bones and her leg bones cracking into many small pieces.

That was when I learned to read. After she came home from the hospital, my mother was restricted to her bed for a long time. Sometimes she would read aloud to us, but more often she was too tired. One day she asked me to read to her. So I did. *Babar.* I had never read a book before.

I still haven't read *Ulysses*, but I know what it is, the words on the pages beneath this postcard (a bookmark, which may mean my mother never finished it, either) that seem so at odds with a story about a mother. *Bloom surveys uncertainly the three whores, then gazes at the veiled mauve light . . .*

But not at odds with my mother, who never hid a book or a story from her children.

VIRAG

(502) (*Arches his eyebrows.*) Contact with a goldring, they say. *Argumentum ad feminam*, as we said in old Rome and ancient Greece in the consulship of Diplodocus and Ichthyosaurus. For the rest Eve's sovereign remedy. Not for sale. Hire only, Huguenot. (*He twitches.*) It is a funny sound. (*He coughs encouragingly.*) But possibly it is only a wart, I presume you shall have remembered what I will have taught you on that head? Wheatenmeal with honey and nutmeg.

(*Reflecting.*) Wheaten... This searching ordeal. ... a chapter of accidents. ... you said . . .

(*Severely, his nose har...*) twirling your thumbs a... forgotten. Exercise yo... Tara. Tara. (*Aside.*) H...

Rosemary also did I u... parasitic tissues. Then ... of a deadhand cures. M...

(*Excitedly.*) I say so. I ... parchmentroll energeti... with all descriptive par... of aconite, melancholy ... going to talk about am... must be starved. Snip ... neck. But, to change the venue to the Bulgar and the Basque, have you made up your mind whether you like or dislike women in male habiliments? (*With a dry snigger.*) You intended to devote an entire year to the study of the religi...

[514]

problem and the summer months of 1882 to square the circle and win that million. Pomegranate! From the sublime to the ridiculous is but a step. Pyjamas, let us say? Or stockingette gusseted knickers, closed? Or, put we the case, those compli- (503) cated combinations, camiknickers? (*He crows derisively.*) Keekereekee!

(*Bloom surveys uncertainly the three whores, then gazes at the veiled mauve light, hearing the everflying moth.*)

... was never. ... Past is ... was be past

... of the day ... red by the messing ex- Poll! (*His* verb in the ... e hundred ... will attract ... choice malt ... thers. (*He* ... ifully with ... ects follow ... madjum... eenth book ... ion. which ... r. Some, to ... automatic ... d nightsun

BLOOM

... ttome too other day butting shadow on wall dazed ... n and wandered dazed down shirt good job I . . .

[515]

The Museum of Modern Art
11 West 53 Street, New York, N.Y. 10019

Dear Mommy,
I'm very sorry you banged up your hip. It scared me half to death. Don't worry about the job and concert. Sorry we couldn't come sooner but we were at the library.
Love,
Jocelyn

Nancy
Sharlet

Jeff
Get Well!

Georgia O'KEEFFE. *Evening Star III*. 1917. Watercolor, 9" x 11⅞".
The Museum of Modern Art, Mr. and Mrs. Donald B. Straus Fund

I asked if I could take her picture.

"Okay," she said. "Why?"

"Your gray jacket and the pink wall," I said. "Your gray-blue eyes."

"My eyes. Yeah."

I took the picture. I took a dozen.

"Can I see?" she asked. I handed her the phone. She scrolled through. "This one," she said. "Can you make it closer?" I cropped it. "Yeah," she said. "I want you to be able to see the eyes."

The article surprised me. Not "my eyes" *The* eyes.

"The eyes?" I said.

"Yeah. The very ones."

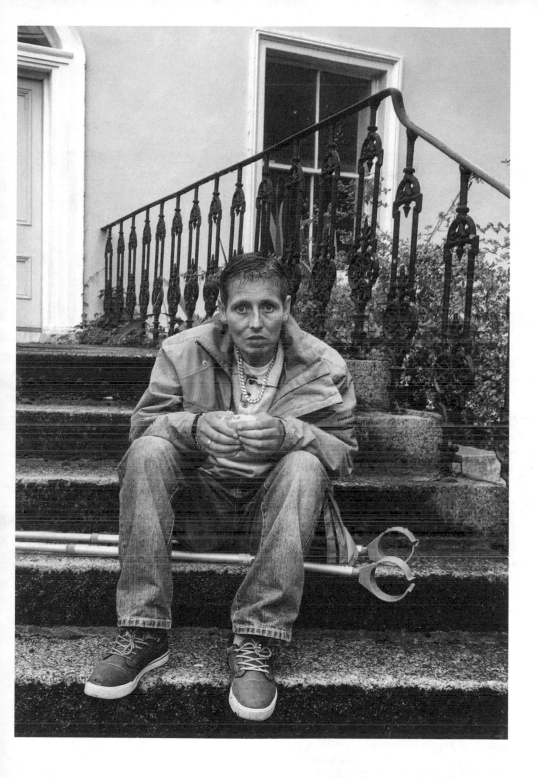

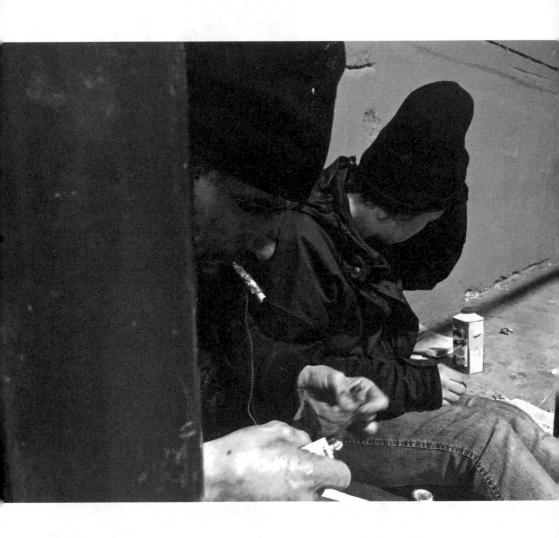

He's smoking heroin from foil, hers is meth on top of a cloudy Coke bottle. Michael's thirty-eight; Siobhan's twenty. He likes me; she does not. He'd like to chat, but she'd like a hundred euros. Twenty? Twenty, agreed. "Who holds the money?" I ask. He takes the bill, hands it to her. "Married yet, are ya?" she asks me. I show her my ring. "You?" I ask. "No," she says. She pulls her bruised face away with bleeding nails, a little bit of red paint still on them.

"She's my sister," says Michael. A Dub voice so low and soft I lean in to hear. His breath warms my cheek. "I'm her brother," he says. I say, "It usually works like that, doesn't it?" He smiles. He likes me, she does not.

Long time sleeping rough, he says. He picks at a black-ridged sore on a swollen hand. They both wear shelter shoes, but shelters aren't right for a sister. "Bad crop," he says of those you'd find there. I look at the half-eaten chocolate bar beside him and the newspaper he squints at when the drugs are in his sister's hands. Their matching black toques, not so much pulled down on their heads as perched atop, like sleeping caps in a children's story.

Michael's the eldest. "She's the baby. I look after her." They say there are six between them, brothers and sisters. Possibly seven. He pulls off his hat, asks me to take a picture so he can see the state of things. "D'ye ever bleed like that?" he asks. I roll up a pant leg, show him my scabbed shin. "Psoriasis," I say. He nods. "Likely that's it," he says of the sores on his skull.

She sets to work on her own head, digging with both hands. She asks to borrow my phone. "To get a place," she says. She gets her man; she has twenty euros, she tells him. He says he'll be round soon. Michael wants to stand. But that right foot, it bends like there's no bone. "Wait," says his sister, half his size and holding down his knee. Then, to me: "Can you leave us alone together now?" Michael says, "Don't make us look bad." I'd never. "Our mother and dad may see this." I nod. He looks down, flicks his lighter. The foil scoops up the flame's little yellow glow and turns his face, his scabs, golden. "Just say us as we are."

Myths say, this could happen to anyone.

—Wendy Doniger, *The Implied Spider*

I asked if I could take his picture. He said I could. I stepped closer, across the band of shit. The pigeons began to frighten. I stopped; I was too close. A cloud of gray and blue and pink and dirty rushed at me. He looked up. Bare of birds. He said nothing. I stepped back. The birds returned. Together they ate, and he said "Now," and I took my picture.

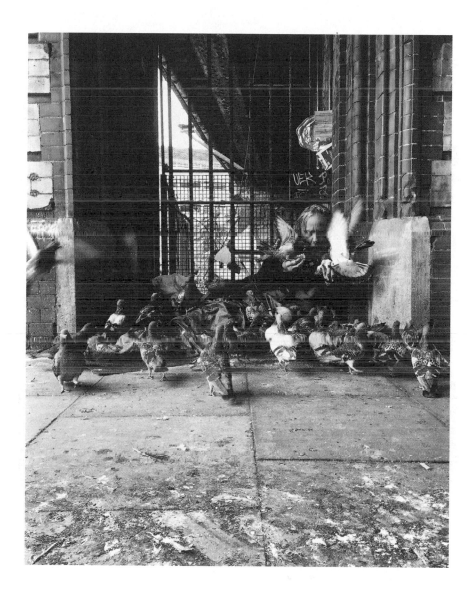

I'm being chased by a man on a bicycle. I know he's coming for me because he's shouting, "Hey, you! You!" I'm the only one in this stretch of the park, walking fast, but he's on a bicycle. Standing on his pedals. Tight Dub-blue hoodie and paint-speckled jeans. "Stop!" he shouts. I stop. He stops. Straddles his bike. "You taking pictures of my house?" he says.

Oh! "I was," I say. He can't believe I've confessed. "You were taking pictures of my house!" I hold up my phone. "I'm a photographer," I say. Half a lie. "You told my mum you fancy our telly." Oh. I did. The older woman, who must be his mother, with a boy who might be his son, had arrived at their stoop just as I took this picture. "You fancy our telly?" she'd asked. "Yeah," I'd said. "I mean no, I just liked the way it glows through the window." She'd said, "Right." I'd said, "I'm sorry." She'd waved it away. Or so I'd thought.

I show her son the picture. He stares. "What's that about?"

"I don't know. I'm a journalist. I walk around—"

He holds up a hand. He gets it. "Okay," he says. "You can't be too careful. Lotta Romanians around." He means Gypsies. Roma. He starts telling me about them: how they pretend to be beggars even as they live in mansions; how they pretend to be Muslims to grift alms from those good people when they go to their Muslim churches on Friday; how they are neither Muslim nor Christian, they are a religion of their own selves; and how they believe their ancestors stole a nail from the Romans and so there was only one for the both of Christ's feet on his cross and for this mercy God gave them a dispensation to thieve. Oh, they are thieves, insists the son. "Drop the eye out of your head!"

"I can delete the picture," I offer.

"Naw. I don't think you're a Romanian!" He laughs. "Not much of a picture, though, is it?"

It's not. But the television—the one perhaps he'd been watching when his mother walked in the door with her tale of a Romanian who'd as much as confessed he'd be coming back for their telly, and would you please go right now and give that fella a talking to and whatever else may need be—it glows.

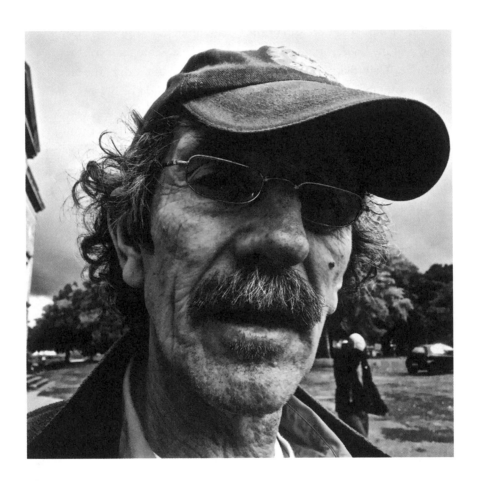

"I'm not a racist," says Aidan, "I'm a plasterer." Which is to say he builds walls. Or, rather, he built walls. Currently he's in between. Between what? I ask, meaning the job no longer his and the one he may yet have. A pint and a stroll, he says.

"I was on TV," he says. Man-on-the-street kind of thing. About the refugees, the Syrians. "Taken our share," he'd said on the TV. He'd like to help, he says, but—not a racist, you know, but the Syrians don't need our help. Not them that are here. Rich men, their money hidden, and they only hire their own besides, and their own do terrible work, not a right wall, and they pay them wages no Irishman could take. And they won't give an Irishman a job. Besides.

We met beneath a stone arch, reading schoolchildren's graffiti: "Miss Law"—the rest of her name obscured by a slash of green—"has the best ass in are school." A conversation starter, that one. We traded our places: Vermont, where I'm from; he'd been to Montana to see a sister. Red car. Irishwoman. Perhaps I knew her? "I'm just fecking with ya," he says. I let that one go. "Been to Chicago," he offers. And he does have a sister in Montana, or did; and a brother in Chicago, or did; and more brothers and sisters back home in Sligo, or did. I lose track of the maladies, dead, dead, dead, that's the main fact, and Aidan's last man standing. If you don't count the brother on his back with leukemia.

Clouds coming up, black and silver, but the sun's last northerly light fills the window of a parked car with gold. I squint. Aidan coughs. We stroll.

"Who's your favorite singer?" he asks. He tells me his: "Mine's Neil Diamond. Best one's 'September Morn.'" He wobbles through a line. "But I don't know where he's from," he says. "New York," I say. "Brooklyn. A Brooklyn Jew." "A Jew!" says Aidan. "Oh, that one can sing. I cannot, I cannot sing. I am a plasterer."

"Rebecca" thinks you'll think her a whore because she works in a massage parlor. She doesn't want to show her face.

You can look at her looking at pictures. She scrolls through her phone, snapshots of her city, Kuala Lumpur, her mother, her brother, her nieces. She takes out her passport. I show her mine. "May baby!" she says. She's May 12, I'm May 7. She's forty-eight; I'm forty-three. "You fat," she says. "And I ugly." She's "ugly" in the terms of her trade because she's forty-eight, and because she's ugly she has to massage fat men. "Big men!" she says. It's unfair. They pay same as the small.

She squeezes her right shoulder. Nobody ever asks if she wants a massage.

I offer to pay for her time, my notebook on the table instead of my body. "No need," she says. I say, "It's only fair," but she shakes her head. "No. Need. You respect me, okay?"

"Rebecca" says she's the oldest single woman in her family; had a boyfriend once; worked most of her life as an accountant; quit at forty-five to study massage; learned about "extras" on her first job; left Kuala Lumpur three months ago; came to Ireland "because, because, because . . ." She doesn't know. She studies English from nine a.m. to one, works in the parlor from one p.m. to nine, walks home, cooks—"Good cook, yeah!"—sleeps, repeats.

"I choose," she says. She's speaking of the extras. "I do not have to." Men ask. They always ask. Kelly, the woman who runs the parlor, doesn't ask. That's how it works: Kelly doesn't ask, doesn't know. Deniability. "Client is boss," Rebecca says. "I am service."

There's more, but we can't get to it. "Truth," she says, looking for the English to describe how much she can say. I draw a circle, divide it, point to the lesser half. Yes, she says. That much. She pushes my notebook across the table and takes my phone, holds it away from her face, considers it with a sideways glance, takes three selfies. "Here," S——, which is her real name, says. These are for me. "For respect," she says. This—"Rebecca," the jungle wallpaper, her gold band, the pale pink of the polish on her nails—is for you, looking.

| JEFF SHARLET

Dark Rooms

Local news, Russian. The news is a mosaic, many small pieces plus a furtive glance. Moscow; but that tells you only the location of the wall on which I found this image. I went there to look for a man who took pictures. He was called "Machete." With his friends, he lured gay men to apartments. There he tortured them. He filmed this torture. Then he posted it online. These videos were very popular.

I wanted to know why he made them. Hate, yes, and sadism, and who knows what sexual delusions. But why *images*? It's too easy to say "hate," to say "pornography." What was he looking for? What did he see?

I went because I'd been looking away. "No more hard stories," I'd told myself. I had children! I should write stories that would inspire them or, at least, give them solace as they grew older, as they, too, learned to see.

One day an editor called. "Do you still write magazine stories?" he asked. I wasn't sure. "Yes," I said, because the truth was, I missed the hard stories as much as I longed for stories to tell my children.

By the time I got to Russia, Machete was missing. In hiding, or maybe just gone. Too crude, anyway, even for a government that agreed with him. In his place the government had passed a new law, banning "homosexual propaganda." What did that mean? Whatever power wanted it to mean. Maybe nothing. Maybe everything. Maybe a beating. Maybe prison. Maybe your child, taken.

Some people fled. I met some who remained. I asked if I could take their pictures.

Banning gays from distributing propaganda to children is not enough. . . .
If they die in a car crash, their hearts should be burned or buried in the dirt
as unsuitable for the continuation of human life.

—Dmitry Kiselyov, director of Rossiya Segodnya,
the state-owned Russian news agency

Zhenya, my translator, and I take a table in one of the club's six small rooms. Zhenya thinks a sour older man in a leather jacket sitting across from us, his face broad and weathered and his eyes small and mean, is a pimp. He's attended by three or four boys. One slips into a seat at our table and tries to flirt. He's too drunk. He slides down the booth to the end of the table, pulls his hood up and puts his head down, and begins snoring.

"Try another one, Zhenya," I say. He ventures over to the pimp's table and returns with a long-necked hustler with bright green eyes, wearing a T-shirt that says "Paris" beneath a cartoon of a big-headed cow on a motor scooter. His name is Nikolai. And the man I thought was pimping boys? Nikolai says he's a producer. "He says he likes how I move." The producer has promised him a part, he says. A part in what? Who knows.

Nikolai says he's done some porn, and when he was younger he fucked men for money, but that's behind him now. "I am too old to find a sugar daddy," he says. He's twenty-five. "Seventeen, eighteen, they get all the fish."

"Do you work together?" I nod toward the boy passed out with his head on our table.

Nikolai blows smoke at me. "I am not friends with alcoholics."

Nikolai first kissed a boy at fourteen, but it took him until he was seventeen to realize that he was gay. He was small in school, and he fought often. He didn't understand why other boys beat him. Then he did, and he learned how to beat them. Such was his coming-out story. This did not trouble him. He liked knowing what he wanted.

The problem was his mother. Gay she could accept, but she wanted grandchildren. She made him a deal: an apartment in exchange for offspring. Two at least. So Nikolai did what he had to: "I married a woman. I am a father!" He beams. He had delivered the goods, a girl, one and a half years old, and a boy, four months. And what was in it for his wife? Nikolai looks confused. "Children?" he suggests.

Once he'd impregnated his wife for the second time, he told her the truth. "She thought it was a joke! But," he says, "my mother confirmed." He drums on the table with his fingers.

"What did your wife do after you told her?"

"Do? What should she do? She has no choice. She is a mother!"

It is probably hard for her, he says. He doesn't know. "She never showed it to me that she cared. Only once. She told me, 'You are a soulless creature.'"

His perfect posture wilts. "Twice a week I meet them," he says. He crosses his skinny arms. "I feel closer to my daughter." He asks Zhenya for another cigarette.

"I don't have long," he says. When he was twenty, twenty-one, he explains, he met a gypsy fortune-teller. I smile, but he does not. "She told me, 'You will have two children, one girl, one boy. And you will die at the age of twenty-seven in a car accident. But first you will be injured seriously.'" He pulls up his T-shirt and tugs down his jeans. A thick welt runs from his pubic hair to his sternum. A car accident, yes, but not the final one. Injured, seriously. His second crash is soon to come. He must live for himself now. It is, he says, a matter of self-respect.

"And the law?" I ask.

"What law?" Nikolai asks. Zhenya explains—the anti-gay law, just passed.

Nikolai scoffs. "I always carry a gun," he says.

The logic takes me a moment. He means nobody can hurt him. Because he has learned how to hurt them first.

Nikolai says that his father, a criminal, recently "found" him on a gay hookup site. He wrote Nikolai that he was coming to kill him.

"I'm waiting for you," Nikolai replied.

He taps one side of his head and then the other, to show the path of the bullet that, one day soon, he says, before he dies, he will put through his father's skull.

"I'm going to Secrets," says Nikolai. Another club. He says it's twenty minutes away. "Will you give me money for a car?" If he'll take us with him. It's around two a.m. and the street's empty, but we flag down an old Soviet rust bucket and Nikolai haggles until the driver waves us in. Then a long ride down small streets and smaller, until Nikolai directs the driver into a deeply rutted dirt alley. At which point Zhenya says maybe we shouldn't be here. *"Da!"* says Nikolai. *"Da! Da!"* I'm looking at his puffy coat. I don't really see where he could have a gun.

We come around a bend. Nikolai says, "There." He points. A small black metal rectangle tied to an iron gate with a piece of wire, "SECRET" written on it in plain English letters. Beyond it, a beat-up parking lot, a study in night colors: a row of fluorescent-lit windows in another building turning the blacktop green beneath a sky the color of cloudy wine; in the corner of the lot a few branches of a leafless tree wrapped in Christmas lights, red as a wound. Beneath it, an open door into what looks like a shanty, a corridor glowing redder. The corridor twists and turns, a big man in a black suit pats us down, leaving no margin of error. Nikolai checks his coat first, so I still don't know about the gun. Then we come around another corner into the club.

And it's wonderful. Three times as crowded as the last one, girls and boys, some of them chiseled and rippling and beautiful, some of them fat and pimply and gorgeous. A banner across the back wall reads, "Secret Lives" in English. Only there was a hiccup in translation, so it says "Secret Lifes": singular—alone, together.

We meet a boy, Kirill, who says he's eighteen and out. "Absolutely everybody knows," he tells us over drinks at a little table on the second floor by the dark rooms. He's built like a giraffe, long spindly legs and an even longer neck, unblinking dark-chocolate eyes. "We don't need gay pride here," he says. "Why do we need to show our orientation?" He's heard of the gangs that kidnap gays, the police that arrest gays, the babushkas who throw eggs and stones. "Everybody wants to emigrate, but not me." He shrugs. "I love Russia."

Kirill says he has a bigger problem: Nikolai, hot and cold. Kirill thought they might be moving toward something, they made out one night on the dance floor, but then Kirill brought a girl with him on a different night, and Nikolai showed his true colors. "He was trying to seduce my friend!" says Kirill. Gay should be gay, he says, or you don't know what to believe.

"Poor Kirill," says Nikolai when he joins us later, speaking in very broken English so Kirill won't understand. Kirill fools himself, he says. "For example." Nikolai spreads his arms and then brings them together, laying his hands on the table. "Boys here tell me, 'I am top.' Then suddenly"—he means in bed or in the dark room—"'I don't have erection. Will you fuck me?'" He wags his finger and returns to Russian. "I don't know why Russians lie."

Well, he does. "It is the fantasy of the beautiful life. They don't have it. They think if they pretend, they can come closer." He grins, his cheeks filling with color, dark as black roses. He says, in English, "I"—he pinches the air, feeling for the word he won't share with Kirill—"lie. I. Lie." He pops his eyebrows and spins a finger around the dim little table, at Kirill and Zhenya and me. "We. Lie. Yes?" He leans back, his tendon-and-bone arms unfolding and his fingers spreading out like bat wings. He holds us all in his hands.

Kirill says something in Russian. "He asks if he can leave," translates Zhenya, but Nikolai has already waved him away.

"Secret Lifes" is a place not so much of secrets as of compromises, hiding and not-hiding at the same time. The twenty-nine-year-old halter-topped-cop go-go girl dancing on a platform lives with her parents, who know what she does for a living—she's a pro in every sense—and accept it so long as when she leaves the apartment and when she returns she's a man. "So long as they don't see me," Zoya says, her hair pulled back after her set to reveal a receding hairline.

We meet by the dark rooms. Where you go to fuck if you can't fuck at home. At first, that's what Zoya thinks I want her for. She has, she says through Zhenya, been "procured." Just as Zhenya persuaded Nikolai to talk with me, so Nikolai has become my fixer. For a price, I think, or maybe two—drinks, of course, and also maybe a cut. He'd seen me watching Zoya. He'd said Zoya wanted to talk to me. That she had a story. But she's a working girl, so time is money. How much? Two thousand rubles. About fifty dollars. I'm to give it to Nikolai. He says he'll give it to Zoya.

He gives her something. She wants to know what I'd like in return. "To listen," I say.

"To listen to what?" she says. This is no radio show, darling.

"To talk."

"To talk," she agrees. She knows about men who want to talk. It's my money, and I've purchased her time. So she tells me. About where she lives. In her heart and in her mind, and the apartment to which, when the sun rises, she will return. Not Zoya but ——, the man Russia requires her to be if she is to survive. She does not want rights, she says. She wants to be Zoya, and then she wants to go home.

We sit in the dim light, the dark room empty. Childhood; awakening; hiding, her parents, whom she loves, the man named ——, whom they love. "Good," she says, in English, "that you don't speak Russian." Good, she means, that this story, her story, is leaving home. English, not Russian. Mine, really, not hers. Zoya will remain hidden. At Secrets she dances in the light, red and blue glinting off her fake badges. Real life, she says, is for dark rooms.

Alex and Alisa

Alex met Alisa not long after he moved to Moscow, twelve years ago, and almost immediately he knew that someday he'd have children with her. Alisa felt it, too. They agreed on it one night over vodka, after a night of clubbing. The party had moved back to an apartment, where they kept drinking, Alisa teasing Alex, Alex marveling at Alisa's brilliant friends. She was a Muscovite, and Alex had come from one of those distant eastern cities, four thousand miles from Moscow, a sprawl of Soviet housing blocks devoid of a decent place to go dancing. Alisa was six years younger, but she was Alex's teacher. She was teaching him how to be silly and modern and free. They drank and danced, Alisa—"Jewish by nature," says Alex, who is as reserved as a Russian can be—shimmying, Alex discovering he had hips, an ass to shake, until they both collapsed around a kitchen table, and drank more vodka, and Alex tried to be funny with shy, sideways jokes, and Alisa thought he was. So she said, "Someday I would like to have a child with you." And Alex said, "I feel the same."

Suddenly they were sober, giddy but clear: They knew it was true. But they had to wait. *To have children is a great responsibility*, Alex thought. *You have to have a place to live, you have to earn, you have to have a partner you can rely on.*

Alex became a manager for the state oil company. Alisa became a doctor. They bought an apartment, a nice one. In 2010, they were ready. But that was the year of wildfire, when flames surrounded Moscow and turned the air black with ash, and Alisa lost their baby boy. They wanted to grieve, only there was so little time. Their best friends, Vasily and Galina (not their real names), were having a baby, too, a little girl, and they lived right next door. They'd bought the apartment so that their children could grow up together, but now there was only Vasily and Galina's daughter, "Olya." Alex and Alisa would love Olya as if she were their own.

Then Alisa got pregnant again. "Emma" was born eleven months after Olya. Olya is three and a half now, Emma two and a half, and they call each other "sister."

Alex and Alisa and their daughter, Vasily and Galina and theirs: two families together, side by side as one. "Normal," says Alex, his highest praise. They go to church together, they vacation together. At their dacha, Alex tells the girls fairy tales around a fire, Russian stories. "This is my nation," he says. At home he sits with them as they watch cartoons he grew up on—"Soviet cartoons are really, really perfect," he insists, though he makes an exception for *Tom and Jerry*. "My wife says that I am crazy—a grown-up person cannot laugh that loud at a cartoon." There's a door between the two apartments that's always open so the girls can toddle between. He thinks little blond Olya looks like an angel. "Oh, Alex," she sighs, pretending she's a grown-up already. Emma's darker, serious like her father. "She keeps her silence," he says, but she watches and she remembers. Both girls call him Papa. The children share a nanny, too, who helps the parents with light cleaning, dishes and dusting, making sure all the family pictures are in place: Alex and Alisa and Emma, Vasily and Galina and Olya, two happy families.

"Our story is a story from Hollywood," Alex tells me late one night, deep into a bottle. He doesn't slur or wobble, his voice never rises, but the wine sets him free. Not as he was with Alisa a decade ago, new to Moscow, giddy and clear. Now he sounds angry. "Nobody," he says, "would suspect us."

Not even the nanny.

Alex's secret isn't that he's gay. It's that they all are, the adults, at least: Alex and Alisa, Vasily and Galina—or Alex and Vasily, Alisa and Galina. The rest of their story is true. Their life together was, until recently, the fulfillment of all Alex had wanted, an ambition that had come to him at almost the same moment he'd realized he was gay. He'd been thirteen, the oldest of three boys and a herd of cousins he helped look after. His parents were workers, good Soviet citizens, kind but too shy to speak to their sons about the intimate details of bodies. So they left a book out, a Soviet version of *The Joy of Sex*. Alex found it, as he was meant to. He read under the covers, studied the drawings of men with women, curious but unmoved. Then, at last, came a short section that seemed to have been written just for him. It was about men who liked other men, boys who liked other

boys. "Homosexuals," they were called. *Yes*, he thought. He was in the book: *normal*. And if he was normal, he thought, then he could be a father. "That," he tells me, "has been my precious dream."

I met Alex—not his real name—through his friend Vlad—also not his real name—a former police officer who'd quit his job rather than enforce Russia's new anti-gay law. He hadn't always been so principled: one of Vlad's early assignments on the force was snooping through a fellow officer's computer files for evidence of homosexuality. "I was just lucky it wasn't me," Vlad said one night at a café.

His boyfriend wasn't so sanguine. "It's Germany in the thirties," he declared.

"Hush, hush," Vlad said. "Not so loud." It's not Germany in the '30s, he said, it's Russia now. And that's a subtler problem.

———

"Something is coming," says Alex. What it will be, he's not sure. He is worried about rumors of "special departments" in local police stations, dedicated to removing children from gay homes. He is worried about a co-worker discovering him. He is worried about blackmail. That is why he's talking: He is worried, and he does not know what else to do. He wishes he could fight, but he doesn't know how. Sign a petition? March in a parade? Alex would never do that now. "My children," he says.

So he has decided to talk. Vlad the cop called Alex, and then Vlad called Zhenya and told us we would find Alex at a certain metro station. Or, rather, we were to go this metro station, and Alex would find us; we would not know what he looks like.

When we get to the station, it's empty, so Zhenya calls Vlad. Yes, Vlad tells us, Alex has been waiting. More directions follow: around a corner and down some stairs into a basement restaurant, Georgian cuisine, a man in a corner with a bottle of white wine. Is this—? Yes. He smiles. We sit down.

He looks like . . . you. Me. Anybody. A man of average height and build, his hair starting to silver early at thirty-seven, neatly dressed. He does not offer to share his wine. I don't think he's rude, I think he's afraid. Not

of us, but of what's coming. It's so big, his fear, this threat, that he forgets his manners.

"This law," he says. "If something happens, it touches only me. And I can protect myself. I can argue. I can provide evidence." But the next law, the one that would take children away from fathers like Alex, mothers like Alisa?

"This is about my child. My baby." If the next law passes, they will leave. They will be poor, but they will leave. They might have to separate, Alex and Alisa and Emma to Israel, where Alisa has citizenship, Vasily and Galina and Olya to any country that will take them. They might have to become the couples they pretend to be. But they will leave, Alex says: "We will leave this country at once." For now they are staying. "We're going to teach them," he says of his two little girls, Emma and Olya. (Those are not, of course, their real names.) "How to protect themselves. How to keep silence."

He has already begun to teach Olya. "She has always called me Father," he says, "Papa." That must stop now. She must never call him Papa again. No, not even at home. "Father can be only one," he tells her. "I can be anybody but Father."

He worries. What if she calls him Papa when he picks her up at school? He must be stern. He can't tell her why. Soon, he thinks.

One day soon he must tell his daughters.

He does not know how he can explain this, to a child, to himself.

"I pray to God," he says, "for the words."

In St. Petersburg, the "Venice of the North," the city center like a bowl of pastel candies, yellow and pink, robin's-egg blue and mint green, Orthodox onion domes rising above like spun sugar, I visit an organization called La Sky, which hosts a gathering called the Rainbow Tea Party. At the Rainbow Tea Party, activists and their friends sip tea and nibble cookies and play board games and celebrate one another's birthdays. There are more brightly colored giant beanbags than chairs, and many rainbows, stickers and pins, and a rainbow plastic-strip curtain covering a little door in the corner.

Outside, La Sky is less welcoming. Its staff asked that I not include its address, but I give nothing away by saying that to get to La Sky you must walk down a long street between a road of fast-moving traffic and a canal until you come to an arch in a building. Through the arch and down a dark alley, until you reach a kind of courtyard, an unlit, empty parking lot, the blacktop crumbling. Cross the lot toward a stand of scrub trees and weeds and take a left down a narrow path. Keep your eyes open: The first step is steep, an even darker set of uneven stairs down to an unmarked steel door. They'll buzz you in. You must be known or come with a friend. And behind

the door at the back of La Sky, the one behind the rainbow-strip curtain, is a club called the Bunker. The Bunker is actually a maze, twisting through the rest of the building's vast basement. It's dark; you have to feel your way through. That's the point: The men who go to the Bunker, many or maybe most of them officially straight men, married men, grope their way into the labyrinth looking for bodies, not faces. They don't want to see or be seen, only to touch, to be touched, in a place where nobody knows them. I bump against shoulders as I make my way through, fingers trailing over mine in the dark, nothing spoken.

At the beginning of the maze, or maybe its end, there's a little bar beneath a string of Christmas lights. There I meet a boy from the provinces who says there is no need for activism because here in the city he is free, he is hardly ever beaten, and a man who says he used to work for the "security apparatus," who says there is nothing to worry about, there are secret gays in the government who will protect them.

But a fat man named Yuri, pink-cheeked and bushy-haired, does not like this topic of discussion. He leans in close, over my notebook. Not threatening; frightened. "No more parades!" he says. "No more marches!" Yes, he would like to have rights, he has been abroad, he has seen how gay people live elsewhere. "But this is Russia!"

He raises his hands, shaking an open palm on either side of my face, making sure I write this down: "I will be beaten!"

He points to the boy, who is giggling.

"He will be beaten. All of us will be beaten! And we will go to the police, and they just smile."

Elena Kostyuchenko

Elena Kostyuchenko knew she would be beaten. It was how hard she went down that surprised her. Not immediately. When the fist connected with her skull she fell, yes, but then she stood again and raised her rainbow flag. The crowd was silent. People's mouths were open as if screaming, but there was no sound. Her hearing was gone. Then the police seized her, and Elena's first gay pride parade was over.

Elena is twenty-six when I meet her. "I'm not very tall, I weigh fifty kilos, I can't overthrow this world," she says. But she is trying. It took months, hospitalizations, five medications, "to widen the veins in my brain," but most of her hearing is back now, and there's a special app on her phone that allows her to jack movies up to 150 percent of what you might consider a tolerable volume. She wears her hair in a short black shag with high spiky bangs, and she has big pale blue eyes that lighten inward. Her voice is droll, her manner deadpan, her presence at first unassuming; I talked to her for a couple of hours before I learned how much violence she's endured since that first Pride in 2011, and she never did get around to telling me that when she was nine she was given up for dead, warehoused in a cancer ward for kids her provincial hospital viewed as unlikely to survive.

She and Zhenya and I meet at dull little café near her metro station. Grayish-pink walls, two TV screens playing Western pop videos from the '80s and '90s and a fluorescent-lit smog of cigarette smoke in which office drones huddle for quiet little meetings on their way home. Elena's a reporter, hard-nosed. "Prostitutes, addicts, these are my people," she says. Sometimes she has fainting spells, but she wills herself to keep standing. "A journalist shouldn't faint," she says. Once she smuggled herself into a city under martial law to report on a covered-up massacre of striking oil workers. In the eight years she's been working for the paper *Novaya Gazeta*—she skipped college and started at seventeen—four of its reporters have been murdered. "I'm lucky," Elena says. She means alive.

She knows some English, but she speaks mostly in Russian. Explaining her view of Russia's rising homophobia, she dictates to Zhenya: "Putin needs external enemies and internal enemies. The external enemies are the U.S. and Europe. Internal enemies they had to think about. The ethnic topic is dangerous. Two wars in the Caucasus, a third one, nobody knows how it will end. Jews? After Hitler, it's not kosher. We"—she waves a hand at herself and Zhenya—"are the ideal. We are everywhere, we don't look different, but we are." She inhales. She's one of those smokers who holds your eyes when she's smoking. Cigarettes disappear into her lungs. She says, in English: "It's our turn. Just our turn." She exhales. She has a pleasant smile.

She met her girlfriend four and a half years ago, at a lesbian movie night in a club. They rode the metro home together, there was an exchange of numbers, and the next thing Elena knew, they were sharing a cabin at a lesbian campground. It was there that they kissed for the first time. Elena liked Anya's seriousness and her broad grin; she liked her earnestness and her calm. Anya was a financial analyst then, but now she's studying law. She has been working on a graph, for her own interest, of the development of various rights in Russia from Ivan the Terrible on. She believes that she can predict the next revolution. Elena likes her girlfriend's theories.

Soon Elena was thinking about a home they could call their own. In Russia, there are no mortgages for lesbian couples. "Then I was thinking, I have health issues. I just wasn't born very healthy. I'm hospitalized once in a while. I can be unconscious, who will come and make medical decisions for me? Then, at one moment I realize, Anya is the one I want to have my children with." That's when she got scared.

She'd reported on pride events. She'd found it pitiful. A mob of hundreds, a handful of queers. She'd complained to her photographer: "Why does nobody want to defend my rights? Why does nobody want to fight for *my* happy future?"

The morning of Pride in 2011, Elena wrote a post on her blog that

would, in the days that followed, go viral. She'd never written anything so popular. It was very simple: "Why I Am Going to Gay Pride." She was going for Anya. They would wear silly T-shirts: "I love her," with arrows pointing to each other. Elena wore a black raincoat, Anya an olive-green one. "I was scared that at the moment I wouldn't be able to unzip my raincoat," Elena says, "that people would somehow feel we were lesbians, that we would be beaten before raising the flag." Anya kept repeating a child's proverb. Something her mother used to tell her when she was scared. "There is a rhyme in Russian," Elena says. "It sounds more beautiful in Russian." She says the rhyme and looks to Zhenya, sitting between us. "You angels go forward," he says softly, rippling his fingers on the table. "We will follow."

There is video of the man who attacked Elena. His name is Roman Lisunov. Elena's flag flickers, and then hurtling from behind comes Lisunov's fist, taking Elena's skull flat across his knuckles, just above her left ear.

Elena is not a believer, but when she was nine, in the cancer ward, she tried to make a deal with God. What she wanted was to walk once more on the boulevard. Just the one outside the hospital. She wanted to go get some yogurt.

Also, if possible, she wanted to be admitted to heaven. Her friend Yulia in the next bed, with whom she'd played a game of plucking flower petals— loves me, loves me not—had gone before her. Elena wanted to follow. She thought if she if she made her request small, God might listen.

"We were scared and we were dying," Elena would recall years later in her journal, sometime in between Lisunov's beating and the attacks that followed. "Why write this now?" she mused. She wanted to remember the children who'd brought the sick girls the flowers, not Roman Lisunov, not the babushkas who shrieked *"Sodom!"* and ripped her dresses. She prefers the flowers; she holds on to the flowers. She will not hide within her anger. "No *fucking* way," she says.

Only it's Zhenya who says it like that, in English, adding italics. She

grins, because what she has said is so much more vulgar. Literally, "No dick," but that doesn't get the half of it. There is nothing outside of Russian, Elena and Zhenya agree, that can capture her meaning—the depth of her determination. "It is so beautiful," says Elena, repeating this vulgar phrase, both of them giggling. "No *fucking* way!" says Zhenya. He slaps the table. Elena applauds. No *fucking* way. It's three, four in the morning, we've been talking for hours, and we're giddy.

No *fucking* way! It's joyous.

———

They caught Elena's girlfriend on the metro. "They know our faces really well," says Elena. "They know Anya is my girlfriend." There were ten. Three surrounded Anya on the escalator going down. A tall man put her in a headlock, then curled his fist up into her face. Once, twice, three times, the fourth, the fifth. Anya counted.

This was after a kiss-in at the Duma. They had been warned. Neo-Nazis had posted instructions online: "The guys, we beat them until they can't stand up anymore. The women, we break their faces." But the men in the metro weren't Nazis. Their leader seemed to be a man named Dmitry Enteo, who leads a fascist "action art" group called God's Will. Like performance art, Enteo will tell me later, only "more real."

The kiss-ins were Elena's idea. She'd been complaining to a friend. "I am tired of standing there with a poster," she said. Well, said her friend, what would you rather be doing? Easy. "Kissing Anya."

Announcing the event on her blog, she wrote, "A kiss only concerns two people. . . . It does not need permission from deputies of the Duma. We do not ask permission." And: "How long should you kiss? However long you like."

She was no organizer. She and Anya were going to kiss before the Duma. Anyone who wanted to come was invited to join them.

The police broke up the first kissing day, at the initial reading of the law in December 2012.

Anya was beaten after the second in January.

She fought back?

"Of course."

Later that day Elena wrote on her blog, "Today two very confident nonhumans broke the bones of two of my friends." She wasn't yet ready to write about Anya. "I'm not going to call on anyone to come with me anymore. But the Duma is pressing the law on January 25. I will be there. If someone wants to stand next to me, they will. There is no fear."

And on the third day of kissing, more came to stand with her. Not just queer people, she says. "There were young guys and girls, very big strong guys, I don't know who they were. When we started kissing, they stood in front of us. A living fence. To stop the attackers. They defended us. I still don't who know they were. I have never seen it before. A guy and a girl, standing just in front of me, protecting me with their bodies."

And the others—the attackers, God's Will—they were there again?

"Yes, of course."

As many as before?

"More."

And the fourth kiss-in?

Elena stubs out a cigarette, lights another. Inhales, exhales. She begins to speak. Zhenya listens. "The homophobes—" he says, starting his translation. Then he stops. Elena continues, very calmly.

"Zhenya?" I ask. He takes out his cigarettes, fiddles with them, puts them down, and looks away.

Zhenya grew up in Vladivostok, learned English from Madonna videos—he began memorizing her songs when he was seven—was beaten, saw his straight friends beaten for trying to protect him, cried "This fucking country, this fucking country." He lived abroad for five years. He met his

boyfriend Igor while working for an international organization called Front Line Defenders, writing reports on the escalating violence in Russia. Not enough, said Igor. Come back, he told Zhenya. You're needed. To fight. "For the motherland," Igor joked, ironic and earnest at the same time. Zhenya returned. To fight; for Igor. Maybe it was love. So hard to say. They never did. Instead they spoke of the struggle, demonstrations, beatings, broken noses.

Elena has stopped talking. Zhenya is still looking away.

To me, in English, she says, "He is crying." She lets him. She laughs quietly. I realize we've been listening to this soft laugh all night. What is it? It is not unkindly. It's stoic, absurd; generous and sheltering.

Later, when I think back to this moment, I have an image of Elena putting her hand on Zhenya's, but that's not possible; he's cupped his hand around his temple, and Elena sits with one arm folded around herself, holding her cigarette with the other.

Zhenya takes a deep breath. With no inflection, he resumes his translation, telling me the story that for a moment, for him, stopped time:

On the day of the last kiss-in, the day the law passed, the mob tried something new. Action art. A mockery. A lesson. They brought their children. Not rocks; their children. The children were their weapon.

Even Igor, who always fought, who maybe likes fighting, a little, was helpless. Who would hit a child? The children, adolescent boys, twelve, thirteen, moved in packs from activist to activist, one by one. It was a day of beatings.

It takes me a moment. "Their kids?"

Elena smiles. "Yeah."

"We couldn't fight them," says Zhenya, finishing his translation. And that's it; he's done. He moans and starts to shake. Elena speaks to him quietly. The only word I understand is "Igor." Zhenya looks up. He snorts a little laugh. "She says, 'Igor does not cry.'" It's not a rebuke; it's permission. Because maybe he needs some permission. People do, from each other. Elena looks at me. She says in English, "You are crying, too." And she smiles. "I think it is because music."

I should mention that Leonard Cohen's "Hallelujah," the long, haunted version Jeff Buckley recorded before he drowned, has been playing throughout this account of the fourth Duma kiss-in. It's a real weeper, that song. If we had chosen this song, you'd have to roll your eyes. But there it is, Buckley's high lonesome tenor and that quiet guitar like light breaking on water, the song we listened to between the words Zhenya could and could not say.

Hymns—and standards, which is what this really is, like "My Funny Valentine," or "I Will Always Love You"—the way they work, when they work, is that they sound like they've always been there, waiting; only suddenly they're breathtakingly, perfectly intimate to *you*. They change the way you feel time. There's a word for this, *kairos*: a moment that returns again and again and yet is its own with every passing. A moment that is always becoming.

Sort of like this: I'd asked Igor who he'd been kissing with his bloody lip and his broken nose, and he'd said, "I don't know! It doesn't matter."

Or like this, something a friend of Elena's said on the way to the Duma for a kiss-in, considering not the stones or the fists but the fact that she did not know who she would kiss, she did not have an Anya: "Kissing there," she decided, "is like praying."

Or this: At the last kiss-in, the day the law passed, an activist named Alexey Davydov wrote Elena to ask if it might be possible to push the kiss-in from noon to one. Davydov was one of the founders of Moscow Pride. At a 2011 protest, police had shattered his arm so completely that he'd spent a month in the hospital. There, say his friends, began an infection that would lead to kidney failure. That was just the problem, Davydov wrote Elena; he had dialysis that morning from nine to noon. To attend he would have to turn off the machine an hour early. Elena wanted to help, "but," she said, "noon is when the deputies will be there." Davydov understood. He turned the machine off an hour early and went to the kiss-in, and the Duma passed the "propaganda" law, and then he became the first person charged with breaking it. For holding a sign outside a school that read, "Being gay is

normal." He hoped to take the case all the way to the Constitutional Court. The propaganda law made it to the court, which ruled in its favor. At least Davydov did not have to see this; he'd already died of complications, thirty-six years old.

And who did he kiss that day in June? What did it feel like? We cannot ask him; that moment is gone.

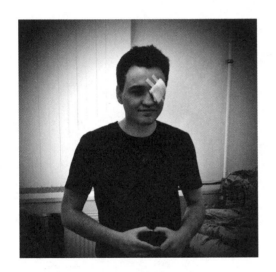

| JEFF SHARLET

Two weeks ago, two strangers rang the bell at La Sky. It was Rainbow Tea Party night. A young woman named Anna asked who was there. "We're looking for our friend," replied one of the strangers. Anna opened the door. Behind her, a twenty-seven-year-old man named Dmitry Chizhevsky—his real name, later he'll spell it for me in the hospital, in English to make sure I understand, "Let them see my name," he'll say—was looking for his jacket. Behind him was a girl I'll call Rose, a few weeks shy of her eighteenth birthday. Rose glanced toward the door: two men wearing hockey masks. "Then," she says, "they started shooting."

Dima: "The first bullet came into my eye. The first, very first." Rose: "I had a thought in my head, maybe I should do something, maybe I should scream." Dima: "I can remember more closely what was audio." *Pop, pop, pop, pop, pop*, he recalls hearing. Five, he believes.

Dima went down and Rose ran and Dima crawled. The men followed, kicking. One had a bat. "A baseball bat, yes," remembers Dima. The men were screaming "Faggot, faggot, faggot," as the bat came down. And then the faggots in the other room charged the men with the gun and the bat and the masks, and the men ran away. Dima and Anna, who'd been shot in the back, inspected their wounds. A pellet gun, they determined. Thank God.

They say you can shoot an eye out with a pellet gun, but that's not what happened. The pellet, a round metal ball four-tenths of a millimeter in diameter, lodged *behind* Dima's eye.

"They tried with a magnet to take it out," says Dima. "But, they failed."

How did they extract the ball?

"A hook."

The doctors told him he was lucky: A little farther, it would have entered his brain. All he will lose is his vision.

"If I wanted to shoot someone," Timur Iasev says, "I would think of my safety first." Which fact is evidence, he says, that he is not the man who shot that faggot in the eye last week. Too risky. Besides, he says, Timur Iasev is a peaceful man. Timur Iasev giggles.

It's late one night at a café in St. Petersburg, and Timur, a translator named Tanya, and I are at the end of hours in which we have been instructed that 61 percent of pedophiles are homosexual rapists and that more than 50 percent of homosexuals in general are pedophiles; and that Timur began the journey of discovery that led to these data points one night five years ago, two a.m., watching what he says were YouTube videos of "girls, young girls," "undressing themselves." Why was Timur watching such videos? He had become a father. He wanted to protect his boy. From the videos? Yes, that's why he watched them. Using a special "tool for developers," he says, he was able to discern that the other people watching these videos at two a.m. were homosexual men. "The analysis of their accounts," he says, "showed that they also watched young boys." Yes, young boys. "Seeking confirmation," he explains, "I learned that psychiatrists say pedophiles don't care about the sex of the children until they're *eleven*."

I sought Timur out to confirm a story I'd been told the night before by a former fifth-grade history teacher named Olga. She said she'd lost her job because Timur, posing as a concerned mother, had outed her. First, he'd sent her a message: "If you don't quit in 10 days, your life will be broken." She'd ignored him. The school's director had wanted to ignore it, too. But there was a complaint. From a "concerned mother." The director had summoned Olga to a faculty meeting. The school, said the director, is like the state. Olga, she said, had shamed the state.

"Is Olga's story true?" I asked Timur.

"Yes!" he says, flattered that his achievement has been recognized. "We usually fire good shots—good informational shots," he says.

Olga was the sixth teacher he's brought down. He tells us the names of the others. He takes out his tablet to show us their pictures. He loves social media. He poses holding up a photograph of Olga he found online. It's a trophy.

He is working on another teacher now. She's going to be fired next week, he hopes. He points to a photograph of a woman he says is a teacher in Moscow. "We have plans for her."

When Timur was younger, he and his friends liked to hunt and beat homosexuals. Once, he claims, he almost killed a man. "Now I wouldn't do that." It is an unpleasant memory. "I am shivering!" he says. Timur Iasev giggles.

More pictures. He's a jeweler. He holds up his tablet to pose for a picture of mine with one of his creations, a bracelet with a giant flower, each petal a different gleaming color. Among his clients are homosexuals, he claims, wealthy men who know his views but respect his art. He tolerates them. "I am not afraid of them," he says. "They are afraid of me."

Today, he claims, he found on social media "a young girl" who was going to go earlier this very evening to a meeting at Coming Out, an LGBT group headquartered in St. Petersburg. He went to the group's office. "I spied on this girl today," he says, "waiting for her to come to the organization." Then he contacted the police, he says, and on his word several officers raided the meeting. He shows me a picture of its ringleaders, a group of middle-aged women. "Guess who's Russian?" he says. He points to one. "The rest are ethnical Jews."

More pictures: the gay activist's office, well hidden in an alley off a courtyard, with no words on its basement door. But Timur knows. Timur says he and two friends took the photographs *after* the shooting, to prove it was an inside job. Look, he says, "thirteen surveillance cameras." He has documented them. "Here," he says, pointing to a picture, "there is a very good camera. You couldn't have gone unnoticed." He points to another. "Can't get past this camera . . ." It is impossible, he says. "No sane person would go there with a gun," he says. "You would have to go there without a mask and put it on there." But this is impossible, he says. He knows it for a fact: "I have blueprints of the building." Why? Perhaps he enjoys architecture, and anyway, the shooting, he says, was staged. Activist leaders had used the man who was shot as a PR prop. They had shot their fellow

activist themselves. To make people feel sorry for them, the gays. Timur won't be fooled. He does not pity the homosexual.

He moves on. He slides the tablet across to me. A picture of an air gun, a pistol, still in the box, on top of it a jar of little metal balls. "Ah—" he says. I take a picture of the picture of the gun. "Look," he says. "Here is my son." A boy, with a pistol.

I thought they were night birds, but Tanya says they're just Russians, whistling at the guard dogs outside the abandoned factory. We're walking down a long dark street on the southern outskirts of St. Petersburg. Timur has arranged for us to meet a friend of his, "Deyneko." Timur showed us a video of his friend, very popular on YouTube, Deyneko beating a gay man. This is the address we've been given. We're confused. Does Deyneko live in a factory? No, no, Timur tells us over the phone. Keep going. You're almost there. Past another factory. Down an alley. The back of a building. Good. You're there. A small plaque by the door. It's a social club of sorts. A far right organization of paratroopers. Good, says Timur. Call Deyneko. He will meet you.

"Wait," Deyneko says on the phone. "Somebody will come for you."

We wait. The door buzzes. There's an old man behind plexiglass. Deyneko? He does not know Deyneko. Wait, he says. "Somebody will come for you."

We wait. We no longer know what we're waiting for. Deyneko isn't coming. We study a large poster: Russian nationalist heroes gathered round an Orthodox Cross. Tanya rifles through her purse, looking for something she hopes she has forgotten. Her Israeli passport. Good: It's not there. Timur has warned us to be wary of "secret Jews."

When the men come they take us into a basement. Wait, they say. Somebody will come for you. Then they lock the door.

The Cossack will begin, he says, with history. "God sends Cossack souls through our blood," he says. A voice cultivated for menace. A barrel of dread. God sends Cossacks, yes, he says. They are his warriors. Do not be frightened, he says. Cossacks are just. For instance: We will not rape Muslim women, for it would be unjust to the half-Cossack child born damned by Muslim blood. And we are creative. "We are famous for our humor," he says. For instance: By rights, homosexuals should be slaughtered. This is tradition. He recounts some of the ways Cossacks murder homosexuals. "Of course," he explains, "I cannot say this officially." He cracks his first smile. But there is something he can speak of. Shit—the medium of Cossack humor. "They like to put their cocks in the ass, so we put the shit on their cocks for them. We smear them." He chortles, waits for me to laugh, glares. Do I not think this is funny?

I try to change the subject. "Tell me about your outfit," I say brightly. He shows me his whip, weighted with a sharp lead block. He puts its thick wooden grip in my hand. "Feel," he says. He unsheathes a wide black blade as long as my forearm. He says nothing about the handgun at his side.

"What kind of gun is that?" I ask.

"A good one," he says. He releases the clip, to show me that it's loaded. He pushes the clip back in. He points the gun at me. Very casual. Just in my direction. Cossack humor. Do I not think this is funny? I lift my notebook off the table. He reaches across to thump it down. *Pishi*, he says. "Write."

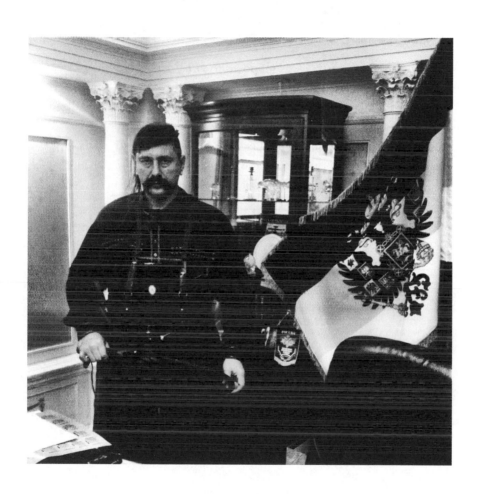

On my last day in Russia I was supposed to visit Alex and his daughters, but I hadn't heard from him; he'd gone to ground. It was the day after the Cossack, and it began with the news that other Cossacks had vandalized two theaters in the night, guilty of showing plays with homosexual characters. One got graffiti; the other got a bloody pig's head at its door. Humor. Then a bomb threat shut down an LGBTQ film festival, and I heard that K——, with whom I'd spent the afternoon, had been beaten by the Cossack's friends.

Late that night I went back to Timur. To ask him about the gun. Timur and a friend, bomber-jacket-wrapped muscle, grew angry, at me and the homosexuals, so angry that the distinctions fell away, not just between me and the gays but between the gays and the old enemy, the Jews. Perhaps I was one?

Timur and the muscle laughed at my silence. They giggled about the bomb scare, and Timur's friend showed off pictures of his fist plowing into a faggot. A man I'd met at La Sky, his face on the screen bright and bloody.

It's time for you to leave, Timur told me. My flight wasn't until midmorning, but I left Timur and went back to my hotel and packed and went to the airport. It was four in the morning. I tried not to think about Timur. I tried to think about a child I'll call Peter.

Peter, Which Is Not His Real Name

I met Peter at Coming Out. He was watching a cartoon. Peter was eight, and he was waiting for his mother, Sasha, to take him home. He invited me to join them. Peter's skinny and pale, with rosy lips and big bright eyes, and he does not like to stop moving. As we walked he played a game he called White Blood Cell, bouncing off us and the walls. Then he pretended to be a bee.

Peter was born HIV positive. He's healthy, but when Sasha met him, volunteering at an orphanage, he weighed half as much as a three-and-a-half-year-old boy should, and his hair was falling out. The only word he knew was the Russian for "Don't do that." The nurses told Sasha not to touch him. They knew you couldn't get AIDs just by touching him. It was love they were concerned with. If he received some, he would expect more. That would not be forthcoming. He was aging out of the ward, and now they were going to send him to another one, one more hopeless still, where he would be thrown in with lost causes of all ages. And there he would remain, as long as he remained.

So Sasha took him. She hugged him and took him. She lied to the orphanage, claimed she was single, and took him home to her partner, Ksenia, and they hugged him and told him they would love him, even though they didn't know him. Six months later, he said the second word of his life: his name. His real name, of which he is proud. It's a fine name, and it fits him. I wish I could tell it to you.

Sasha grew up in a city without a name, one of the old Soviet Union's secret closed military cities, left off the map and known by a number. When the Soviet Union ended, she and her parents moved to Ivanovo, a provincial city of about a half a million. Sasha looked like an elf, with freckles and red hair pulled back in a ponytail, but she was shy and dutiful—until she saw Ksenia, on the day of her college exams. They marveled over each other. Neither of them knew what to call this feeling. They had never heard of lesbians. They did not know the word. When

they kissed, Sasha wondered if they were inventing something. They knew they could tell no one.

But Sasha's aunt spied them together and reported her suspicions to Sasha's mother, who confronted Sasha one night. "What is it you have with this girl?"

Sasha, who had never defied her parents, who had never defied anyone, was speechless for a moment. She had no words. Then she found one. "Everything."

Sasha's father, normally a kind man, beat her. Her mother sent her away. By train, eighteen hours, to family friends in another city, who imprisoned her. They'd been told that Sasha was an addict. They were going to help her get clean. But one day, while the parents were out, Sasha told their daughter the truth: She was in love. *With a boy?* said the girl, excited. *Yes, of course!* A boy. Would the daughter let Sasha out so she could call him?

Ksenia came on the next train, eighteen hours, and for one night they were free, wandering the city until four in the morning. Then the family found them. They locked them up in separate apartments, but Sasha and Ksenia both climbed out of windows to find each other, and then they rode the train home eighteen hours, because they had nowhere else to go, and they spent the next four years pretending they didn't know each other.

The rest of the story—how they left the provinces for the big city, how there everything was different, how they discovered that they could be open—it's familiar. It happens here in America, too. There, in the mid-2000s, it was better than normal. Everything was opening. It was a time not of activism so much as of parties. It was a time not of hiding but of coming out. For Sasha and Ksenia, it was the time of Peter, a time of family.

Peter knows that his mothers are lesbians. What he does not know is that people hate them. He has learning disabilities, so he goes to a special school—I visited it, it's great, a whole room full of bees and dinosaurs and kids playing White Blood Cell—where everyone is different and thus no one is. Two mothers simply means twice as much love.

Or it did. Soon, says Sasha, they will have to tell him. Maybe sooner

than they had planned. One law has passed; another is coming. They are thinking about Finland, so they can stay close to Russia. They are thinking about Russia, and about how they don't want to leave.

Peter is thinking about airplanes. Over dinner after our visit to the park on my last day, he asks me if I'll send him a card from America. I'll do better than that, I say. How about a present. "Yes!" he says. He knows what he wants. He asks if he can borrow my notebook. He'll draw it for me. It's an airplane. A big one, he says, so there's room for his whole family, everyone who loves him, he says happily, drawing the wings.

No story, just the dead, in their tidy rows. Seen from a plane banking over a cemetery, on my way home.

Which Is Not
Her Real Name

"Role of the State / vis-a-vis the Individual," reads the note at the top of my father's poetry cabinet, in which he kept a menorah, the full extent of his religious practice, and a box of multicolored flexi-straws for the grandchildren. Before he retired, he was a scholar, a "Sovietologist," but as a younger man he'd wanted to be a writer, and here he taped poems, clipped from magazines, to remind him of that feeling. "Eurydice," by Tim Kendall, "Telephone Ringing in the Labyrinth," by W. S. Merwin, and on the side, two little poems my daughter said when she was three. "Good people / and mad people / and bad people / and Jewish people / and knockabout people."

Then there's her second poem:

The night I was born
You were born
We were born
We were born together.

"Let's sit on the bench," he says. By the carousel, empty now these fall evenings. He missed most of the autumn, in a hospital bed, his heart finding a new and more cautious rhythm. "Where are the ducks?" he asks. "I don't see the ducks." He studies the pond. "Well, of course, it's dark now." Sedentary behind his typewriter and then his computer for decades, now he strolls the park, counting his strides. He measures his accomplishments in football fields. He's small—five-nine once, an inch and a half shorter now—but he went to college on a football scholarship. "I was fast," he says. "Now, of course, I'm slower." He counts the steps between benches. His favorites are those dedicated to someone's memory. "I wonder who he was," my father murmurs to himself, pausing before a name. "This one's no good," he says of the one we settle on. It has no name. "I'll tell you what it is," he says. "The park is waiting for someone's family to dedicate a bench in his memory."

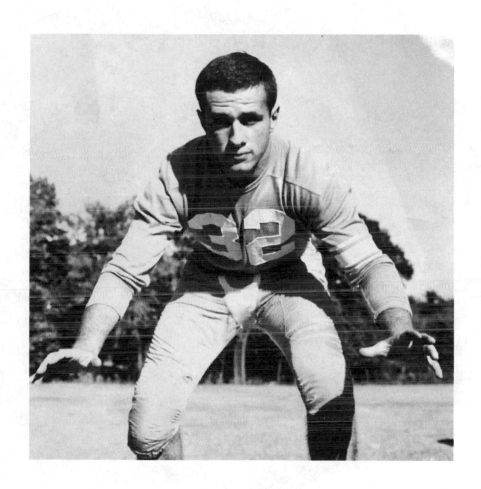

A small brass box lined with burgundy velvet. Inside, my mother's Girl Scout badges. I didn't know she'd been a Girl Scout. She was not, in general, an admirer of badges. But there they are. Kansas, 1954. Troop #283. Red slipper, golden wings, kind of beautiful.

In another box, a letter from my grandmother to my mother. Circa 1986, not long after my mother was diagnosed with stage IV breast cancer.

"Dear Nancy, I keep remembering how determined you've been all your life—like the time I found you on the top of the house when you were only 19 months old—and the time you were trying to throw rocks higher than Samuel Branch, and one hit you in the top of your head, blood running down your face, but you wouldn't stop—and when you got your first bicycle and when I told you to learn in the yard, you took off down the street saying I can ride it!—and the time I took you to the K.C.A.C. to learn to swim and you took off into the deep end swimming, and wouldn't take lessons—and the time you were determined to have more honors after your name in the yearbook at high school, and you did. And many more—so I suppose that's the reason it may have seemed at times that we might not have been as concerned about you as we should have been—we always thought; no, knew, that you were special and unique. I know it's still true, and for what is happening now, we'll just have to accept all the help available and realize there are times we have to moderate our own determination and 'go with the flow.' Now I know you're going to not like that remark. What I pray for most is that the 'peace that passes understanding' will fill your heart and mind all the while you're struggling with the day to day problems—I know how hard it is—but I also know without a doubt that peace is there—just let it in . . . We love you very much—Your Ma"

My window. Roger, my sister, and me, and Nancy, my mother. I don't know exactly what to call her. Had she lived, I suppose I'd still call her Mom, but she did not, and after she died, when I turned seventeen, I spent months reading her boxes of poems and unfinished stories and journals, getting to know her as the adult she was. You can imagine, and you can't, which is as much as we can say of any life of four and a half decades. I was too young to know my mother like that, maybe, but what's too young when your mother's gone? My mother/other-than-my-mother. Mine/her own. In those pages, she's Nancy. When I speak of her with her old friends—when I exchange messages with her friend Roger—she's Nancy. I'm as old now as she was when she received a terminal prognosis. ("Terminal." As if our lives should be measured by train stations.) I'm as old as she was when she was told she was going to die, sooner rather than later, as old as she was when she decided not to believe it was true, and soon I'll be as old as she was when it was, anyway. True.

Even then, she had my sister and me, and her friends. For years—decades—I didn't grasp that. I felt grief for the terrible aloneness of her dying, guilt for what I couldn't give her. And then came my firstborn, my daughter, Iris, which is not her real name, because her real name is hers, not mine. She is her own, just as I am, just as Nancy was.

I realize only now, at the age my mother learned she would die, that we are our own, and we also belong to others. My mother; and Nancy. My self; and Nancy's son. My daughter; and Iris, whose real name is her own, and who gave me this little faded rainbow I placed next to Nancy and those who were hers.

WHICH IS NOT HER REAL NAME | 231

| JEFF SHARLET

I thought they were wild, but I'm told irises rarely are. Planted; invasive; European, mostly, or Asian. But there are natives, too. These, with their ribbed yellow tongues, resemble an iris called the wild flag, which grows from Vancouver to Sitka. How might they have come to this small Vermont valley? First a bulb, then a garden, then flowers, planted; now flowers, wild. Escapees or refugees, invaders or simply the left-behind.

Every foot of land along this road has been cultivated at some point or another during the past 220 years, and maybe much longer. Crops or sheep or swine, or just a pretty field. Maybe before the beavers who turned the field for a time into a swamp, before the beavers were hunted and the swamp became again a field—maybe before the swamp but after the wild, this was a garden. We could sift the soil. Search for a shard, a shell casing. Maybe bird bones, preserved by the still-swampy ground, relics of a funeral conducted by a child, like that of the goldfinch my daughter buried beneath our lilacs a few miles up the road. To find out I'd have to uproot these purple strangers, and there's a mist slipping in from the trees. And because I've been memorizing Yeats's "The Stolen Child" so I can sing it at night with my daughter, who has claimed a piece of the poem as her own— "come away, O human child! To the waters and the wild"—because I've been preserving these words as well, I imagine the mist speaks: "Take your picture and leave. This isn't your field; these aren't your flowers."

I chase the mist, I try to step within. It says, "I'm not your mist."

No. And: "I'm not even my own."

Nothing is. I crouch to pick an iris. For my daughter, Rosy, which is not her real name. But then the mist swells like a whale breaching and disagrees. Field, swamp, garden, sheep and beavers and flowers, people who plant, people who wade through ticks and tall grass as the evening earth exhales. The mist moves. Always. Let the irises be, it says. Pretend that they're wild. Forget where they came from.

Come away, O human child!
To the waters and the wild
With a faery, hand in hand
For the world's more full of weeping than you can understand.
 —W. B. Yeats, "The Stolen Child"

A Resourceful Woman

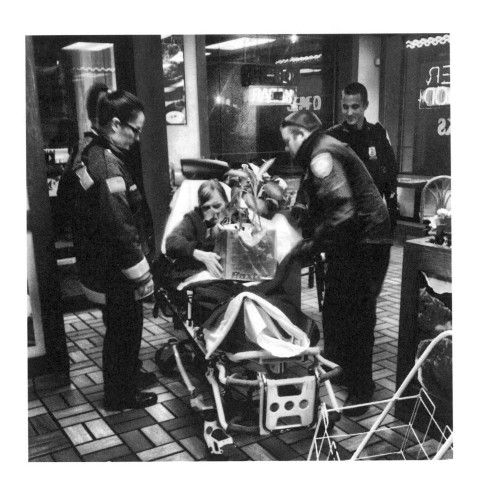

Mary Mazur, sixty-one, set off near midnight to buy her Thanksgiving turkey. She took her plant with her. "He doesn't like to be left alone," she explained later. The plant rode in a white cart, Mary in her wheelchair, traffic rushing past on State Street, Schenectady's most dismal drag. With only one hand to wheel herself, the other on the cart, she'd push the left wheel forward, switch hands, push the right. Left, right, cursing, until a sweet girl found her and wheeled her into Crown Fried Chicken. "Do not forget my plant!" she shouted at the girl. I held the door.

"I have a problem with my foot," she said—the left one, a scabbed stump, purple in the cold. Her slipper wouldn't stay on.

Mary wore purple. Purple sweats, purple fleece. Thirty degrees. "I bet you have a coat," she said. Not asking, just observing. Measuring the distance. Between us. Between her and her turkey. Miles away. "You'll freeze," I said. "I'll starve," she said. I offered her chicken. "I have to have my turkey!" Also, a microwave. Her motel didn't have one.

"Nobody will help you," she said. "Not even if you're bleeding from your two eyes."

Two paramedics from the fire department. Two cops. An ambulance, two EMTs. "I didn't call you!" she shouted. "I don't care who called me," said one of the cops. One of the paramedics put on blue latex gloves. "She won't go without this—this friggin' plant," he said. "You'll go," said the cop. "You're not my husband!" said Mary. The cop laughed, said, "Thank God." The whole gang laughed. One of them said maybe the plant was her husband. That made them laugh, too. "I'm not going!" said Mary. "Your plant is going," said the cop. Mary caved. Stood on one foot. "Don't touch me!" They lowered her onto the stretcher. "Let me hold it," she said. "What?" said the EMT. "The plant," said the cop. He lifted it out of the cart. "Be careful!" she shouted. He smirked, but he was. "Thank you," she rasped, her shouting all gone.

Mary Mazur, sixty-one, shrank into the blankets, muttering into the leaves, whispering to her only friend.

After the ambulance took Mary, I walked down State Street to her motel. The Scottish Chalet. Twenty-four-hour surveillance, front desk behind glass. Ashok Patel runs it. Small man with a smooth round head, smooth round body. He knew Mary. DSS. Department of Social Services. Good business. "They always pay," he said. Sixty dollars a night. Six weeks so far. Thirty-six hundred dollars. "Until they find a bed in a shelter." He thought they gave her food. At the beginning. "Cans." She ate them cold. "We worried," said Patel's wife. "We called her every day," said Mr. Patel. They didn't want her to die at the Scottish Chalet.

The cans were empty. Her stomach was empty. So she put on all her clothes, her purple sweats, purple fleece, purple slippers that would not stay on the foot covered in scabs. She hoisted herself into the wheelchair she'd gotten from Social Services in Albany, after the police broke her old one, the last time they took her to the hospital. She put her plant in her white cart. All she had. Where she went, he went. For six weeks she had gone nowhere. Hadn't left her room once. But she'd run out of choices. She'd even called the police. They wouldn't take her to the grocery. "I have food stamps," she'd told them. "I'm not poor." But they wouldn't listen. There were no more choices. Together, they wheeled into the darkness. They would have their turkey or they would freeze. Mary Mazur, sixty-one, was not going to die in a motel room.

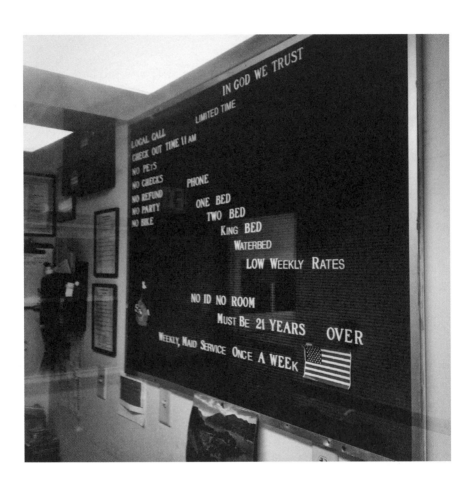

The next day I called the hospital. I wanted to know if Mary Mazur would have her turkey. A Thanksgiving dinner for the patients? Yes, there would be something. For the patients. But not for Mary Mazur, who'd checked herself out into the blizzard. I called her motel. Mary Mazur had returned. And she'd gone again. "Into the snow," said Mrs. Patel. To buy a turkey. "I try to stop her." She'd called the police, but they wouldn't come. They'd had enough of Mary. Her right to freeze if she wanted to. I called a number Mary had given me. Social Services. A woman asked me to spell my name. DOB. Social Security number. "I'm not the client," I said.

"All the same," she said.

"With whom am I speaking?" I asked.

"Emergency Call," she said. Mary Mazur, I said, sixty-one, hospitalized, now likely lost again in the snow. "You need Adult Protective Services," she said. "I work in Child Protective Services." But there'd be nothing "Adult" could do.

"A danger to herself," I said.

"That's hard to prove," said Emergency Call.

I drove into the blizzard. Empty roads, room to slide, but no Mary Mazur. I went to the motel. NO PETS / NO CHECKS / NO REFUND / NO PARTY . . . ONE BED / TWO BED / KING . . . IN GOD WE TRUST / LIMITED TIME. A man came in from the cold. A younger Patel, weight in the chest, the shoulders. The son. "What do you want?" he asked. "I'm looking for a woman," I began. "Crackhead?" he said. "Sixty-one," I said. "Mary Mazur, wheelchair." Her. "She went out into the snow. I tried to stop her." Until she screamed. Then he held the door. "What choice did I have?" None. "What do you want?" he said. He stepped closer. "What are we supposed to do?" Chin to chin. "Should be Social Services," I said. He agreed. "Leave us out of it," he said. "It's not our fault." He stepped back. "I've been here since I was six years old." He stepped back again. "We're just a motel." He turned away. "This place is a joke." He left me standing there.

"It's okay," Kayla whispered to her husband, who reached out through the doorway. "He's a reporter." She turned and smiled. We were talking about Mary. Kayla saw her last. "I immediately seen she wasn't right." It wasn't the wheelchair or the foot or going out into a storm in nothing but a hoodie. It was the plant, its leaves. Mary had taped ripped ones together. "I told her the bus don't run for twenty minutes," said Kayla. "I told her why not wait inside." She hoped the cops might get there in time. But the cops weren't coming, and Mary was going. "Pushing that lady-cart thing," said Kayla. So she put Mary's hood up and wheeled her into the storm.

"Your plant's gonna die in this cold," Kayla had told her. "My plant," Mary had said, "will die inside." Plants need light. Mrs. Patel, claimed Mary, turned hers off.

"It is not true," said Mrs. Patel. "It isn't," agreed Kayla. "It is on a sensor," said Mrs. Patel. "She don't move." Mrs. Patel checks on her every day. They speak through the door. "Because she don't wear the clothes."

A red-faced man staggered up. He grabbed Mrs. Patel. "Excuse me!" she said. "You're warm," he said. "Is he a cop?" "I'm a writer," I said. "Just asking about an old lady." He looked at Kayla. "You?" Kayla pulled her hood up. "Do I look like an old lady, bro?" He stared. "You look really young," he said. "You wanna hang?" He put both hands on Mrs. Patel. "Excuse me, sir!"

"You live here, bro?" Kayla asked. Her door cracked open. Inside, her children, three and five. They live here. "She asked you three times not to touch her," Kayla said, stepping forward. The man wobbled. Forward, back, away. "One twenty-two," he said. "If you wanna hang."

"The problem is the plant," said Kayla. "She's a germophobe." Mary's afraid it'll be contaminated if she leaves. Afraid she'll starve if she stays.

Kayla thought she got on the bus. "When I looked, she was gone." Kayla knew the buses. "She could ride for hours."

I left at ten-thirty that night. This morning, I called. Mary had returned. "Yes, yes," said Mr. Patel. "With a bag of groceries." Something to eat—yes, yes—a cold can, in the dark, naked, talking with the leaves.

At first she'll speak only through a crack in the door. She is not, she explains, wearing pants. "You want to interview me?" she says. "Why? I don't have any power!" She slams the door. Opens it an inch. "What's in it for a little old lady like me?" I tell her I was the guy she met at the fried chicken place. She asks for three forms of ID. "Wait," she says. "I have to wash my hands." After a half hour of murmuring and peeking through the crack to compare me to my license, she opens the door. "You can come in. But you might not like me."

"I bounce around," says Mary. An apartment here, a shelter there, nights beneath a bridge in between. She's lived in the Scottish Chalet, State and Route 7, six weeks now. "Bugs," she whispers. She doesn't want Mrs. Patel, the owner's wife, to hear. Not out of kindness; she's afraid she'll be evicted. "They try to say you brought them." Not Mary. "I'm a germophobe." That's why she doesn't want me to sit down. That's why there's newsprint—pages neatly torn from free copies of *Auto Trader*—folded around the door handle. That's why, she says, she's ashamed. "I-I-I-" Mary has a stutter. "I am," she says, gathering her voice up like an infant to be stilled, "n-n-n. *Not* as clean as I would like to be." She crooks her finger. Whispers. "Come closer." She stands on one foot, the other hardly a foot at all, wounds festering for years now, the scabrous skin that remains red and purple and orange and flaking like ash. She gestures at her body. Her arms are very long. Graceful. "Do I—?" she asks. She wrinkles her nose.

"I was pretty," she says. She was. Look closer. The eyes, what's left of her cheekbones. She's wearing lipstick. Mary Mazur, sixty-one, most of her days in the dark in this room, half-naked, will prepare for a visitor.

Mary Mazur at twenty-one, 1974: her first year on welfare, her first year without her mother. "C-c-c-cancer," she says. Mary Mazur at nineteen, 1972: a mother for the first time. "Jerry," she says. She gave him up when he was—"well, he was walking" is what she remembers. Mary Mazur at thirteen, her father gone. "Nursing home," she says. "Three strokes." She does not stutter when she says his name. "The temper," she says.

Mary, thirteen, just Mary and her mother. "Sh-sh-sh-sh-sh-" She stops, twists her toothless jaw, and with her long, graceful arms waves away invisible things. Her brow lifts, her lips purse, and she says what she wants to say. A voice like a young woman's: "She was my friend."

Mary says: "Her name was—" She stops. She won't stutter. "Her name was Anna May."

"Maybe you better not use that word," says Mary. She means "c——," rhymes with "daisy." I'd quoted one of the cops who'd declared her "a danger to herself" a few nights before: "C—— old lady," he'd said, nervous about touching her. Mary shakes her head. That's not what she is. "I'm one tough bitch. I'm not what they peg me to be." They: cops, Social Services, Adult Protective Services, forty years of ER nurses and landlords and the managers who ban her from grocery stores. And maybe—she won't say it— her mother. When Mary quit school, her mother sent her to a stepbrother, across the country. "She said otherwise they'd put me in a home." They might have. They do things, they really do. The "they" who put her in the motel, the "they" who put on latex gloves to shovel her into squad cars, the "they" she met in bars, the "they" who took her to rooms, the "they" who used to give her rides—"truckers," she says, "the truckers," nothing really bad ever happened, "I never got killed"—the they who took her three children. They put them in homes. They are, Mary says, right about some things. Her children? "I don't have children," she snaps. "I had children." Jerry and —— and ——. She doesn't remember their names.

She's made some bad decisions. "But they're *mine*." She puts up an open palm: "No" to that word I'm not to say. "I am not," she says, "a whackadoodle." Her real problem is upstairs. "These people right here." She points up. Three brothers. "Certifiable ding-dongs." They harass her. Mock her, follow her, try to make her fall down. Nobody stops them. "Not their nanny, I'll tell you that!" Mary says. Their nanny? How old are these boys? She does the math. "They showed up in 'ninety-four." At the last good apartment Mary had. And they've been there every place since. They move with her. Always above. "Like cockroaches." She thinks they're spies. From Welfare. "The question is: Why?" It's the double standard that kills her. "They slide through life, and I'm the one who gets treated like a nut." She sighs. "I know it makes me sound—" We won't say that word. There are other concerns: Footsteps above. "Listen!" she says. "They're here."

"They think I can't do nothing," says Mary. "But they don't know." They: The three brothers she says live upstairs, the three ding-dongs. Her three children—rather, she insists, the children she bore—gone, but some ghosts never leave. "They turn off my lights, they change my channels." She makes her hands into fists. Stands on her one good foot. "Psychos!" she says. "They don't know I'm a fighter." She hops to her TV. Taps it on with a knuckle. Bumps through channels, looking for static. "Snow!" she says. She hits the volume, loud as it goes. Upstairs there's stomping. She grins at her TV. "Hear that?" she shouts—to me, to them, to anybody.

Mary loves her television. She likes Raymond, she likes Don Knotts. She likes horror. "My scary movies," she says. She likes slashers. "Michael and Jason." *Halloween* and *Friday the 13th*. She names her stars in pairs. Above all, Clint and Burt. Burt is the light, the one who makes her laugh, *Smokey* and *Hooper*. "And that one where everybody thinks he's crazy just because he's trying to kill himself?" *The End*, with Dom DeLuise. Clint is the darkness, the one who makes her feel strong. She holds out her palms, a star in each hand, Burt and Clint, and clasps them together, the joke and the revenge. "*Fistful of Dollars*," she says. "*The Good, the Bad. High Plains Drifter. Pale Rider.*" She pauses.

"*Unforgiven?*" I ask. She nods. She likes the end. After Clint has given up his children, after he's accepted what he is, a killer, after his partner has been murdered. "Morgan Freeman," I say. The partner.

She's not listening. "They whipped him," she says. The partner. "Actually whipped him. And when Clint finds out from one of the hookers, the whores, he goes into town. And it's raining. And he rides through the rain. And, ohhh . . ." Her hands over her eyes. The rain, the torches, the friend's corpse displayed on the porch of the saloon. She hears Clint cock his shotgun. "First he shoots the bartender. And Gene Hackman says, 'You shot an unarmed man.' Clint says, 'Well, he shoulda armed himself.' Clint says—" She opens her eyes, black and wide: "Any man don't want to get killed better clear on out the back." They run. Clear on out. "It's beautiful," says Mary.

PAUSE. I forgot something important. Mary told that particular story in pairs—Clint and Burt, her favorite stars; *Pale Rider* and *Unforgiven*, the darkest and most doubting of Eastwood's westerns. And her recollection, her reconstruction, of *Unforgiven* came as a pair, too. I gave one half, the finale, Clint as death, unforgiven, unforgiving, unforgivable. "Beautiful," said Mary. But that's not all she said. "And I like it when all three of them"—Clint, Morgan Freeman, and the Schofield Kid—"are out there on their horses. That part's good."

A gentle scene, sunlight and soft music, and the Kid, he's the comedy, can't shoot straight, a braggart, never really shot a man. And maybe he won't have to. That's the promise of those scenes on the prairie, the three friends riding together.

I think that's what Mary likes about them: the possibility that it won't all end in sorrow, even if you've seen this movie before.

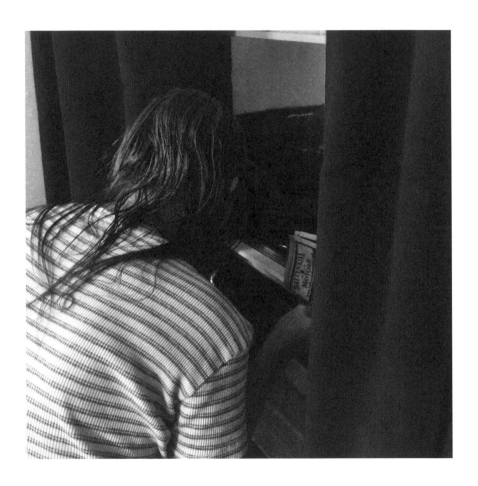

Mary's thirsty. She hops on her good foot over to her refrigerator, which is the space between the screen and the window. "I need my sugar," she says. Nesquik or A&W. "If I'm going to die, I'll drink water." She doesn't like going outside. "I'm a TV bug." She watches and she sleeps and she eats her food-stamp groceries. She tries to eat healthy. Cans. Lasagna. Frozen seafood. "Thaws in a day." Eats it all at room temp. Keeps watching. The Nesquik runs out, then the root beer. Then Mary. "Just my throat. Gets raspy, you know?" Then—only then—water. "Because I still have my cookies." Her cookies, her movies, Clint Eastwood, Burt Reynolds. No love stories—"sickening." Then she eats her last cookie. Keeps watching. "I'm just a bug, a TV bug, a bug."

This is how it began, she says. Nineteen eighty-two, eighty-three, she can't remember. Not long after the last of the three children she bore was taken. "Eighty-two, eighty-three, that's when I got in the system." Adult Protective Services. "It's not too good what I did. You won't think good of me." Her hands fall into her lap, her face goes still. For a moment she's one kind of lovely. Then she flicks back her hair, sends her hands aloft, and she is Mary Mazur, sixty-one, her own woman. "I don't care if I make bad choices!" Her hands whirl, point, shake, conduct. "I don't care a rat's spit! I'm *not* like everybody else!" She wouldn't want to be. "It's my brain I'll do what I want with it."

Watch TV as long as she wants to, all goddamn night if she wants to, weeks if she wants to. That's what she did after her children were gone. Watched, ate, slept, drank her sugar, lived on water. Then they took her away, too. Just like the children. It's been the same ever since. Watch, eat, sleep, starve. She was seven days hungry when I first met her. "I screw myself." She says it with pride, her wrinkles returning, her creases and folds, wrapping around a caved-in grin, one dark eye glaring—the knot she has tied, the only thing that can't be taken. It's what she owns.

Pumpkin pies, Mary's Thanksgiving after the fact, the tub her pantry. "Of course, I can't get clean," she says of her tub's other function. She doesn't like the way she smells. "I'm not stupid. I know how I'm perceived." Every day the motel owner's wife knocks on her door. "To see if I'm alive." Once Mrs. Patel opened it. "Afraid of me dying." Mary was asleep. Naked, on top of the covers. "Just because someone's in their bed doesn't mean you're dead." Mary's not dead. Just dirty, and that's not a permanent condition. She could be clean. She could be pretty. There's a certain store, she knows, with a blue suede coat, "down to your toes!" She caresses her cheek, imagining how it'll feel. She'll wash her hair when she's ready to wear blue suede. She'll put her lipstick on, she'll buy shoes. She has only one right now, a single gray sneaker. She'll buy shoes in which she can stand, shoes in which she can walk out of here. To hell with her pies. She'll leave them behind, she'll quit her wheelchair. She'll walk out of this dump on her own, robed in blue suede. "Pretty as the rain!" She'll rent her own apartment. She'll have a refrigerator. She'll never have to ask the front desk for toilet paper again. Blue suede, faux-fur lining. On sale, $170. She says she put twelve dollars down. Gave it to a girl in the store. Told the girl she was coming back with more.

I wonder who took that twelve dollars. What did she buy with Mary's money?

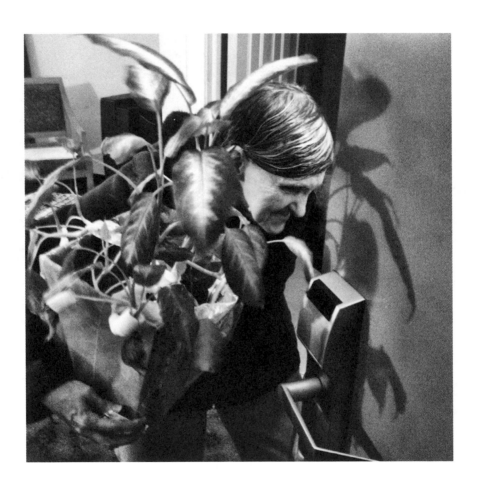

We're going to Walmart. To buy a microwave. Mary has a gift card. "A hundred and fifty dollars. Social Services, that's how they give it to you." The problem's getting there. "You'll drive me?" she asks. I will. "And Bandit?" Her plant. Bandit's been sitting quietly on the bed while we've been talking. Her best friend. They watch TV together. Mary under the covers, Bandit sitting right up by the screen. "Well," says Mary, "Bandit doesn't *watch*." Bandit doesn't have eyes. "But he listens." You can tell, she says, because if the volume's too loud, he turns his leaves away.

Mary's had a lot of pets over the years. "I'm a bird girl." Parakeets, couple of cockatiels. Not easy on the street, wheeling yourself around with a birdcage. "But you gotta love something." Now the birds are gone. For a while she was alone. Then she found Bandit. Or, rather, the plant he was clipped from. At St. Peter's Hospital. "You could see it from the hallway," she says. "Very handsome." When Mary left, a social worker gave her a piece and some soil. "She was kind," Mary says. "Very kind."

Mary doesn't go anywhere without Bandit. "He doesn't like to be alone." She knows he's not a person. "It's a *plant*," she says. She knows that. She does.

"You can't touch him!" I'm trying to help lift Bandit from the center of her bed, where he's surrounded by the remains of her last haul of groceries. She doesn't want Bandit to be contaminated by my touch. He's sick. His leaves are broken. She's been bandaging them. He needs attention. He can't be left alone. I prop the door open with my foot. That's okay. Just don't touch anything with my hands. I pull them back into my sleeves. Now Mary can hold on to my arm. No skin. "I know, I know," she says. She does. She knows how it sounds.

"Bandit," I say as together we hobble. "As in *Smokey and*?" One of her favorite movies.

"No," she says. Before Bandit the plant, there was Bandit the bird. "The bird, *he* was named after Burt." Reynolds, she means. "Bandit"—she smiles into the leaves—"he's named after the bird."

Lost in the dark with Mary and Bandit, searching for Walmart on a cold highway. Snow in the headlights. Mary moans. She doesn't like dark roads. Bad memories. Truck-stop days. She pushes her face into Bandit's leaves. I try to distract her. "*Everybody Loves Raymond*," I say. One of her shows. "What's your favorite episode?"

She thinks. "I don't really remember those so good," she says. "Now, horror, though." We're on the wrong road. "Ask me about horror," she says. Michael and Jason, *Halloween* and *Friday the 13th*. "They both wear masks," she observes. I slow down, pull a U-turn.

"What do you like about them?" I ask. "You like being scared?"

She looks up from the leaves. "No." Her voice gone sharp. "I'm not a little girl! *I'm* not the one who's scared." She likes being the one who's not scared. She likes being the one who scares. Scary Mary.

"Oh, it's dark out here," she says. "You ever been out alone on a really dark highway?" I have. "I mean really dark?" Sure. "Like so dark you have to take any ride you get?" No. "I have," she says. California. Florida. "Georgia." She shudders. We're on the right road now. Walmart, glowing blue and white, parking lot nearly empty. "Bring me in close," says Mary.

Right up to the door. Her choice of motorized shopping carts. She carries Bandit with one hand and hangs on to my arm and hops on her good foot from cart to cart, studying seats, until she finds the right one. Bandit up front. She wishes there were a seat belt. There isn't, so he'd better hold on. Mary is off. Full speed. Laps round the lobby. Like Burt-as-Bandit, in his black-and-gold Trans Am. Nobody can catch him. Nothing can slow Mary down. There's a speed bump at the help desk—the Walmart gift card through which her caseworker holds her on a leash is worth $50, not $150—but Mary keeps cruising. She has food stamps. The card will get her what she needs. A microwave! She used to have one. She'll have one again. Tonight's the night. She has the card, she has me to carry the machine. "Let's go check them out," I say. "We will," she answers. No rush. So much to see. "I like the light here," she says. She likes the space. "Room," she says. She stretches her arms condor-wide. Warming up. Grips the handles. Ready to roll. Past the jewelry, beaming like it's hers. Past the Christmas sweaters—"Looks great," she says of a blue one with two snowmen. Past a stock clerk who fails to answer her questions about chocolate milk. "Nice boy," she says, but he doesn't get it. Here, Mary chooses. There's no caseworker, no motel lady, no stalker ding-dongs. No ghosts. Here, her money—stamp, card, cash—is as good as yours. She's as good as you. Maybe better. "I'm a shopper," she says. Here—with a thousand constraints—she sets the terms.

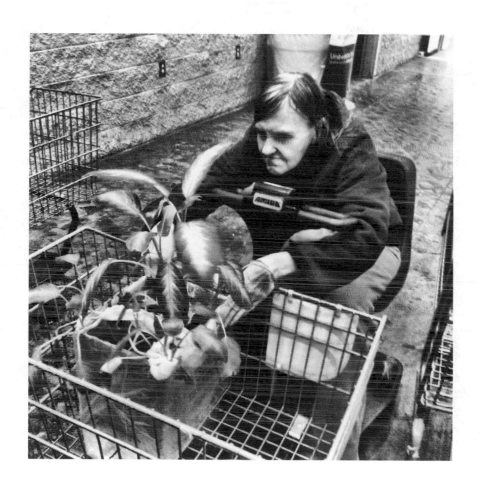

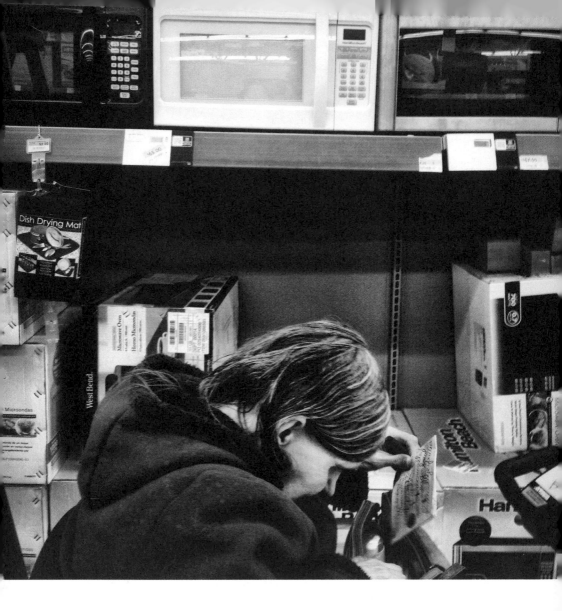

Mary's microwave brand is Sunbeam. That's what she's looking for. A big one, big enough for her frozen lasagna. "They're all big enough for lasagna," I say.

"No." The microwave she's looking for must be correct. White.

"Here's a white one," I say. No. It must have a clock. "They all have clocks, Mary." No. Not like the clock she's looking for. And big buttons, too.

"I know what I want," she says. She does. I can't tell her otherwise.

"This one's fifty-five dollars," I say. "I'll spot you five if you want it."

"No. You can give me five dollars if you want, but I'm not taking that microwave." She flags a stock clerk. "Sunbeam," she says. He smiles. She frowns. She doesn't mean him. Not a very bright man, thinks Mary. "S-S-S-" she says. The first time I've heard her stutter in hours. "*Sunbeam*," she says. The one that belongs to her. The one she's thinking of. "You're supposed to have everything," she says.

"I don't think we have a Sunbeam," says the clerk. He pauses. Takes in the fullness of Mary Mazur. The plant. The plant's bandages. The slick shine of her hair. Her foot. The wounds. The smell. It's rich, the smell. As complicated as her condition. Sweat and shit and dust. And lasagna. Frozen food thawed at room temperature over days, and the smell of what remains in the ring of cans in which Mary sits in the darkness, and flies, maggots if she's too tired to clean. It's always hot in her room, must be over eighty, but Mary smells cold, too. What does cold smell like? Like Mary Mazur. The clerk takes a big breath—that's what I did, too, the first time, it's what we do when we encounter a human being around whom the veil of the world is very thin—and he does not turn away. *He does not turn away.* He doesn't smile, either. Maybe he's not so dumb after all. "I get it," he says. "You gotta have your Sunbeam." He doesn't offer to find it for her. He can't. They don't have one. He's not selling. This isn't his store. He just works here. She just shops here. We're just three bodies amidst the things, and there's nothing we can do now about the choices that aren't offered.

I left her there after midnight with cab fare. As she wished. Bright lights, warm air, nobody making decisions for her. For almost twenty-four hours she glided down aisles on her motorized cart, selecting and discarding and asking questions, dispatching clerks in search of her needs and desires.

When we speak next, I ask her what she bought. "You'll never believe!" A coat? "An aquarium!"

A fish tank, plus ten fish, calico fantails, $2.39 or $2.49 per, she can't remember. Pinky, Cleopatra, and Beauty. Ten fish, three names. "That's all I have." Namewise, she means. "It's all I want," she says. They're gold and black and silver, "and orange and red and blue, and oh, I've never seen colors like these! D-d-do you want to see them?" Her stutter, so far reserved for talk of her dead mother and her long-gone children. It's big, inviting someone over to see your aquarium. Especially when you've spent most of the money you had in the world to buy it, and you can't afford all the supplies, and one fish has already died—"She wouldn't eat!"—and the water is murky, and you love these fish as much as you love anything outside of a plant and a television screen. As much as you loved your three parakeets, who were named Cleopatra, Beauty, and Blue Jay, because Pinky is no name for a bird. And the fish are named for your three little parakeets, who died because you did something you shouldn't have. It takes you a while to say it, eyes downcast—"I fed them pasta," you whisper, dry pasta, it expands, "I didn't know"—and there were three parakeets, so there are three names. The parakeets are named for—"I don't know where the names begin." Three fish, three birds, three children.

"I'm saving her," Mary says of her dead fish. "I'm not ready to let go." Bandit, the plant with bandaged leaves; a fish that no longer shares the name Beauty, dead in a box for days. "I don't let go so easily anymore." Take a picture, she says.

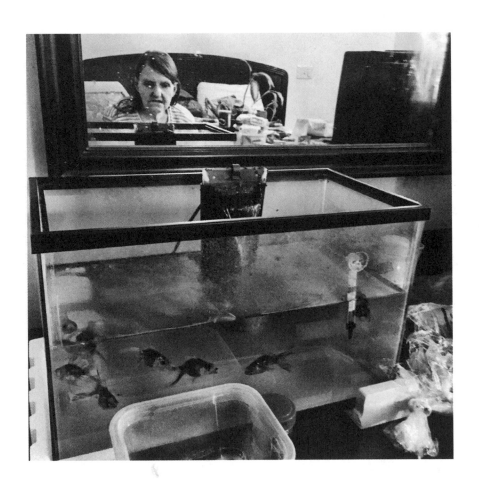

So I take a picture: the fish and Mary Mazur, sixty-two; Christmas was her birthday. It was a Thursday, and she was hungry, because by then all her food was gone, and her fish food was gone. "If you don't eat, you're going to be starving." Two more days before she could go shopping, and that might be why her fish died. She doesn't know. She can't remember its name.

She sprinkles the body with water when she feels sad. "I do stupid things," she says. "What I did was wrong." We're talking about the birds now. Not the parakeets, one of the cockatiels: Bandit, for whom her plant is named. What Mary did was ask someone to take care of him. The cockatiel. A woman who seemed kind, who drove her to another Walmart and returned her to a different motel, two motels before this one. When that motel told Mary to leave, she asked the kind woman to take her bird. It would be cold where Mary was going. The kind woman took the bird, but she did not take care of him, and Bandit died. "It's my fault," says Mary. "I was in the street," she says. "I didn't have anything." But she's not talking about Bandit now. She's talking about Jerry, her baby. She wanted to keep him warm. Nineteen seventy-three, seventy-four. She can't remember. A boardinghouse, but Mary was leaving. Why doesn't matter. She was leaving, and the baby was in the carriage, and the landlady—"that fat bitch!"—called somebody, "the cops, I guess," and then Jerry was gone. "I was the mother!" She can't remember how old he was. She remembers standing alone. She remembers the empty carriage.

They brought him to see her once. Knocked on her door. Mary didn't answer. "I didn't know who was there," she says. "It could've been anybody." He'd be forty-two now. "Like you," she tells me.

I'm not her son. She knows that. She does.

She knows that he's gone. Jerry and the two she can't name, the two they took from her before she left the hospital. "My children," she says. The first time she's called them her own. She should not have let them take her babies. "I didn't know," she says. "I didn't know. I wasn't as smart then as I am now."

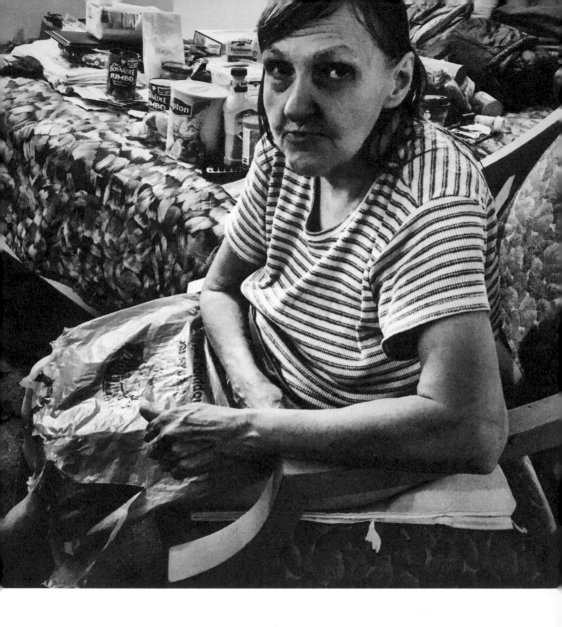

Now, rape, says Mary, that's something she knows. She says the first time she was raped, she was thirteen. "A punk," she says. "Sandy-haired." After that? She counts on her fingers. There was her uncle, of course. "He nearly killed me." She was seventeen. And the truck stops. Her fingers unfurl, one hand then the other. But the number she settles on is three. That seems right, she says. Something like that. She's lucky, she says. She's heard there are some women, they get raped, they never recover.

"Maybe I'm just seeing something that's not there," I say. "Well, there's three kids."

Mary nods. "Three."

"There's three parakeets."

She grins. And three Bandits: Burt, Bandit the bird, Bandit the plant. Mary giggles. It's girlish, this sound. There are the three names for the nine fish that remain.

"And there are three people upstairs who haunt you."

She stares. Her mouth splits open. The heat within her seems to be escaping. I can smell it. We listen to the fish tank bubble. Three ghosts. Three fish. Three birds. Three rapes. Three children. She composes herself. She's smarter now than she was then. "I see what you mean," she says. "The curse of three." It should be six, she says. "Like the devil. Three sixes." She stops. Three sixes. "There's still three!" She gestures up with her eyes. "Yeah," she says, "there's three of them." The three brothers she believes stalk her. "Well, four, with the bitch." Their nanny. "Well, there were three kids I had," she continues, then stops. Four, with the mother.

We watch the fish. Cleo, Pinky, and Beauty. "I'm a tough bitch," Mary says. Twice. First to herself. Then to me. "I'm a tough bitch," she says.

She tells me to stand in the corner. "Face the wall." She's going to get up. She doesn't have pants. She's wearing a plastic bag. "You're not my boyfriend," she says.

I stare at the wall. She has a job for me. The trash. I'm to put it in the lobby.

"Turn around," she says. She's arranged it in three piles. The maggots are contained. Easy to carry.

"Are you sure you're ready?" she asks.

"I am."

"Take it away," says Mary.

One last picture for Mary. "Oh, I know a little something about fish," she says as I peer into her tank. "And I've never seen colors like these." I show her this picture. "Oh, that's Beauty," she says. Could be. "She's special."

She is.

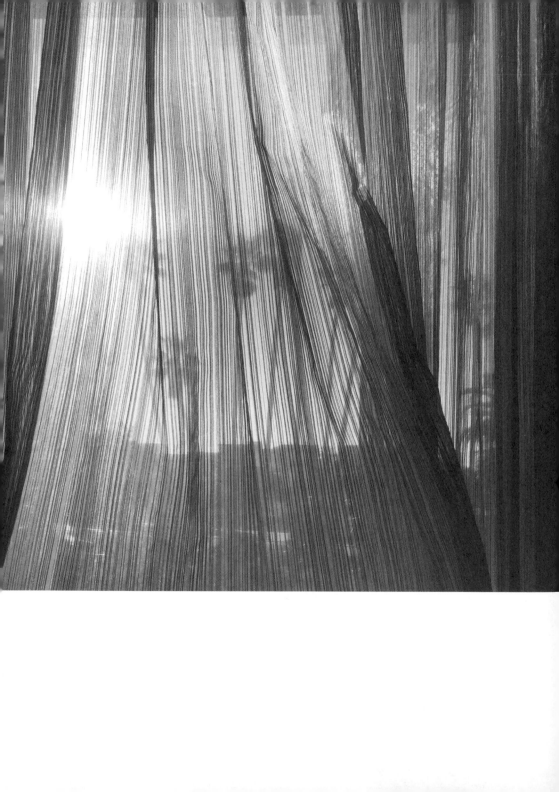

Says She Wobbles

Local news. Structures tumbled downstream by last year's flooding said to be a blight on the region, though some appreciate "odd angles." Fifteen pigs and eight cows burned alive last night in South Royalton, and barn-burning season not even begun. For sale: "Princess, floor length, white, sparkly, $15." Sentenced: Debra Bristol, 49, mother of four, twenty months federal, for selling a fatal dose of heroin.

Prosecutor doubts the justice of the conviction. But, but, but, he says, tumbling back: to a mother's addiction: to pain pills: to the prescription: to a surgery: to a car accident: "the seminal event," he says.

E. who takes in cats, tells the story of a neighbor's farm, recently burned: An old couple, in their 70s, mother and father to many children; unhappy souls. The old woman used to be a town clerk. Retired, now, and a drunk; so, too, the husband, of whom she is not fond. Comes a night not long ago when a state trooper, making rounds of Vermont's little no-cop towns, spots the farm burning. In front, in his truck, the old man. Naked. Says he only had time to get out; not for clothes. "Anyone else in there?" asks the trooper. "Well, she probably is," says the old man of his wife. "She was sleeping. Didn't wake up." He had not called 911.

The trooper peers. Through the flames, he spies her: Unconscious in a chair. What to do? Meantime, a son has arrived. E. says he hates his father but loves his mother so he takes a wooden ladder and props it against the burning family home. Up he goes. So, too, the ladder, in flames. But the trooper pulls the old woman out, chair and all. Saves her. And the son leaps to safety, and the father is naked, and unashamed.

No charges filed.

The old woman and her husband are living together again. A trailer, nearby. E. sees her from time to time in town. Says she wobbles.

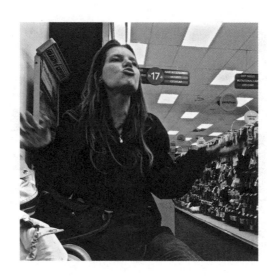

Only pharmacy open on Christmas. When I arrived a man was shouting at a pharmacist and Hope was the heart of a knot of three doped-out dudes, asking Hope her age. "Guess! Guess!" she said. They couldn't. "Thirty-six!" she said. She said it again. A man of roughly the same vintage, a star tattooed beneath his left eye, nodded to the youngest man, strawberry-blond and blotchy-faced. "He's, like, twenty," Star said. Star's phone rang. Some back and forth, and then he delivered the news: "He says he has twenty Klonopin for five dollars each." "Let's go," said Like-Twenty. Each hugged Hope in turn and shuffled down the aisle.

Hope's toes drummed. There was a free blood pressure machine, so she stuck her arm in and waited. Good news. "I'm not dead!" she announced. Then she said it to me: "I'm not dead! I should be!" Hope's woes: gluten intolerant. Not celiac. Her brother's celiac and that's different but she could control it with chocolate. Dark chocolate. If she didn't control it the wheat would build up and it was a fucker. She'd had five kids and the wheat, she said, was worse. Than childbirth, that is. Also, she had back spasms. She fell out a fourth-floor window once, and she'd been pregnant, and she'd had back trouble since, which was also definitely worse than her five children, one of whom she delivered without drugs because, she said, they wouldn't give her any. "You want to find your blood pressure?" she asked. I slid my arm into the cuff. "Now I'm gonna make you laugh," she said. "I could tickle you!" She didn't. "Are you alive?" she asked. "Did I make you laugh?"

She was just out of jail last night, Christmas Eve; so was her husband, a domestic thing, bullshit. Something about day-care bills. Also something about a food stamps card, her good one and her bogus one, and a bathtub, stolen. I didn't ask. Her problem was her husband. She needed to find him. Down at the Saw Mill, maybe. Biker bar on South Ave. She was going to walk. I gave her eight dollars. "For a cab," she said. "For a cab," I agreed. Her number was up. A bag of prescriptions. She asked the pharmacist if there was anything else. "Under that name?"

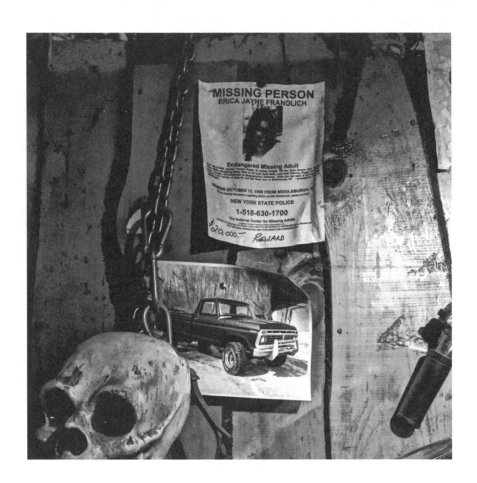

Twenty-thousand-dollar reward, never claimed. Erica Jayne Franolich, given a place of honor above a full Harley and a skull and beneath the bras at the Sawmill, Schenectady's last biker bar. Missing since October 13, 1986, married mother of two little boys, for months nobody reported her gone. Foul play, the state troopers suspect, but all they could say as fact then was that she was wearing blue jean overalls; and that she had a mole on her left knee; and that her two front teeth "protruded," by which they meant buck, though you can't tell in the picture. She was twenty-six then, she'd be fifty-nine now. She was one hundred pounds then, likely much less now. Even the missing persons websites that remember her are decaying.

I ask Arnie, vice-president of the Death Risin MC, why she remains.

"Dunno," he says. Says they looked, but they did not find. No body, no sign. He shrugs. "Nobody took her down."

There are things, Hilda says, "about which I cannot speak." Then she speaks of them. At first, standing in the doorway to room 116, at the Scottish Chalet, then, after an hour, standing inside, by the light of the television. "I'm nearly fifty," she says. "I watch the news. I know what goes on." She does, but what goes on is not on the news. What goes on comes in beneath the door, through the cracks in the walls, roaches, mice. What goes on is the smell of burnt rubber, coming up through the floorboards of her next apartment, from the couple downstairs. Hilda doesn't know how to name the smell. She's never touched a drug not prescribed. Is it crack? Meth? She doesn't know. She asked the couple: What is that smell? Politely, she asked. "I am always polite," she says. *Leave*, they said, so she did, and that was 2013, the last time she had a home of her own.

She's lived on couches and in motels and flophouses. She knows what goes on. She doesn't want to be near it anymore. Needles beneath her feet and the strange gunk in the radiator and the sounds of the woman next door. "I'm not gonna talk about it, what they did to her!" But she does. The woman next door. "Fragile," says Hilda. "You get fragile." She feels it, too, but she locks the doors and she keeps to herself and she doesn't trust anybody, but then she does and she tells me about the woman next door at the Twins motel, "fragile," mentally ill, maybe she thought she wanted it, but nobody could want what she got. "I can't think of it!" cries Hilda. She can't not. "Moaning," she says.

I say, "Somebody was hurting her?" "No," says Hilda, then: "Yes. No. Yes." She shakes her hands around her ears, blocking out the sound. "Lascivious," she says. It was at its worst when Hilda couldn't hear the woman, or maybe that was the least worst, when the woman couldn't even make a sound Hilda could not name. Hilda doesn't know. This isn't her life. But it is. "It could be yours," she said. "It's mine."

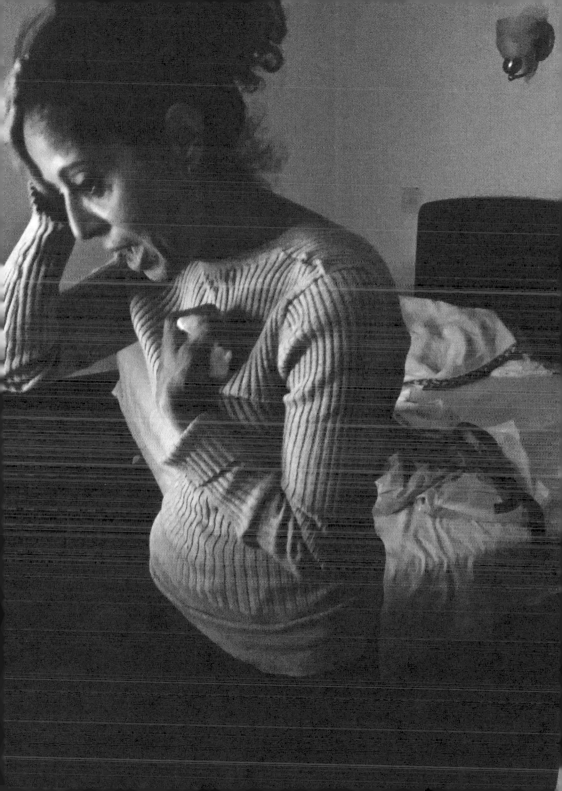

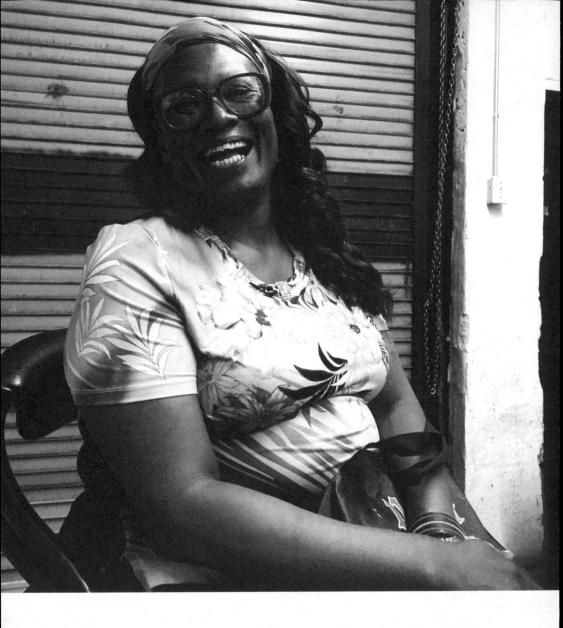

It's five a.m. Paige apologizes for calling at such an ungodly hour, but she needs to know: "That article, honey, did it ever come out?" She means the story about Charly, a man some cops held down and shot six times, muzzle to bone. She means the one about Skid Row, where Charly lived, where Paige lives. She means the one about Mecca's store, where people gathered at ungodly hours, for blessings, or songs, or jokes. Paige came for it all, brought it all. She shared it with me. Blessings, songs, jokes. Grief and anger. Almost none of it made it into the article. She knew that. Or she had known that. This isn't the first time she's called. She calls every other month or so. To ask about the article. She calls about the men who are after her. She knows they're following her. She apologizes, because she doesn't want to get me involved. "It's not for you, honey, you couldn't handle it." She can handle it. Most of the time. Not all the time. Then she calls. "That article, honey?"

Paige is a trans hooker. Her terms. The men who follow are clients, for whom she's grateful, and police, for whom she's not. She says she's been arrested twelve times. She says that police sometimes demand sex. She says sometimes they follow her. "I'm not afraid of the police," she says, "because you know what? I was raised in the country and I was raised in a good family and I know how to read and write and I don't have to be afraid of a fucking police officer, 'cause half of them, you know, half don't have a four-year education. They're just a band of bullies. If they didn't have each other, I would take one on and work them out. I'd have them eating out of my palm, 'cause that's how they are. You motherfucking miserable ass white boy." She's talking to the cop. She knows I know. This isn't the first time she's called. "I will wear you out. I will WEAR. YOU. OUT." She dreamed, she said, of strapping a bomb to her bosom and walking into Central, the precinct's police bunker.

I offer to send her the article. She says no. She does not want a paper trail.

"You go back to sleep now," she says. "Good night, honey."

Then I came to a story I couldn't write. So I texted a friend.

Jeffrey Sharlet:

skimming through Skid Row photos looking for something there's Alice.*
Never wrote her story. Don't think I told you: One day I get to Mecca's shop
early, around 5 am, which is just late for Mecca, to see the cardboard trucks
come round and take people's box beds. Mecca's got an 18 year old girl there—
got lost on Skid Row. Alice. She shows me her résumé. Bussed down from
Fresno, I think, to find her favorite music star. Can't remember his name.
She'd been fucked by who knows how many when Mecca and Prophet Chris
found her. She'd ask young dudes, "Are you So-and-so"—the rapper she loved—
and they'd say, Sure, and then she'd let them fuck her. She was, you gather,
crazy, actual 51-50, out of an institution, getting along, functioning, but then
God told her to go off her meds and now here she was. Mecca and Chris held
her in Mecca's shop—her garage—and went thru her phone. Found her mother,
called her 3 am.

A Neumann:

Damn

Jeffrey Sharlet:

I get there at 5 am, there's a conference about what to do. Easy, I say—I'll
buy her a ticket to fresno. But we need to sit with her till the bus leaves. Then
we walk the mile to the bus station, me and Alice. I get her a ticket. We sit in
McDonalds and I look up her rapper, who it turns out doesn't live in LA but
Atlanta, she asks me where Atlanta is. Then she has to go to the bathroom. Ok.
I consider—I can piss faster than she can, so I go, too. And, of course, when
I come out she's gone. I spent the rest of the day looking for her, got a cab for
an hour so I could roll up and down streets, but I never did find her, and I
can't imagine what became of her. Or, bullshit, of course I can—I could look
in any direction in Skid Row and see what became of her: Men fucked her till
she wasn't fuckable and then spice and then crack and now, likely, she sustains.
This is how you get to Skid Row. I never did write it because I couldn't. Such a

* Which is not her real name.

sap. But here's the thing. I look at the Alice pictures this morning—all blurry crap pictures—and it gets me in the chest, and I think, What a sap, any social worker has a million of these stories. And then that gets me, too—"a million of these stories" isn't really, you know, consolation. It's like an ocean and our seemingly stable lives are little boats we mistake for land. Thanks for letting me rant. Better get back to writing.

A Neumann:

Yes, keep going.

Jeffrey Sharlet:

Maybe I use this one somewhere in the book instead. I must still have the ticket somewhere.

A Neumann:

Yes. It's a better photo than you think.

Jeffrey Sharlet:

Thanks. She was middle class, or working class. Had a mother who tried to help her. Good student. Sort of a case for why you should say no to drugs: Everything cracked for her in 11th grade, I think, when she first tried weed. Of course, obv, she had other issues—she said she was schizophrenic—but it was like the weed activated it. Her mother put her through all kinds of programs, and some worked, and she got a job as a clerk, and was going to try to go back to school, but then, God spoke, and then Skid Row. That's why this book is so much about [my daughter]. I don't have the words: The fear that comes with the love that as soon as you have a child you can lose the child, that you can do all the right things and still it won't matter. That's Jared, the dude with the tattoos, whose mother found him on my Instagram, and then lost him when he OD'd. They tried. Dunno if I can.

A Neumann:

You can.

Jeffrey Sharlet:

Man o man the longer I think about this, the longer I linger instead of going forward, the more I see the problem with the way stories pile up in your

head, too many stories of all the things we've seen. They don't just haunt you. The haunting, that's just the outer shell. They give you futures as well as pasts. Look at your daughter and see Alice or Jared. You realize just how fragile everything is. Instead of standing on land you realize you're on a boat, and it's a small boat, and the ocean is all around you, and the best hope is just to stay on the boat, because there is no land.

Maybe we got it all backward: we die, then we live?

—Kevin Young, *The Grey Album*

I Take My
Little Picture

ANOTHER MIDNIGHT DRIVE across the mountains, first the Greens, then the Adirondacks. Todd Rundgren on the radio, "I Saw the Light," 9N near Lake George, 1972, says the DJ, the year I was born—when the red taillights in front of me blur left, revealing another pair. One driver thinks he'll pass another. Impossible move. Across the double lines, around the curve, the glare of white light oncoming. Double red, white, double red, and for a second I flash back to J. G. Ballard's novel *Crash*, the alleged eroticism of machine smashing into machine. I read it when I was eighteen because I thought it was cool, but I didn't get it. It was just pulse and metal and flesh, the fantasy not so much of the crash but of "this immense motionless pause." That was the line that returned. A frozen moment, red and white, all electric color. I get it now. It's gorgeous.

Then one pair of red taillights swerves behind the others and the white lights pass on by, and I need a breather, and here this is, genocide kitsch, "efficiencies," "honeymoon suites," off-season, parking lot empty. So I leave the car running and the door open and because it's upstate New York, next on the radio is Zeppelin, no kidding, "Stairway," and I take my little picture.

Q drives an ambulance, so he wasn't really interested when just after midnight we came upon a city block taped off for an accident. He'd seen it before, knew nothing good comes of seeing it at all. But the cop at the end of the block drew me in. Whole block taped off, just one cop. Fat guy drinking Diet Snapple. Leaning against his SUV. Bit of a chill in the air. Decided to sit inside. So there was nobody at the tape, nobody on the street. Like a movie set, after the shooting. I walked down the middle of the road. Nothing to see but police tape. Tape on both sides. Tape around cars like presents wrapped in yellow ribbon. Tape around trees. Then, middle of the block, the crash. No bodies, no blood, no people. Just cars, or what had once been cars. Now they were beyond such categories. Beyond physics, it seemed. I studied it. Like I'd been given a problem to solve. I couldn't solve it.

After a while, the cop told us to leave. Said it was a crime scene.

Around two-thirty we found ourselves, by accident, back at the crash. The tape was gone, a few banged-up cars sat slightly askew from where their owners had parked them; there'd be surprises in the morning. Only spray-painted outlines remained, like chalk around a body.

I looked at Q. Something about this felt different from gawking. Maybe. I took a picture: There'd been a wheel here, and part of an axle. That was a fact.

"You'd be amazed at the ways bodies survive," said Q. He said he'd seen bodies—people, alive—pulled out of arrangements like this one. "So, you know, maybe."

Let's call that a fact, too.

Two days ago, a fat red fox stalked our two and a half acres on the edge of our neighbor's untended 170, hunting our marmalade tabby, Nina, right under the afternoon sun. Our dog, Frieda, who is a red coonhound puppy from Mississippi, barked the fox away. That night the fox skulked along the road and in the dark took our neighbor's last rooster. The rooster died bravely, said our neighbor, squawking and alarming and leading the fox away from the hens, down to the road, where it lost its first flight of black-and-white feathers, and then farther, where another bed of feathers become a home the next day for an orange salamander. My daughter, Bithiah (not her real name), and the neighbor girl, Phoebe (nor hers; their names belong to them and these dirt roads), set the feathers afloat in a crisscrossing stream, running from one side of each culvert to the other to see them glide out from under.

Phoebe wanted to show us the rooster's body. It lay among purple wildflowers, red and open and meaty where the fox had taken its head and shoulders. She poked a stick in and hoisted it up. She said, "A puppet." Bithiah nodded. She'd been learning about elephants in school, and ivory, and how wrong it is to kill an animal for just one piece, tusks or feathers. "That's good," she said. "You have to use all the parts."

The stick cracked. The body dropped. My little boy pointed to an ant on the open neck. Bithiah said that was good, too, and then the kids walked home for strawberry popsicles.

I went down to the stream at five this morning. When I was Bithiah's age, my grandfather Irving gave me a hard yellow rooster spur, a souvenir from a cock fight about which he said nothing. Until I was ten, I thought it a totem. I wanted one for Bithiah. Maybe just a picture. But this morning, the rooster was gone. He'd done his job again, the rest of him filling some other creature's belly.

I picked up a feather and dropped it on one side of the culvert and then ran to the other, waiting for it to flow out from under. It never did. Just the water and this day's pale white light of dawn.

First I smelled it, and thought my own car was burning. Then I saw the black column. When I came around the bend, I saw the flames. Later that night the police would confirm what we, staring, believed: There was somebody inside. But the police said the responding officer had tried to rescue that somebody, unnamed, and this was not true. I was there before the officer. He did indeed screech to a halt and jump out of his car and sprint toward the fire; he was indeed brave. But he stopped well short of the wreck. There was nothing left to save. We thought there was a body inside not because we could see one—we could see only fire slicing through metal, wrapping around tires and inching forward in the grass—but because a man said so, a crying man, a wreck himself, tweaking maybe, but he made himself talk to the officer, one hand pinning a shivering arm to his side. By then the officer had stopped running (back to his car, down into the ditch, out into traffic, anywhere he might do something). By then he knew there was nothing for him to do but listen.

The cop looked like he was about twenty-two, twenty-three. There was no call to be ashamed. But later, his superiors shamed him, by claiming for him a heroism that wasn't his, that wasn't possible.

The first picture I ever took was of a fire. I was, I think, seven. A friend and I were riding our bikes when we came upon the senior home in our little town, burning. Already a crowd. I raced home to retrieve the camera my grandfather had given me, and pedaled back furiously, and that was my first photograph; like this one, it was grainy and inexact, and I did not know when I took it why I did so.

Sensation? Yes, in the barest sense of the word. An impression. Sensation is what's possible when seeing won't change anything, when you don't know enough to bear witness, when all you have is the fact of your eyes, the fact of the camera: a record of things, seen and unseen.

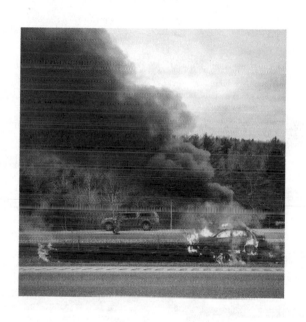

| JEFF SHARLET

Yesterday I posted a snapshot of a burning car, and last night I dreamed of a crash; this morning my daughter, who's six, told me that my dream came from the smoke of the wreck I saw on Tuesday. In the dream, we'd moved to Schenectady, the burned-out city in which I spent Tuesdays and Thursdays and every other weekend with my father until I was sixteen. Then my mother died, and I moved across the river to Schenectady full-time. "Full-time." A term denser in meaning than its ordinary application. Grief filled me with a sense of time like an ocean, not a line on which we travel but a volume in which we're submerged.

Since I've been driving, on a weekly basis, over the mountains from Vermont to Schenectady, in the dream I knew that when my landlord and I went for a drive (I don't have a landlord) and skidded across the ice-slick grass of empty lots on a street of abandoned houses, we were on Summit Avenue, or I was on I-89, watching the car burn, or I was in 1989, on Eastern Avenue in Schenectady, thinking of my not-long-dead mother as I eased, unseeing, through a red light, into an intersection, into the path of—. I remember the car, not the one that hit me but my mother's car, spinning, barely 360, but it felt like circles within circles.

In the dream the car punched straight through a condemned house and came to a stop atop the cliff of Summit Avenue. Then, as in a cartoon, the car tipped backward, our eyes goggled, and down we went. Seat belts. "We're alive," I told the landlord. He wasn't sure. A feeling crept up his legs and into his mind and he started to scream. The ambulance took a long time. But they were good when they came, they gave him a drug and drove him away dreaming, and left me to walk home, up the hill, along the crumbling sidewalk, past the old houses with their things turned out onto their frozen lawns, for sale or for taking.

I stopped to take a picture. Two men approached. "Give up the phone," one said. I said, "But I have so many pictures of my kids!" They sighed and began to beat me. One held a wrinkled piece of paper. It was a script, for this moment between us, and I knew it mentioned a knife, so as we

grappled I patted him down and I found it. "I've got the knife!" I shouted, and even in my dream I heard myself echoing a cop who helped kill Charly Keunang. I wrote a lot about Charly, but my words couldn't help him, and in the dream my words couldn't help me; so I plunged the knife into the back of the man pinning me down. I wrenched it out and drove it in again, retching at the discovery of how much the body shivers up the blade. The men fled. I got up. I took my picture. I walked home. I told my family what had happened. My daughter said, "You were gone a long time."

This Brilliant Darkness

FOR TWO YEARS I've been walking into the tall grass to take snapshots of this field at the top of the "crooked mile," a winding hill road that leads into the shallow valley of swamp and stream in which my house stands, just past the sign that reads, PAVEMENT ENDS. I use my phone. I want the rough eye. The note. The diary. The record. The document. This time, this moment, unplanned.

This moment: paused on the drive home from another trip to the hospital. One of many during the past two weeks, after two heart attacks, or maybe it was only one, rising and falling like a tide, across thirty hours. It began in the clock tower, as night fell, as I wrote what I thought were this book's last words, "You were gone a long time." And then, I almost was.

I'm told the pain can be instantly alarming. Not for me. I had been hitting snooze on this pain for months. Maybe years. Doing so was easy. It was only an ache, or sometimes a ripple, weak as chamomile, never sharper than nettles. That is, I did not know it was a heart attack. Then, just after midnight, my chest began to fill as if with heavy water. My breath was cut into small and ragged pieces. I was being pressed, as if by a hard hand, back into the rocking chair, in which I sat until dawn.

The second heart attack didn't begin until evening. By then I was in the hospital. I would have known what was happening even if I hadn't been. It was obvious. I was dying. Doctors hovered above. "I'll be all right, won't I?" I asked. One said, "We'll do the best we can." I thought he hadn't understood, so I asked again. Again, he said, "We'll do the best we can." I thought, *That's the wrong answer.* But it was the only one they had.

This place: this field, not mine, once a swamp, now just tall grass and a low hill and the weather, a sky filled with water. Wetlands, wet air, the sea we breathe. I trespass quietly. I take my picture. This place, this moment, unplanned.

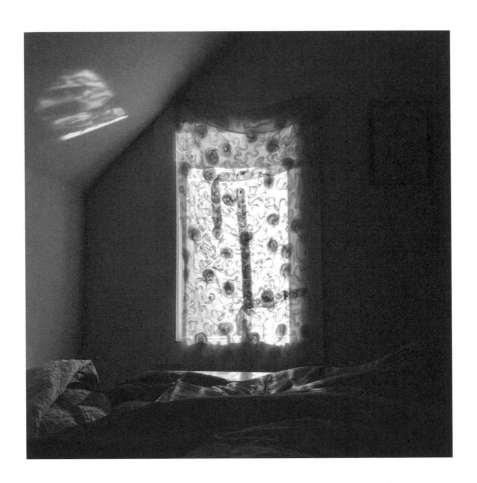

Before this room belonged to my three-year-old, Edgar (which is not his real name), it belonged to my daughter, Terra (which is not hers, either). She made this curtain with tacks and duct tape when she was four. We hadn't bothered to cover her window, thinking she might like to sleep by the light of the moon and wake with the sun. We hadn't considered the pines, which whisper.

Now, for a while, the room and the curtain's soft light belong to me. This low bed is good for recovering. I like the framed collection of four-leaf clovers my wife hung beside the window, beneath each one the date on which she found it as a girl: May 1, 1980; June 1, 1980; July 9, on into summer. I was eight in 1980, and I remember arguments about Reagan and Carter and the Russians, and nuclear war, the threat of which seemed to hum beneath the noise of our lives.

One night when I was in the hospital, I woke in the dark in the cardiac wing and looked past my toes to the light of the door, open like a book. In the hall, a nurse's face glowed with the light of the telemetry monitor on which she watched our hearts. I took a picture. I posted it with a note about the smells and shapes and sounds of the hospital, my neighbor gently snoring. He was a dishwasher who loved his job; he liked to tell the nurses about his co-workers, "old hens" who would, he said, cluck over him when he returned. He had been washing dishes for sixteen years, ever since he'd stopped driving, because of depression, because, he said, "you don't ever know what you might do." He said he was happier just walking.

The next morning, two police officers came to my room. A report of picture taking: not allowed in the hospital. I apologized and deleted the post. It's pretty scary, this world. The trees, the whispers, the pictures.

Night walking through snow-covered fields. Waiting for the words to return. Not sure I need them to. Even a snapshot of the dark-that-isn't-dark-at-all might be more than I want to set down. Never before in my life has just being here—with the fox and the doe and the owl, with my pulse and my fears and the frozen air hot in my throat—felt like so much.

Cold, my friend Q reminds me, does not exist. Cold is not a presence; it is an absence. It is the name we give to a void from which some measure of heat—the measure we desire—has disappeared. There it is, the heat, rising up from the hill. What does it lift from the trees? Up and away, south along the river, drifting or blowing according to mood. Our moods—that is, our inclination to name the movements of air with the eddy of a lazy *f*, *drift*, or the plosive declaration of a pompous *b*, *blow*. Either choice or any other, they're ephemeral as the vanishing heat. The movement of air has no name.

"Why did you write?" Q asks, using the past tense to indicate the state of the present, in which I don't, at least not as much as I did before.

"All the usual reasons," I answer: ego and art and anger and money and joy. Joy most of all. A pleasure likely no greater or less than that of some of the other men I met in cardiac rehab. Before our heart attacks, we were a builder, a mailman, a restaurateur, a writer. Now we are patients. Patience.

"Because it made me feel alive," I tell Q. "It was like electricity sparking out of my fingers."

"That can't be good for your heart," Q says. He's joking, but I wonder: about adrenaline and cortisol, sugar in the blood, fight or flight, the inflammation of vessels, the inflammation of words into sentences; the violence of naming, the fury of order.

The other name we give to the absence of heat is death. These are, of course, relative terms. Somewhere there may exist a state of absolute zero, -459.67 degrees Fahrenheit, but this is referred to as a "theoretical temperature." And death, we know, is simultaneously a presence and an absence, an event and a cessation. I won't say beginning and end; what little thought I ever had of an afterlife rose off me during the heart attack, like vapor, and drifted away.

What to call the absence of something that was hardly ever there? Not any kind of certainty. It's an emptiness that feels alive. It needs no name.

That morning, as I ran, a streak of pain floated down from my shoulder and into my left arm. It lingered. I felt in my pocket for my tiny jar of tiny pills. I kept running—three miles, four. At five the pain was gone. I wiped the sweat off my face, and my hand came away red. Blood. Winter air, dry air, nothing suspicious about a nosebleed. Unless your body itself is suspicious. A suspect, an unreliable narrator. A telltale, a ticker, *tick-tock, thump-thump,* minutes, seconds, the beat, there it is, the number of days.

I rubbed the red against the grain of my fingers. They're a tell, too. Who I was. The skin of him, anyway, too much of it now, wrinkled and loose. Who I was: a fat man. I liked being a fat man. I liked filling space. Now the fat of me doesn't fill the skin of my hands.

I pressed my red fingertips together; they flattened, stayed flat when I spread them apart. These days, these nights, they take the shape of whatever it is they last held: a glass, the steering wheel, each other.

I drive past the field, kids in the car. "Is it night?" asks my son, M., who is three and likes to verify. "Almost," I say. What to call the blue that pours into the open space of the day's collapse? Snow blue, dusk blue, storm? Each an ink washed over the other, bright as blood beneath the white sky that morning, before the snow began to fall. Color that contains its own light. Like your blood on your hands, when you're thinking maybe it's a symptom. When you're listening for the words, the right ones. When you're coming to terms.

Or maybe the terms will come to me. I look for a fat man's face in the mirror, but I no longer see Irving, my father's father—his jowls, his lips, his junkman's gaze measuring the odds. Instead, Ruth, my mother's mother, the shadow of a gourd, the distance between her mouth and her eyes, the space between what she said and what she saw.

I turn around, drive back to the field, tell the kids to wait in the car. "A minute," I say. This moment. The color. The yellow slash of the headlights across the snow. The red in my veins. This blue sky, same as the snow-covered land. This brilliant darkness, with which I am coming to terms.

Acknowledgments

It seems to have become customary to save family for the end of the acknowledgments, in a last-but-not-least kind of way, but in this case, there is no book—indeed, no reason to make one—without my children. I made this book for my daughter, R., and my son, M., and I made it as a way of returning to them from the darkness in which I had become for a while disoriented. My daughter's questions and wisdom suffuse *This Brilliant Darkness* from its title to its final page—on which my son, M., poses this book's final query, one to which I believe the world offers a hopeful answer. M. was not even a year old when this book began, so he is only now coming of an age when, like his sister, he likes to make up poems and songs and stories. But like his sister's, his stories sustain me and shape my own— not just as a father but as a writer who has learned to listen closest to the language of those closest to me. That includes their mother, Julia Rabig, who's a storyteller, too.

Then there is my father, Robert Sharlet, with whom this book begins. When I was younger I thought I became a writer because of my mother, who died long ago; she'd wanted to be a writer, and I felt I was picking up her dream. As much as that's true, I realize now that as an adult, I am a writer because of my father—a writer himself, of a different kind, a scholar—who picked up my mother's dream for me the countless times I

misplaced it. Without his help as a reader and moral conscience, I could not have carried it forward.

I write at the start of this book that my father, like me, survived his heart attack, that he had become healthier than ever before, but between that draft and these acknowledgments, he fell suddenly ill, and on January 26, 2019, he died. It will remain a sorrow to me that he will not see the finished book, in which he believed more steadily than any other. But it is a solace that as he lay dying, I could read the above acknowledgment to him. This book remains dedicated to my children, as he would want it to be, but it is for my father.

Twenty-seven years ago at Hampshire College, Michael Lesy introduced me to Walker Evans, Dorothea Lange, Ben Shahn, Diane Arbus, Gordon Parks, and many more. Most importantly, he showed me the power of snapshots. He has been a friend and an adviser since. I wrote my first book with Peter Manseau and continue to depend on him as a careful reader. Ann Neumann read my work in progress as well, as did Rianna Starheim and Kathryn Joyce, a journalistic comrade who not only read a draft but also lent me her apartment to write the piece that was missing. I met Randy Potts, a.k.a. @thephatic, on Instagram, and as of this writing I've yet to meet him in person, but he has become such an insightful reader of my work, as I hope I am of his, that I feel like he's an old friend. Paul Reyes is an old friend, and also my editor and collaborator at the *Virginia Quarterly Review*. He helped me shape the crucial final pages of this book and, through our long, wandering conversation over the years, the ones that precede it, too. Eric Sullivan, my editor at *GQ* and then *Esquire*, is one of the best editors I've had the pleasure to work with. I'm also indebted to Luke Zaleski in his capacity as *GQ* research director and to Esther Kaplan and The Nation Institute. The International Reporting Project took me to Kenya. Photographer Pieter Hugo let me watch him work on Skid Row. Many pages herein were inestimably improved by his sharp eye and open heart. Photographer Tanja Hollander invited me to teach words+pictures with her at Hampshire College. She generously read drafts with insight, taught me visual truths, edited photographs, and

introduced me to new ways of considering the flow of imagination and perception. Kathy Anderson, my agent, is one of my oldest friends and subtlest readers. More than twenty years ago, Alane Mason, an editor at W. W. Norton, wrote me about a story of mine and asked if I'd thought of a book. That first book we discussed is still to be written, but I owe something of my life as a writer to her early enthusiasm, and much of whatever is good in *this* book to her wise and perceptive editorial vision. My mother was a production editor for a small press. For years after she died, in 1989, I didn't know much about her work; in the Internet age, though, it became possible to search for references to her in acknowledgments such as these. I'm grateful to those authors who named her contributions to their books, and grateful to all those at Norton who contributed to this one, especially Mo Crist, Sarah Daniels, Julia Druskin, Rebecca Homiski, Susan Sanfrey, Will Scarlett, Sarahmay Wilkinson, and William Willis, and to my copyeditor, Bonnie Thompson.

Mark Armstrong, the editor of *Longreads*, published an early selection of this work. Jessica Lustig at the *New York Times Magazine* commissioned the essay that became "#Rise&GrindMF$." William Boling and Dawn Kim invited me to co-edit a special issue of their photography journal, *Documentum*, dedicated to writing on Instagram. Emily Smith at *Ecotone* and Michael Kusek at *Take Magazine* featured work in progress. Tara Wray invited me to publish some small pieces of this work in the literary journal *Hobart* and then did me the honor of sitting in on one of my courses at Dartmouth College, despite the fact that she is far the superior photographer. Other former students who became friends have shaped this work through their own experiments with the form, among them Jamie Alliotts, Sadia Hassan, Sarah Khatry, James Napoli, and Meera Subramanian. At Dartmouth, Aimee Bahng was my closest colleague before she left for greener pastures, but I'm glad she and Bill Boyer-Bahng remain among my closest friends, the kind through whom all the questions of this book were filtered. I'm indebted to another one of my closest friends, Jeff Allred, for conversations about documentary art that made this book what it is, and to both Jeff and his wife, Gretchen Aguiar, for the kind of

friendship that makes it possible to even imagine writing. I'm grateful, too, to my Dartmouth colleagues, especially Cynthia Huntington, who helped me walk again after my heart attack and whose writing helped me see before it and after. Quince Mountain and Blair Braverman, who make several appearances in these pages, are comrades as well as friends: fellow travelers, night shifters, and reporter-gatherers. When I try to think of an audience for my work, it's them.

And finally, genuinely last but not least, last and most of all, the community of this book: the night bakers, the last-call drinkers, the strangers you meet after all the bars are closed; frightened people—fugitives from God, underground abortionists, men in closets within closets—and frightening people—men with guns, men with knives; the homeless, the houseless, and people who live in motels; the usual suspects, those whose lives are organized around addictions, and those whose livings depend on the sale of their bodies, and those simply trying to hold on to their minds. All of you who allowed me glimpses of lives beyond value, and who allowed me to snap your picture, frozen moments clipped from the beauty of your continuity. I especially want to thank the families of Charly Keunang and Jared Miller; Pastor Cue Jn-Marie; Mecca Harper; Pete White and the heroic organizers of Los Angeles Community Action Network; Zhenya Belyakov, Elena Kostyuchenko, and all the brave Russians who could not share their full or real names; and Mary Mazur, wherever you are now—may Bandit be with you.